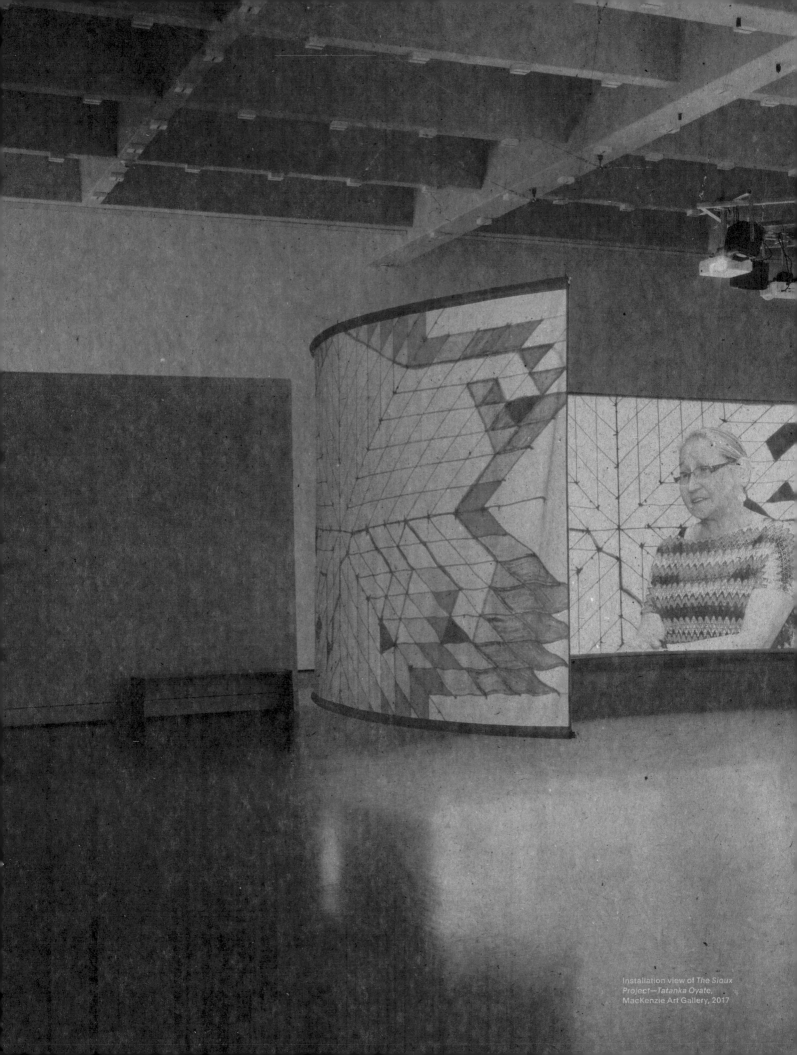

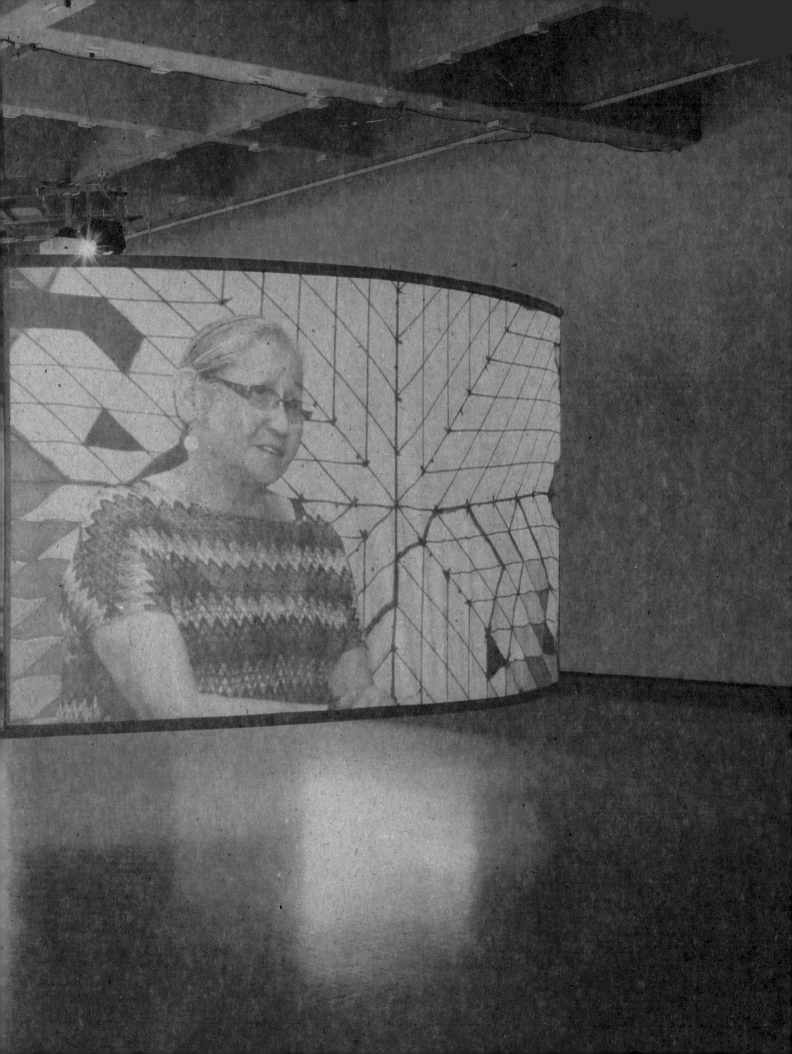

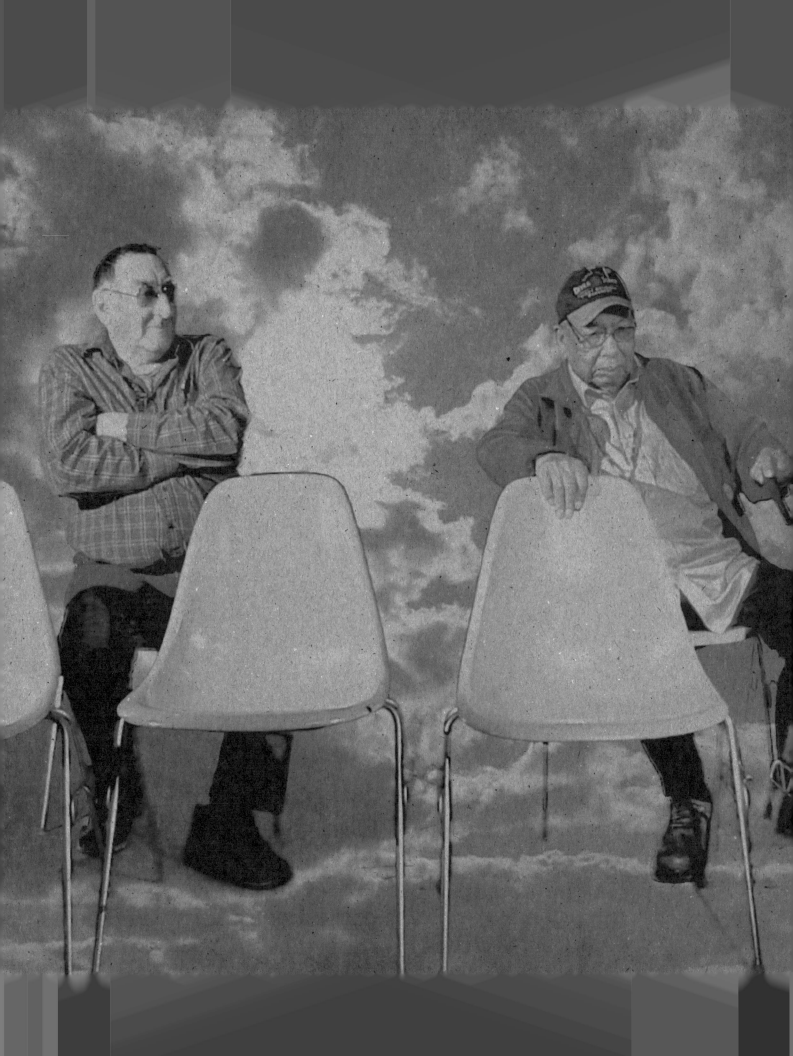

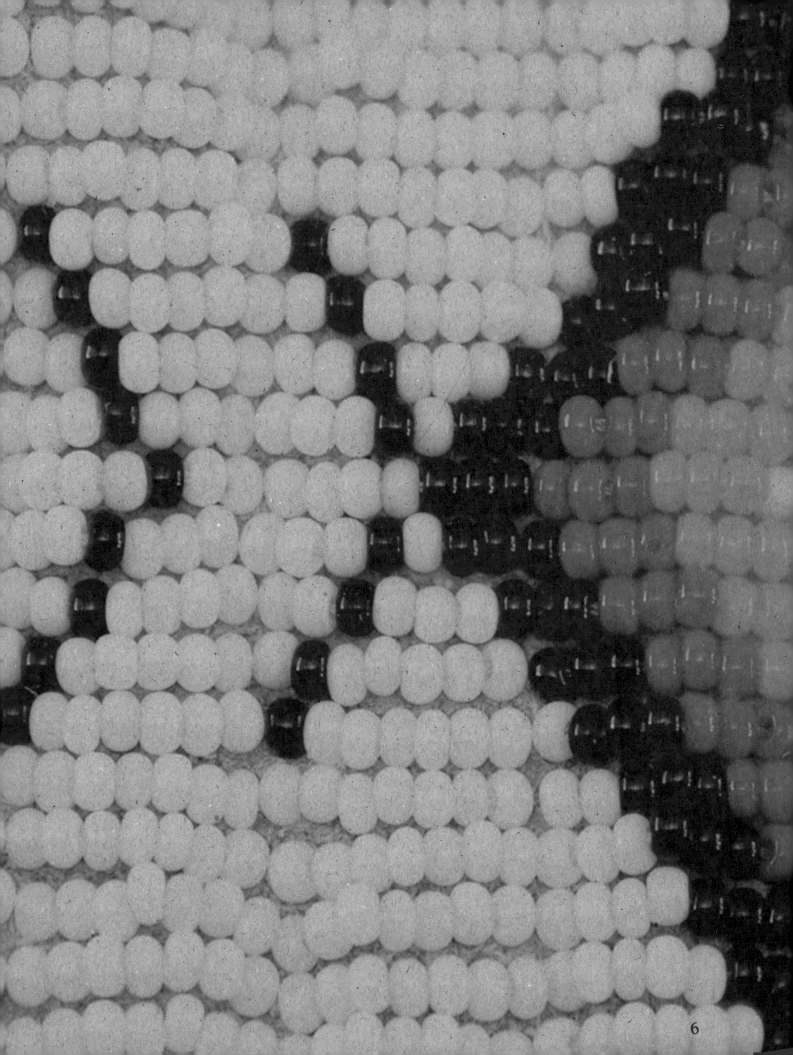

**Information Office**

MUSÉE D'ART MACKENZIE — MACKENZIE ART GALLERY

# THE SIOUX PROJECT TATANKA OYATE

Edited by Dana Claxton

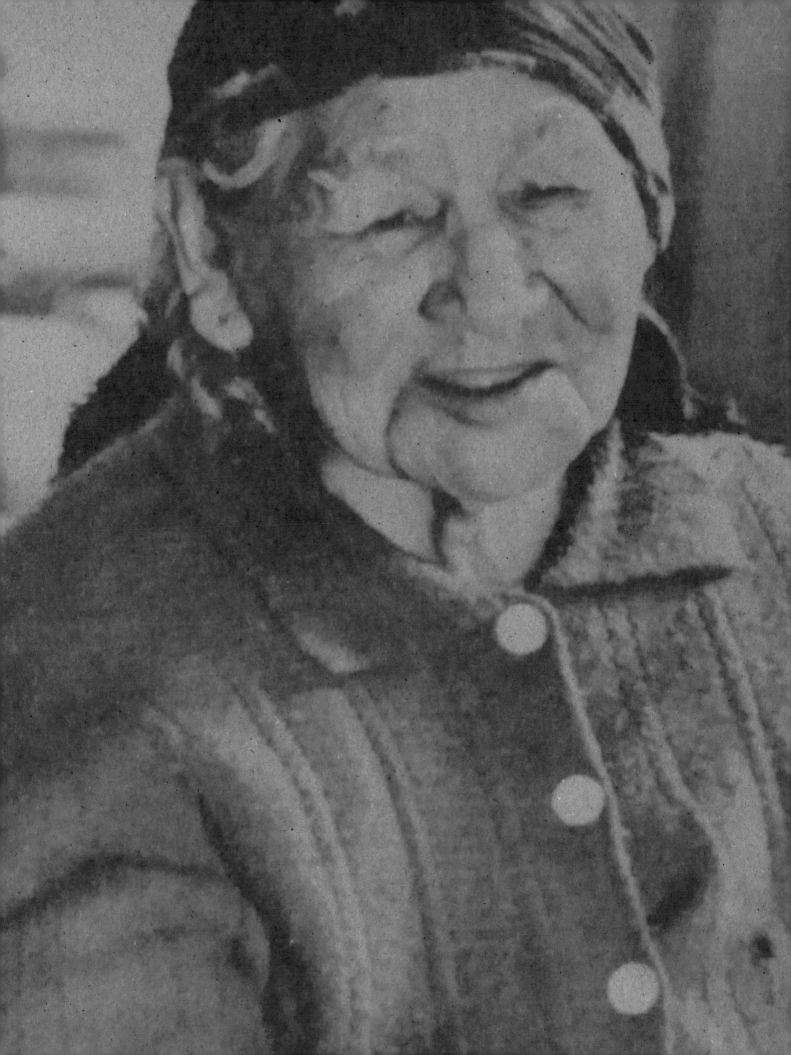

# Executive Director's Foreword

With *The Sioux Project—Tatanka Oyate* the MacKenzie Art Gallery is pleased to continue its long relationship with the celebrated Hunkpapa Lakota artist Dana Claxton, one of the foremost figures in Canadian art.

I personally had the pleasure of working with Claxton during the creation of *Buffalo Bone China* (1997) for TRIBE in Saskatoon while I was working at AKA Artist-Run Centre, the site of that project. Over twenty years later, I think how remarkable it was to have witnessed Dana working through the creation of what is now considered an historically significant work, and one of Claxton's major successes. To see first-hand the performance that was the raw material of the subsequent video installation, a work that has now shown internationally, was a privilege. I recall Dana showing up at the gallery with a rubber hammer and protective eyewear, ready to smash porcelain. It was of course political, but also a delight. In *Buffalo Bone China* Claxton offered a pointed but poetic response at the near extermination of the buffalo over a century ago, and the anguish resulting from this horrific massacre. This work was purchased by the MacKenzie in 1999 and is now in our permanent collection.

Two decades later, *The Sioux Project—Tatanka Oyate* turns the perspective from colonial erasures to an affirmation of Indigenous self-determination. Looking specifically at her extended Sioux community, the Dakota/Lakota/Nakota peoples of Saskatchewan, this immersive four-channel video installation offers an engaging survey of the cultural traditions and connections that have sustained the Tatanka Oyate, "the Buffalo People."

During the years between these two projects, I have often observed and admired Claxton's work, which has continued to evolve in numerous directions. Leading up to a 2003 exhibition and a related publication in 2005, I worked with Claxton in her capacities as a guest curator and co-editor for projects at Walter Phillips Gallery at the Banff Centre (I was by then Director there).[1] In the book *Transference, Tradition, Technology: Native New Media Exploring Visual and Digital Culture*,[2] Claxton demonstrated the depth and breadth of her research and knowledge in mapping and historically contextualizing Indigenous new media art. The early digital prints by Buffy Sainte-Marie that she presented,[3] as well as works by other artists, still linger clearly in my memories. In retrospect, it is clear that, even as she was enjoying increasing success as a solo artist, Dana was intentional in documenting and honouring peers that came before her and worked alongside her in Indigenous new media practices. Continuing in this spirit, *The Sioux Project—Tatanka Oyate* is another instance when Claxton has been intentional and committed to acknowledging her predecessors, her culture, and indeed now subsequent generations of artists whose works are part of this cultural legacy.

I also recall an exhibition at Urban Shaman in Winnipeg in the fall of 2008. It opened the night Bob Dylan was performing in town—and that seemed fitting. Claxton's work in the exhibition *TXT4WPG* was as minimal as I have seen—word-based texts in light projected on the walls. It struck me as extremely raw and challenging. She had abandoned any extraneous visual reference or support in favour of text—a notable change after having been so celebrated as a visual artist and filmmaker.[4] I remember being awestruck by the gesture of abandoning her established form. Perhaps with poetry on my mind that night—we were heading to the Dylan concert a few blocks away—I was opened up to Claxton's own words and power in a new way. I recall the élan of that exhibition with admiration. I was also amused to witness the fleeting consideration, when we met, that she skip her own opening to go see Dylan perform.

Eleven years later, I saw Claxton and her newly commissioned photographs at the Toronto Biennial[5] in the fall of 2019. These photographs (LED fireboxes with trans-mounted Duratrans), to me, were again embarking in a rich and new direction. They feature portraits with headdresses—mashups of Sioux aesthetics and visual culture that, by contrast to the 2008 work, rely on a completely enthralling, seductive, and effervescent profusion of visual information. Mixing resistance and visual pleasure, they are characterized by a "surplus" of baroque visuality that draws the viewer into a metaphorical candy store of references to pop culture, Indigenous iconography, fashion, textile, and portraiture. Charged by socio-political allusions to nationality, religion, and migration, these images of women

obscured by headdresses are imbued with implicit cultural meanings that are specific to the end of the twentieth century, including trans-national migration. While the works seem startling in their fresh approach to subject matter, I immediately began to make the connections to *The Sioux Project—Tatanka Oyate*. I would characterize the latter as first and foremost the product of an intensive period of research-creation and collaboration. In retrospect, I believe that the *Tatanka Oyate* work has fed the tightened conceptual frame and formal rigour of the more recent works. While one might argue that Claxton's initial headdress works date back up to eight years, I believe these recent photo works delineate a compelling narrative which demonstrates the transfer of so-called "pure" artist-creation research into a dialogue with the "applied" production of works both preceding and following the research, and that research-creation projects such as this are therefore essential to the advancement of new work and new knowledge. Artistic research-creation has arguably been fraught over the past twenty years of its burgeoning emergence in academic contexts. On the one hand, academic institutions have perhaps not fully appreciated the specific priorities and practices of the fine arts in general and visual art production more specifically—knowledge necessary in order for works to be properly assessed using existing (non-fine arts) models. On the other hand, some artists and art commentators have been dismissive of the "academization" and formality of research-creation practices. No doubt, part of this disconnect is a result of art's unique condition of simultaneously embodying the "hard science" of experimentation, the social consciousness and relevance of the social sciences and humanities, and the poetics and aesthetics of artistic creation. Therein lies the particular challenge in assessing research-creation projects. I believe *The Sioux Project—Tatanka Oyate* is an exemplary model of how research-creation in the visual arts can be done well. Not only did the project engage community while at the same time fostering the highest level of artistic production, it ultimately addressed a research question, and created and disseminated new knowledge.

*The Sioux Project—Tatanka Oyate* fills a major gap in our understanding of contemporary Sioux aesthetics in North America. The product of over three years of on-the-ground research involving a team led by Dana Claxton, Dr. Lynne Bell, Gwenda Yuzicappi, and Cowboy Smithx, the installation presents a moving community portrait in which the traditional knowledge of elders is actively transmitted to and translated by a generation that is as comfortable with video mashups as they are with star quilts and beadwork. The importance of Claxton's project was underlined by the warm community response to the opening weekend events, which included a public barbecue, performance, workshop, and live-streamed symposium attended by over 100 people, including an enthusiastic contingent of students from Whitecap Dakota First Nation.

My profound gratitude goes to The Sioux Project team of Claxton, Bell, Yuzicappi and Smithx, who initiated and directed this visionary project with the financial support of the Social Sciences and Humanities Research Council of Canada and the administrative support of the Department of Art History, Visual Art and Theory, University of British Columbia. With them, we are deeply grateful to the many community members who shared their knowledge, passion, and creativity on screen.

I wish to acknowledge the contribution of guest curator, Dr. Carmen Robertson, whose Lakota connections and extensive knowledge of Indigenous art history greatly enriched the exhibition and programming, as well as this volume. My sincere appreciation is extended to the contributors to this catalogue for their many insights into the project and exhibition, as well as the wider fields of Sioux aesthetics and history: Dr. Janet C. Berlo, Dr. Carmen Robertson, Dr. Lynne Bell, Timothy Long, the late Dr. Bea Medicine, and Cowboy Smithx. A special thanks must go to Bobbi Kozinuk, Claxton's long-time collaborator, for his work on this technically demanding installation. Also, thank you to Winston Xin, who has worked with Dana for 28 years as an editor and who also supported production of this work.

Thanks go as well to Don Hall for his expert installation photography and to Derek Barnett and Jonathan Middleton of Information Office for their exquisite catalogue design and coordination. As always, I am grateful to the MacKenzie

staff for their commitment to the highest standards in realizing the Gallery's programs: Larissa Berschley MacLellan, Peter Brass, Leevon Delorme, Timothy Long, Jackie Martin, Lydia Miliokas, Krysta Mitchell, Sandee Moore, Caitlin Mullan, Nicolle Nugent, Marie Olinik, Christy Ross, Wanda Schmöckel, Brenda Smith, and Janine Windolph. If I have omitted anyone here it is an unintentional oversight, and my gratitude and acknowledgement is without exception.

The MacKenzie Art Gallery is Saskatchewan's original non-profit public art gallery and is generously supported by our members, volunteers, and donors. Core funding is provided by the South Saskatchewan Community Foundation, Canada Council for the Arts, SaskCulture, City of Regina, University of Regina, and Saskatchewan Arts Board.

Finally, I wish to sincerely thank Dana Claxton for years of continually inspiring work and encounters, often characterized by sly humour, creative enthusiasm, and new ideas. I hope there are many more to come.

Anthony Kiendl, Executive Director and CEO
MacKenzie Art Gallery
Regina, Saskatchewan, March 2020

1. Claxton curated the exhibition *Back/Flash* for Walter Phillips Gallery in 2003 featuring the works of Buffy Sainte-Marie, Ahasiw Maskegon-Iskwew, Lawrence Paul Yuxweluptun, Thirza Cuthand, and others.

2. Dana Claxton, Stephen Loft, and Melanie Townsend, eds., *Transference, Tradition, Technology: Native New Media Exploring Visual and Digital Culture* (Banff: Walter Phillips Gallery Editions, 2005).

3. Digital prints included *The Pink Village* (1994) and *Elder Brother* (1994), from the collection of First Nations University of Canada, as documented in *Transference, Tradition, Technology*.

4. Although notably Dana's earliest work in the early 1990s was in poetry and performance.

5. Viewable at https://torontobiennial.org/work/dana-claxton-at-259-lake-shore/.

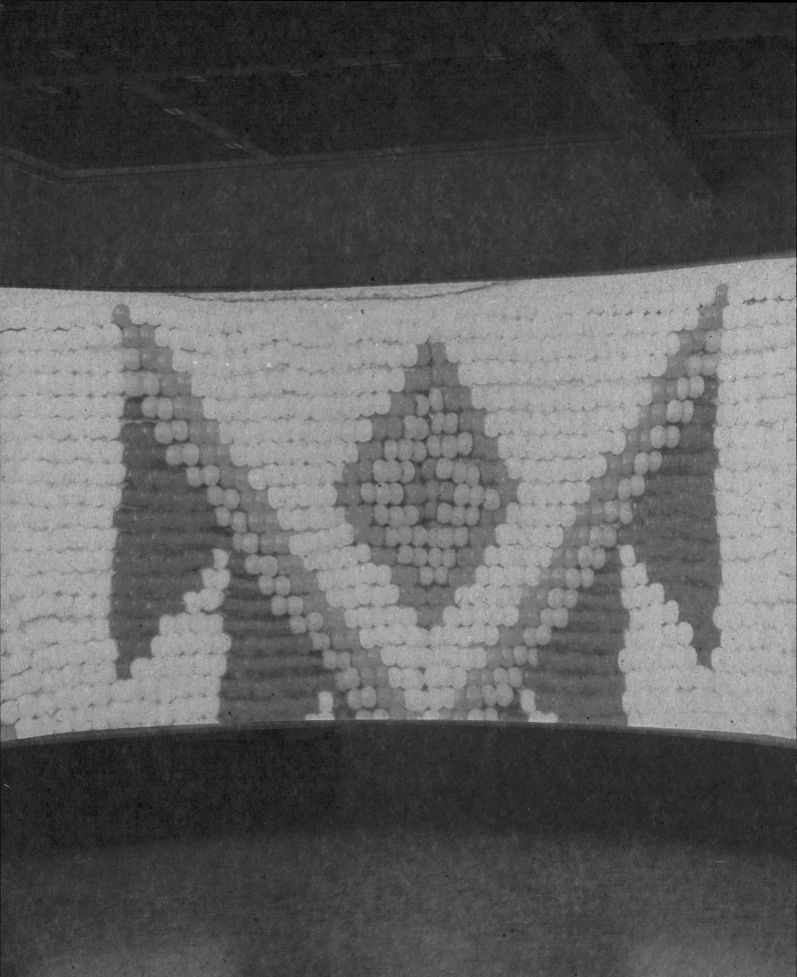

Installation view of *The Sioux Project—Tatanka Oyate,*
MacKenzie Art Gallery, 2017

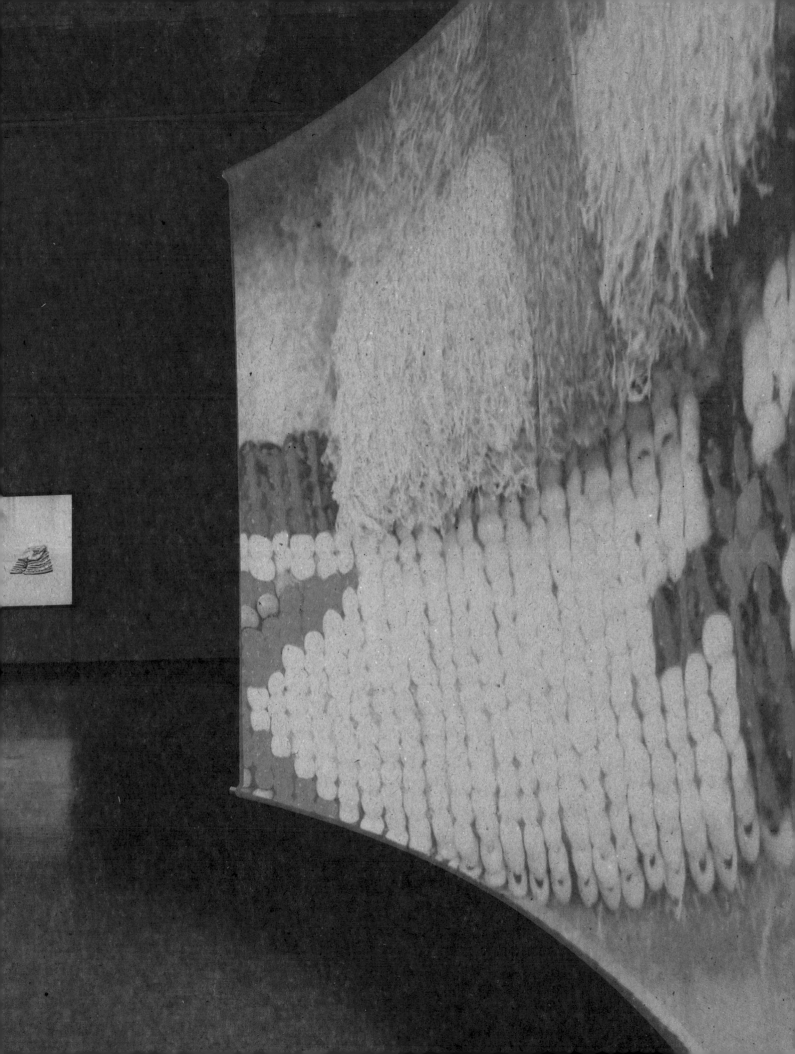

# The Sioux Project: Tatanka Oyate—The Buffalo People

Lynne Bell

On a beautiful afternoon in August 2013, I got a phone call from Dana Claxton. She was on a stopover in Saskatoon on her way back to Vancouver after a summer visit to the prairies. Could I meet her in the hotel gardens along the river? As it turns out, she wanted to invite me to participate in a research-creation project on the cultural arts of the Lakota, Dakota, and Nakota Nations living in southern and central Saskatchewan.[1]

As an artist-filmmaker, Claxton is inspired by the worlds of the Tatanka Oyate, the Buffalo People. She was born and grew up on the Great Plains, in Moose Jaw, Saskatchewan. Her mother's family is from Wood Mountain Lakota Nation in southern Saskatchewan. Her work is filled with Lakota ideas and worldviews. It also offers a keen political analysis of settler-colonial power and its violent impacts on Indigenous people in Canada, past and present.

As someone who was born in Yorkshire in the north of England and educated in the Western humanities and fine arts, the experience of looking at the world through the perspective of the teachings of the Indigenous humanities and fine arts continues to be an ongoing transformative educational experience. While the Western discourse of aesthetics (theorizing about artistic practices) takes many forms as it moves across institutions and discourses, it is still in many places a privileged terrain from which Indigenous voices, knowledge, and perspectives are excluded.

\* \* \* \* \*

*The Sioux Project—Tatanka Oyate* was designed to pursue research-creation in a series of planned events that included: several video workshops for youth from differing Lakota, Dakota, and Nakota communities; a series of full-length interviews with community artists filmed at Standing Buffalo Dakota Nation, Regina, and Saskatoon; a video installation exhibition and symposium at the MacKenzie Art Gallery; the training of students in our respective universities, University of British Columbia (Claxton) and University of Saskatchewan (Bell); a publication mapping the project's four-year journey; and a DVD compilation of the video installation (and book) to be gifted to each community and interview participant.

The research-creation project did not have the familiar academic model of beginnings and progression to a foreordained end, whose outcomes were something that could be predicted ahead of time. Instead, we thought of multiple platforms and multiple beginnings that would bring differing publics into an ongoing conversation about the cultural arts of the Tatanka Oyate. Our thinking, here, was informed by critical curatorial praxis and its understandings that the spaces of contemporary art-making are multiple and the ways in which artists engage with wider public domains are also multiple.

From the outset, Claxton wanted to run video workshops for Lakota, Dakota, and Nakota youth living in Saskatchewan. This was her "dream project" to "give back to Sioux youth," by sharing her craft with the next (potential) generation of film and video artists. We also wanted to film community artists talking about their work and the Tatanka Oyate aesthetic sensibility. To achieve these objectives, it quickly became clear that the community had to take the lead in planning and organizing events that gathered elders, community artists, and youth participants together. In terms of methodology, we recognized that every location would have its own practice-based critical epistemologies (ways of knowing and doing), even when not defined or limited by them. So the founding principle of our project was one of openness to the protocols of all communities involved. From the outset, the living heart of the project was the community. The exceptional work of Gwenda Yuzicappi from Standing Buffalo Dakota Nation as community partner made the project possible. Gwenda (with her husband Mike) began the research journey in a good way at Standing Buffalo: following protocols, they organized a *Wopila* (give-away) and the first of many feasts.

As our research got underway, the "road trip" became an important site of work as the film crew travelled around Saskatchewan in a rented van stuffed with bags of camera equipment. We had a great deal of fun together as we travelled to various planned events, listened to playlists, discussed matters that lay at the heart of the project, and filmed the magnificent summer skies and rolling landscapes of southern and central Saskatchewan. On a trip to the city of Moose Jaw, we "travelled in the footsteps of Sitting Bull and the old Lakota," as Gwenda put it; we visited "the Turn," where Sitting Bull and the Hunkpapa Lakota who travelled with him set up winter camp at Moose Jaw Creek from May 1877 to July 1881. We also visited with Heather Smith, the Curatorial Director of the Moose Jaw Museum and Art Gallery, who arranged for the crew to film the museum's archive of the regalia and cultural belongings of Sitting Bull and the Hunkpapa Lakota.

## Standing Buffalo Dakota Nation: A Community Research-Creation Project Takes Shape

On a crisp sunny day in October 2014, we took the turnoff to Standing Buffalo. Below us in the valley, we saw the community sitting between two lakes, and houses on the surrounding hills. There is something magical about the Qu'Appelle Valley for visitors unused to its winding lakes, undulating hilltops, and immense prairie skies. In describing Standing Buffalo to me, Gwenda Yuzicappi said: "We have the hills, the valleys, the lakes, the trees, the rocks. Everything that surrounds the community is a part of Mother Earth. When we say creator's country, it is 'creation.'"

On that first visit, we parked in front of the Standing Buffalo Dakota School, close to the lakes in the valley bottom. As the crunch of gravel announced our arrival, Gwenda came out to greet us. Inside the school gymnasium, we met Beverley Yuzicappi, the Dakota language teacher at the school, and the youth she had invited to participate in the first video workshop. We were thrilled to see twenty-five participants, aged 8 to 16.

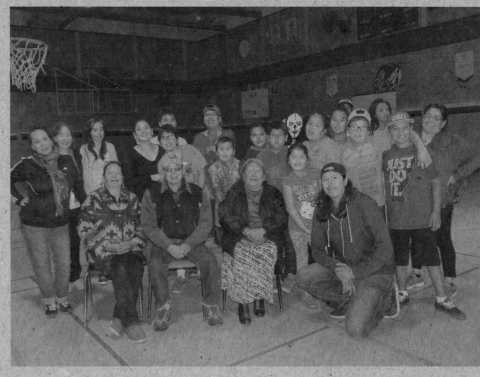

Over the next three years, the Dakota Oyate community of Standing Buffalo became the base camp for the research project. It is home to Dana Claxton's relatives: Elder Hartland Goodtrack (Uncle Spike) and Elder Evelyn Goodtrack (Auntie Evelyn) who assisted the project in so many ways, including hosting the film crew as they interviewed Elder Wayne Goodwill, a Keeper of History, in their home. Today, the population of Standing Buffalo has a high percentage of youth.[2] The community places particular emphasis on teaching "the Dakota language and culture" to the youth. As the Final Report of the Truth and Reconciliation Commission (TRC) notes, it is "the youth [who] are taking up the challenge of practicing, maintaining and re-vitalizing the 'cultural ways,' of Indigenous people in urban and on-reserve communities across Canada."[3]

\* \* \* \* \*

We held a total of three video workshops with Lakota, Dakota, and Nakota youth: two at Standing Buffalo, and one at PAVED Arts in Saskatoon for youth from Whitecap Dakota Nation and the city. The workshops were run by Claxton and Cowboy Smithx, a talented filmmaker and director from the Kainai Nation in southern Alberta, and his assistants, including film editor Rio Mitchell. Cowboy has taught many professional video training workshops in which he delivers "the full package" of pre- and post-production, editing, and screening, all in one day. At the beginning of each "video boot camp," as they came to be known, Claxton and Cowboy gave brief "Artist's Talks" on their work as filmmakers and

artists. In these talks, they stressed that the youth did not have to leave their own home cultures to tell significant stories in film and video. They taught that a situated politics of location matters, and that film and video are storytelling media that can address important issues in the youths' own lives, communities, and families.

After the introductory talks, Cowboy launched into his "crash course on how to pull a video together." This included an introduction to basic terminology (film 101 style) and hands-on demonstrations. He split the group into "departments"—a sound team, a lighting team, a camera team, an editing team, actors who perform in front of the camera, and creatives who develop and direct the storyline—and set up a rotation system that gave each participant a turn at the different activities. The methodology of these workshops was all about learning through doing and making, and working collaboratively.

\* \* \* \* \*

On our second visit to Standing Buffalo in 2015, Gwenda Yuzicappi and the community organized a video boot camp alongside (and in the midst of) an exhibition of the work of fifteen community artists in the gymnasium at the school. This community-led event gathered together youth, elders, and artists in one intergenerational research-creation community engaged in filming the creative expressive arts of the Tatanka Oyate.

Walking into the gym at Standing Buffalo Dakota School on that day was an unforgettable

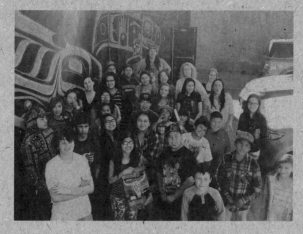

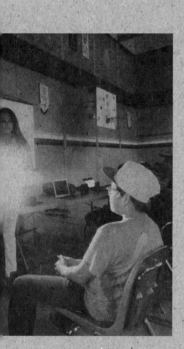

experience. I had no idea of the richness, beauty, and diversity of the work being made, nor that such a large body of work was being produced on a regular basis. The artists had installed their work on tables around the gymnasium. Moving from table to table with the film crew and the youth, I met artists who made exquisite jingle dresses, capes made of dentalium (seashells), beaded lanyards and moccasins, a hand-drum of raw buffalo hide and sinew (made during the event), fringed dance shawls, star quilts, parfleche paintings, quilled medicine wheels, pipe bag panels, and much, much more.

While this was going on, the film crew transformed the gymnasium into a film studio, setting up a green screen for the on-camera interviews, an editing station, and a big screen for playing short takes of the interviews. The community partners set up food tables with big pots of buffalo stew, buns, and salads; and the youth participants began to film the dance regalia and cultural belongings displayed. This footage shot by the youth later became part of Claxton's video art installation.

\* \* \* \* \*

Once seated in front of the green screen, Claxton asked each participant a series of questions, including, What does a Tatanka Oyate aesthetic mean to you? Addressing themselves to Dana and to the youth, the artists told the story of their work: who taught them; the practices they used; and the "teachings" that are carried in the dances, regalia, belongings, songs, and drums. As their storytelling spun out into focused and rich discussions, we were given a rare front-row view into the skilled praxis of highly committed artists, historians, dancers, and musicians.

Indigenous education is grounded in conversations across the generations. As the artists and elders talked on camera, they addressed Claxton and the youth, who listened attentively. Later, Gwenda Yuzicappi told me that it was Elder Barbara Ryder who set up the model for the cross-generational

on-camera interview. In the first video workshop, Elder Ryder waited patiently until the workshop was completed, so that her grandchildren could use their newfound skills to interview her on film about her childhood and the Dakota way of life. This is an Indigenous model of education that involves talking together as a way of knowing, a mode of learning that is as comfortable as breathing, as the Indigenous educator Gregory Cajete puts it.[4]

Listening to the artists and elders, I learned that while the Tatanka Oyate communities in Saskatchewan have distinct histories and differing geographical settings, they share a history of surviving and resisting the violence of settler-colonialism from the late 1800s to the mid-1900s when "the law waged war on Indigenous peoples" in both the United States and Canada, as Chief Justice Murray Sinclair has described.[5] The Tatanka Oyate also have a shared ecological worldview that is focused on creating and maintaining close, respectful relationships with the Earth, with their home territories, with all living species, and with each other. This ecological worldview, shared by Indigenous people around the world, is expressed in such concept metaphors as *mitakuye oyasin* (all my relatives).

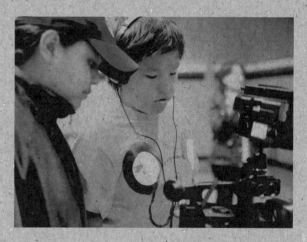

In his book, *The Lakota Way: Stories and Lessons for Living* (2001), the Lakota educator Joseph Marshall III describes the meaning of this metaphor of *mitakuye oyasin*:

> A cornerstone of Lakota culture can be summed up in the words family and kinship. Family is the backbone, the foundation of our culture.... Kinship goes beyond family and is the connection we feel to the world at large and everything in it.
>
> ... Many of our stories about animals refer to them as the "elk people," or "the bear people," or the "bird people," not because we were anthropomorphizing them but because in our language the designation "people" was not limited to humans.[6]

As many of the artists and elders noted on camera, the songs, drum, dances, regalia, and cultural belongings are all "carriers" of ancestral teachings about how to live the Tatanka Oyate "way" of life and its shared worldview of kinship, interconnection, and interdependence. This is not a Western knowledge system fragmented into differing silos of knowledge. This is interconnected thinking based in a reverence for the living world. As the Final Report of the TRC notes, through all the disruptions of colonialism, the people kept alive the ancestors' teachings to always remember to listen to the voice of the land, the communities, the families, and the children.[7]

## Honouring the Voices

Dana Claxton's video art installation, *The Sioux Project—Tatanka Oyate* (2017), opened at the MacKenzie Art Gallery in Regina, in Treaty Four territory.[8] This exhibition event included a video installation and a day-long symposium curated by the Lakota scholar Carmen Robertson. In both events, the creative expressive arts of the Tatanka Oyate were framed as a dynamic contemporary force in the Canadian art world.

In the exhibition and the symposium, the MacKenzie Art Gallery gathered Indigenous and non-Indigenous publics together (online and offline) to celebrate the "creative expressive arts" of the Tatanka Oyate. The symposium provided a critical frame which grounded the video art installation, and the entire research-creation project, in the following epistemologies: the "voices" of Lakota elders talking about their worldviews, values, and "ways" of living; and the "voices" of community artists and elders talking about their praxis and the collective teachings carried in the creative expressive arts. In talking about her video installation, Claxton noted: "This work has been made by many people and not just by myself." With this comment, she opened up an expanded discussion on the community arts, aesthetics, and authorship in the contemporary art gallery.

* * * * *

Walking into the MacKenzie Art Gallery on the day of the opening, the discreet architecture of the gallery wrapped visitors in an immediate calm. It was hot outside, and the generous windows of the spacious foyer flooded the building with sunlight. On that late September day, the windows framed a dramatic visual experience: in the lingering summer heat, the trees had turned a fiery tangle of reds, oranges, yellows, and lime green. But inside the foyer, it was the soundscape of Claxton's video installation—drumming, singing, voices talking, children laughing—that tugged at the visitor's attention, urging them to climb the wide staircase to the main galleries.

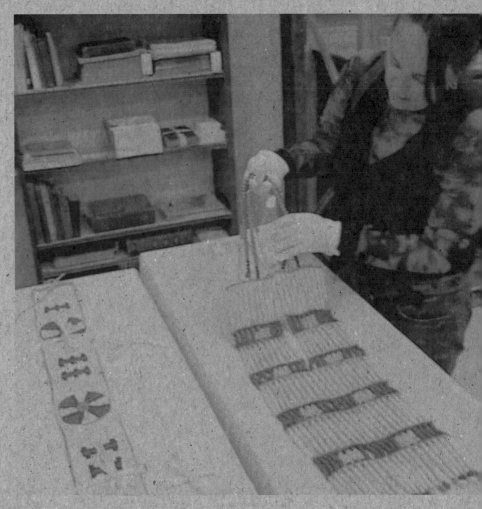

On entering the dimly lit gallery, Claxton's installation appears at first glance to be a circle of moving light, color, sound, and imagery, shining in the darkness. The architecture of the installation is impressive: four massive curved screens hang from the ceiling in a circle. Four projectors (reminding us of the physicality of digital imagery) are also suspended from the ceiling: they project a two-hour, 360-degree, four-channel video narrative onto the circle of screens. The giant screens are made of raw stretched canvas—a porous, translucent medium that seems to breathe. As the light of the projected imagery pours through the weave of the canvas, viewers can watch the video projection while standing in the inner circle, and, while walking around the outside of the installation. The four openings between the screens act as doorways into the large yet intimate inner circle of the installation. Here, a circular cushioned seat invites us to linger and take in the dialogue that is unfolding all around us on the four screens.

As I watch the video narrative unfold, huge moving images of tasseled corn plants appear on the screens, their restless green leaves rising and falling in the breeze, like the long fringes of a dancer's shawl. The green leaves fill the darkened

gallery with a glowing dappled light that splashes and bounces onto the surrounding walls and across the polished floor. As the images dissolve and change, Elder Connie Wajunta of Standing Buffalo Dakota Nation appears on the screens. We see her in the gym at Standing Buffalo and in her corn garden in the Qu'Appelle Valley at the height of summer. At times, the camera watches in extreme close-up and we see details of her face and hands, the leaves of tall corn plants, and tight rows of kernels on ears of yellow, red, and purple corn.

As Elder Wajunta talks about the corn and its traditional teachings, she carries the voices of her ancestors into the gallery. Talking about the significance of corn in the lives of the Dakota Nation, she says that in her childhood corn was a major food staple in the sustenance economy of the Tatanka Oyate. Corn soup and delicious corn balls mixed with dried buffalo meat and cranberries kept the people in good health in difficult times. Growing up she was told: "You need to take care of this food. It is sacred." She notes that she always follows her ancestors' instructions when planting the corn: "You plant from north to south.... I usually do fourteen rows.... That's what I was told. So I try to teach that." When she begins to plant, she starts with a ceremony. "I was told that you have to pray." She offers tobacco as a thanks. She notes that this practice of planting the corn is an emotional one: "I'm thinking about the old people, when they first came here.... I think it's something that we have to have. It's been brought to us, and someone has to do that."[9]

In the ancestral instructions handed down in her family, we hear about a sustainable way of life, forged over generations of living in close relation-ship to the land. In talking about the Indigenous garden, the Native American educator Gregory Cajete says: "Native gardens ... are as much a mythic-spiritual-cultural-aesthetic expression of [the peoples'] participation and relationship with nature as was 'native art, architecture and ceremonialism.'" As Cajete notes, the Indigenous corn garden is "a way of continuing to remember to remember what our relationship to our place is throughout our life and to preserve our view of life for the generations that will follow."[10]

* * * * *

On opening night, I met up with other members of the research team in the inner circle of the installation: Gwenda Yuzicappi, Cowboy Smithx, and Kim Soo Goodtrack, Claxton's sister (also a gifted artist). We were captivated by the beauty of this immersive art installation. Although the research team worked closely with Claxton in the early stages of the project, none of us knew ahead of time what the final "reveal" would look like. In post-production, Claxton took thirty-eight hours of footage shot during the project, and condensed it into a powerful visual rhetoric of image-sound-and-movement capable of speaking about the living aesthetic sensibility of the Tatanka Oyate. As we turned 360 degrees to view Claxton's four-channel video projection, we experienced the image as both raw material presence and as a multi-voiced discourse on the creative expressive arts of the Tatanka Oyate.

In the video's narrative, we see the three-year journey of the project unfolding on the massive screens. "Dana has filled the installation with all of the memories," says Cowboy. She has also filled the screens with images of the land and skies of the Tatanka Oyate's home territories in Saskatchewan, seen from many differing vantage points, as they cycle through the seasons and times of day. As we watch, we see buffalo grazing on the hilltops, horses at a fence, sunlight shimmering on water, the wind ruffling cottonwood trees, two dogs grinning into the camera lens, and a baby sitting in a blue beaded cradleboard that wraps the infant in a thin red line of beads, signifying "the good red road" the child will walk in life. In one memorable instance, we see Elders from Whitecap Dakota Nation taking their seats for a group portrait. Preferring not to speak on camera, they are pictured in the wide embrace of a summer sky filled with white clouds.

In the circle of screens, we meet up with the thirty-two elders and artists who gave on-screen interviews. These conversations (seen in short clips) provide a thread of continuity throughout the video's two-hour looped narrative. In talking about their work, they address us one at a time, as if they are in a "talking circle." In these moments, the video's footage becomes a "watchful documentary," slowing down and listening closely to the words of each speaker. As they talk, images of the regalia

and belongings the artists have made appear in close-up detail on the encircling screens. In this talking circle, everyone's voice matters, none are excluded. "In a circle discussion," writes the Indigenous legal scholar John Borrows, "everyone is permitted to speak, although only one person speaks at a time." "Circles are considered sacred," he notes, "and represent the bringing together of people in an atmosphere of equality, as they do not raise one person above another."[11]

In *The Sioux Project—Tatanka Oyate*, Claxton has created a remarkable portrait of a brilliant "teaching civilization" at work. In shaping her video installation, she clears a space for viewers to hear the immediacy of the artists' and elders' voices, as they talk about their personal life-stories, their involvement in the creative expressive arts, and the significance of the ancestral teachings that are carried in the songs, the drum, the dances, the dance regalia, and the cultural belongings. Listening to this dialogue on the cultural arts of the Tatanka Oyate repairs the cognitive blind-spots I learned at school and university. In those days, the discourses of the high humanities and fine arts had two major structuring absences: the living Earth and Indigenous people. Riddled with colonial "ways of seeing" and habits of thinking, these Western disciplines taught that disconnection from the natural world was a normal state of affairs. They also marginalized or erased Indigenous knowledge and Indigenous ecological perspectives. In complete contrast, the creative expressive arts of the Tatanka Oyate are carriers of an ecological worldview that puts the living Earth—her ecosystems and abundant resources that sustain all of life—at the heart of every curriculum.

\* \* \* \* \*

The four curved screens of Claxton's installation can also be read as a dance circle that is filled with the rhythm of the drumbeat, songs, and powwow electronica of Claxton's soundscape. As we listen, Kristen Yuzicappi holds up her jingle dresses in front of the camera; she moves them so that we can hear the sounds that the decorative jingle cones make when she dances. As she talks about her experience of jingle-dress dancing from the age of seven, the massive screens are flooded with the vivid colors of her dresses: lime greens, neon golds, and shimmering silvers. Dancing is her "comfort zone," she says. When something is troubling her, she will just "go to a powwow and dance.... It's a therapeutic way for me to just be calm, and just be myself, and just enjoy life." She goes on to explain:

*I'm the mother of two children. My husband, he sings. My daughter is a jingle dress dancer and my son is a chicken dancer. So I sew for them and bead.... As a Dakota woman, jingle*

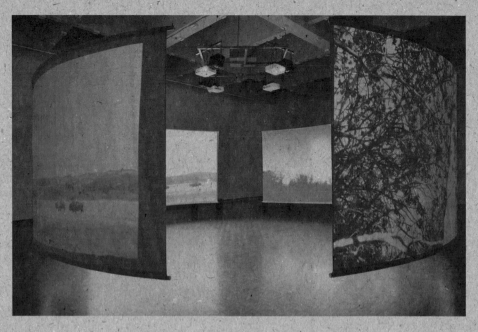

Installation view of *The Sioux Project—Tatanka Oyate*, MacKenzie Art Gallery, 2017

*dress dancing really helps me to pass my ways on to my daughter. So when you are wearing your jingle dress, there's a certain way that you carry yourself.... The way you walk as a woman is almost sacred.... Just treat people with respect.... Once I get out there on the dance floor, it feels like that's where I'm supposed to be, and all my hard work with my dresses and my beadwork, it all just comes together.*[12]

\* \* \* \* \*

As the renowned Lakota scholar Beatrice Medicine notes, the attempt by settler colonial governments to suppress the cultural and spiritual practices of Indigenous communities in the United States and Canada from the late 1800s to the mid-1900s "was aimed at the very matrix of the expressive elements of the culture: language (vernacular and ritual), music, song, dance, art and other emotion-laden aspects such as religion."[13] During these years, Indigenous people were arrested on both sides of the colonial border for performing their music and participating in their dance circles.[14] Talking about the aftermath of the 1890 massacre of three-hundred men, women, and children at Wounded Knee by United States troops, the Lakota artist and singer John Trudell says: "They went after every part of our culture so of course they were going to go after our music because it was an integral aspect of our culture. Because back in those times every one had a morning song to greet the day. They were songs of our ancestors. They were songs of the 'old way.' They went after our culture and it was genocide and they wanted to erase every cultural perception of reality that we had."[15] But Indigenous people did not stop dancing, singing, drumming, holding their ceremonies, and creating their cultural arts which carried the "old ways" of their ancestors.

Today, on the screens of Claxton's installation, the artists, drummers, and singers tell us that the creative expressive arts are nourished, maintained, and renewed by the annual powwow at Standing Buffalo (and elsewhere)[16]. When Claxton asks Angela Buffalo of Whitecap Dakota Nation, "How does powwow culture sustain Dakota culture?" she replies on screen:

> It's the feel of dancing. I danced when I was a child. It made me feel good and proud inside that I was First Nations.... Now I feel like making regalia for my daughter and nieces and watching them dancing.... It brings pride about their culture. In so many Indigenous cultures, the drum is what keeps it going.... The songs and dances are spiritual.[17]

Jason Wasteste, lead singer of Elk Whistle, also talks about the significance of the annual powwow at Standing Buffalo. He notes that:

> [it] calls everybody in the community to get together, to hold hands, so that they could have a good time. It gets them up, it excites them. And it gives them a good feeling when they leave. It really builds friendship. So it's a good way to socialize.... There's powwow songs and then there's songs for ceremonies, celebration and for healing.[18]

When Patti Yuzicappi Buffalo from Whitecap Dakota Nation is asked, "How does the powwow sustain culture and art?" she replies:

> It goes hand in hand. The whole powwow culture is about spirituality. Spirituality is part of everything.... I love my grandchildren and I want all children to have this opportunity.... Teach the children to be good relatives. This is our Dakota Way. You teach kinship. All the wisdom of the ancestors has to be handed down.[19]

* * * * *

In another moment in the video's narrative, Gwenda Yuzicappi appears on the screens. She is standing on the hilltops above Standing Buffalo; the wind tugs at her hair as she holds the mike. As she talks, she is surrounded by images of the Buffalo Nation, the Horse Nation, and ribbon-images of the land in the Qu'Appelle Valley, projected onto the massive screens. When Claxton asks her what it means to her to be a Dakota woman, she replies:

> I am very proud to be a Dakota woman.... I'm with the Tatanka Oyate. For me, living, waking every day and being part of what the Creator has planned for each one of us and for myself, every day's a blessing, and every morning,

> every time that I need, I say a prayer.... They always tell me when you walk, walk in prayer.

As Yuzicappi delivers a beautiful spoken memorial to her daughter, the soundscape and imagery on the encircling screens wrap her in an image-blanket of support. Alongside images of the buffalo, we see an aerial view of a large circular drum surrounded by drummers; transformed digitally into a sunburst design, it is a signifier of participation in the Sun Dance ceremony.[20] As a mother, Yuzicappi testifies to the healing power of the sun, the Buffalo Nation, the land, and the ceremonies. On learning of her daughter's death, she says:

> I was so happy that the buffalo were right there. They were my helpers, they're my "everything."... I have so much respect for them, and I am very honoured to be living right beside them, for them to be right at my back door. That's my life and I'm very proud that they are there. They still come every morning when I get up.[21]

As the images of Yuzicappi dissolve, the singer Jason Wasteste appears on the screens. He tells us that "everything in our culture we do for ceremonies." When his drum group travels to different powwows and celebrations, he notes that they look for

> the ones that need the drums... because without the drums a lot of our celebrations couldn't happen.... As my father taught me, the drumbeat is the heartbeat of our Mother Earth, and it heals the People.... Sometimes when people aren't doing too well they'll do the drumming and the singing and it'll help them feel better; that's what we try and do across Indian country, as best we can, to help people out.[22]

In this moment, we see how cinematic meaning is created by the linking of images and sound into signifying chains. The juxtaposition of Yuzicappi's difficult testimony with images of the buffalo, and the testimony of the singer Wasteste about the healing power of the songs and drum, creates an image-and-sound montage that speaks to the medicine that is carried in the creative expressive arts. The video's narrative transports the spiritual knowledge expressed in the Tatanka Oyate metaphor of "all my relatives" into the gallery. This metaphor teaches humans to have a sense of empathy and kinship with other forms of life, and to walk a path that is, at all times, in harmony and balance with the natural world. It is a way of living that is based on coming together in ceremony to remember the "old ways" of the ancestors and their ecological teachings of how to live in balance with the world.

## Final Thoughts on the Tatanka Oyate Aesthetic

With *The Sioux Project—Tatanka Oyate*, Claxton sketches a movement of thinking, doing, and creating that begins, not in a series of research questions, but with her original response of deep appreciation for the beauty of the Tatanka Oyate people: the beauty of their creative expressive arts; the beauty of a "way" of living that still listens to the voice of the land, the communities, families, and children; and the beauty of an ecological worldview that is carried in the metaphor of "all my relatives" that is filled with "old values to save a modern world," as Joseph Marshall puts it.[23]

When I started out on this project, I was in the habit of referring to the regalia and cultural belongings of the Tatanka Oyate as "objects" and "artefacts," in the manner of the Western discourse of the high arts. In the early days of the research journey, we visited archives and museum collections where beaded moccasins, dance regalia, and cultural belongings were on display in glass cases as beautiful "objects" or "things," patiently waiting for the next ethnographic encounter. But the cultural arts of the Tatanka Oyate (and other Plains Nations) do not belong in a Western discourse of aesthetics that views "art" as "objects" of formal beauty. The regalia and cultural belongings are not made to hang on a collector's wall, or to sit in a bank vault accumulating value as a new asset class in the neo-liberal art market. Rather, like the beaded moccasins depicted in Claxton's installation, they are a central part of their owner's social lives: they are beautiful, they are "carriers" of the culture's most important teachings, and they need to be taken out regularly so that they can breathe and dance.

Where mainstream Euro-American modernity has understood "art" to be the work of the "unique individual" and placed it in a special transcendent place, separate from the world, there is nothing elite or distant about the Tatanka Oyate aesthetic sensibility. The creative expressive arts of the Tatanka Oyate are egalitarian and accessible activities that are integral to the daily lives of "the people." As Claxton notes, "The dance regalia is made to be worn on the body." "The Sioux aesthetic," she says, is found "on people's moccasins, their regalia, their leggings, their dance roaches, [in] all of the incredible beadwork, or the parfleche, the paintings, and winter counts on hides… that's where it is." "And then, of course," she adds, it is found in, "the repeated conversations about the Sioux—the Lakota, Dakota, Nakota—relationship with the Star Nation and the Tatanka—the Buffalo Nation."[24] In Claxton's words, we hear that the creative expressive arts are both material culture and a set of active social relationships. They have a "social life" in families and communities; they are "actants," setting in motion a series of social relations between bodies, material culture, cultural narratives, and creative expression, in the multiple events and networks that constitute community life.

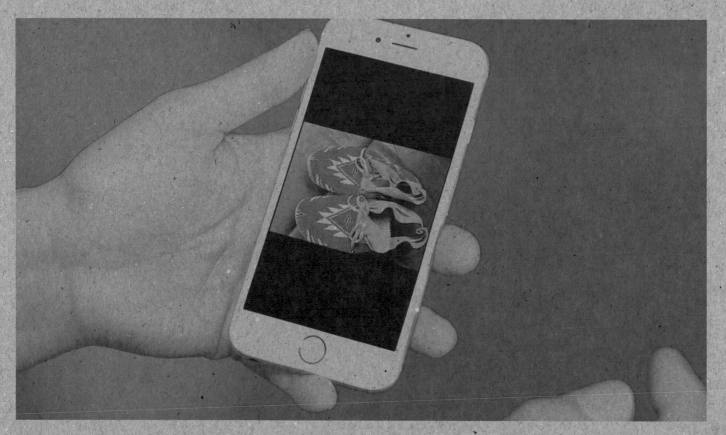

In developing this research creation project, Claxton followed in the footsteps of Beatrice Medicine (Auntie Bea). In a talk entitled, "Lakota Views of 'Art' and Artistic Expression" (reprinted in this book), Medicine notes that, while there is no specific word for "art" or "artistic expression" in the Lakota language, there is a shared consensus that creative expression is always about the things that are "WOLAKOTA— 'honoured by the Lakota.'"[25]

Many of the artists and musicians who participated in the talking circle of Claxton's installation echoed this sentiment. Elder Bernice Yuzicappi, for instance, says that she always begins her star quilts with a ceremony: "I dream about them.... I smudge and I pray, before I make them. I have my Sun Dance CDs on...it inspires me, it brings me the colours, it...makes me think of the old ways, the landscape, the...fall and spring." When asked how it feels to make her star quilts, she says: "It feels good. It feels like my relatives, my grandmothers are there to help me." She notes that making the star quilts is all about "honouring the universe."[26]

While the Western industrial worldview teaches a mindset of dominance that (still too often) places human beings as superior to, and separate from, the natural world, Indigenous worldviews such as the Tatanka Oyate metaphor of "all my relatives" are based in "a deep ecological sensibility and sense of responsibility" that generates close relationships between humans and the natural world.[27] As Western societies wake up to the ecological crisis they have created, people everywhere are calling for a transformative shift in the mindset of global corporate capitalism and its metaphors of value that have commodified the natural world and economically outlawed a spiritual and sustainable relationship with Mother Earth in the name of profit and market efficiency. In this historical moment, we all need to listen to the ecological teachings carried in the Tatanka Oyate aesthetic, and its worldview of "all my relatives," a message that offers all of us "a path forward," as Carmen Robertson so aptly observes.[28]

---

1. This project was funded by a grant from the Social Sciences and Humanities Research Council of Canada.

2. See *The Story of the Dakota Oyate and the People of Standing Buffalo* (Saskatoon, SK: Office of the Treaty Commissioner, 2015), 23.

3. Truth and Reconciliation Commission of Canada, *Honouring the Truth, Reconciling for the Future. Summary of the Final Report of the Truth and Reconciliation Commission of Canada* (Winnipeg, MB: Truth and Reconciliation Commission of Canada, 2015).

4. Gregory Cajete,"Reclaiming Biophilia: Lessons from Indigenous Peoples," in *Ecological Education in Action: On Weaving Education, Culture and the Environment*, ed. Gregory A. Smith et al. (New York: State University of New York Press, 1999), 189–207.

5. Senator Murray Sinclair, "The truth is hard. Reconciliation is harder," Keynote at the Canadian Centre for Policy Alternatives BC Office 20th Anniversary Fundraiser, October 19, 2017, https://www.youtube.com.

6. Joseph M. Marshall III, *The Lakota Way: Stories and Lessons for Living* (New York: Penguin, 2001), 210–11.

7. Ibid.,1–15.

8. The video installation, *The Sioux Project—Tatanka Oyate* (2017) is the final work in a major trilogy of video installations that Claxton refers to as her "Plains Project." The first work, *Buffalo Bone China* (1997), a performance and video installation, speaks to the genocidal destruction of the Buffalo Nation and the sustenance economy of the Plains Nations on both sides of the colonial border in the 1870s and early 1880s. The second, *Sitting Bull and the Moose Jaw Sioux* (2004), is her immensely human appraisal of the aftermath of the Battle of the Little Big Horn in Montana in 1876, when Sitting Bull and his people (including Claxton's great-great-grandmother and other relatives) fled to Canada on foot in the spring of 1877.

9. Elder Connie Wajunta, Standing Buffalo Dakota First Nation, interview, *Dana Claxton: The Sioux Project—Tatanka Oyate*, video installation, 2017.

10. Gregory Cajete, *Native Science: Natural Laws of Interdependence* (Santa Fe, NM: Clear Light Publishers, 2000), 131–33.

11. John Borrows, *Canada's Indigenous Constitution* (Toronto: University of Toronto Press, 2012), 39.

12. Kristen Yuzicappi, Standing Buffalo Dakota First Nation, interview, *Dana Claxton: The Sioux Project—Tatanka Oyate*.

13. Beatrice Medicine, *Learning to be an Anthropologist and Remaining 'Native': Selected Writings*, (Urbana, IL: University of Illinois Press, 2000), 23.

14. Ibid.,152. *The Final Report of the Truth and Reconciliation Commission of Canada* notes that the goal of eliminating the distinctive worldview and cultures of Indigenous peoples and assimilating them into mainstream society against their will continued into the twentieth century.

15. John Trudell, *Rumble: The Indians Who Rocked the World*, directed by Catherine Bainbridge, Montreal: Rezolution Pictures, 2017.

16. For information on the history and significance of the powwow, see Patricia C. Albers and Beatrice Medicine, "Some Reflections on Nearly Forty Years on the Northern Plains Powwow Circuit," in *Powwow*, ed. Clyde Ellis, Luke Eric Lassiter, Gary H. Dunham (Lincoln, NE: University of Nebraska Press, 2005).

17. Angela Buffalo, Whitecap Dakota First Nation, interview, *Dana Claxton: The Sioux Project—Tatanka Oyate*.

18. Jason Wasteste, Standing Buffalo Dakota First Nation, interview, *Dana Claxton: The Sioux Project—Tatanka Oyate*.

19. Patti Yuzicappi Buffalo from Whitecap Dakota First Nation, interview, *Dana Claxton: The Sioux Project—Tatanka Oyate*.

20. Elder Wayne Goodwill, Standing Buffalo Dakota First Nation, interview, *Dana Claxton: The Sioux Project—Tatanka Oyate*.

21. Gwenda Yuzicappi, Standing Buffalo Dakota First Nation, interview, *Dana Claxton: The Sioux Project—Tatanka Oyate*.

22. Wasteste, interview.

23. Joseph Marshall III, *Returning to the Lakota Way: Old Values to Save a Modern World* (Carlsbad, CA and New York: Hay House Inc., 2013).

24. Dana Claxton with Toby Katrine Lawrence, "Locating Sioux Aesthetics through The Sioux Project—Tatanka Oyate," *BlackFlash* vol. 35, no.1 (2018): 58–60.

25. Beatrice Medicine, "Lakota Views of 'Art' and Artistic Expression," reprinted in this volume.

26. Bernice Yuzicappi, Standing Buffalo Dakota First Nation, interview, *Dana Claxton: The Sioux Project—Tatanka Oyate*. See also Beatrice Medicine, "Lakota Star Quilts: Commodity, Ceremony, and Economic Development," in *Learning to be an Anthropologist*, 167–77.

27. Gregory Cajete, "Look to the Mountain: Reflections on Indigenous Ecology," in *A People's Ecology: Explorations in Sustainable Living*, ed. Gregory Cajete (Sante Fe, NM: Clear Light Publishers, 1999), 1–21.

28. Carmen Robertson, "Visual Histories/Contemporary Stories," in this volume.

# Beauty, Abundance, Generosity, and Performance: Sioux Aesthetics in Historical Context

Janet Catherine Berlo

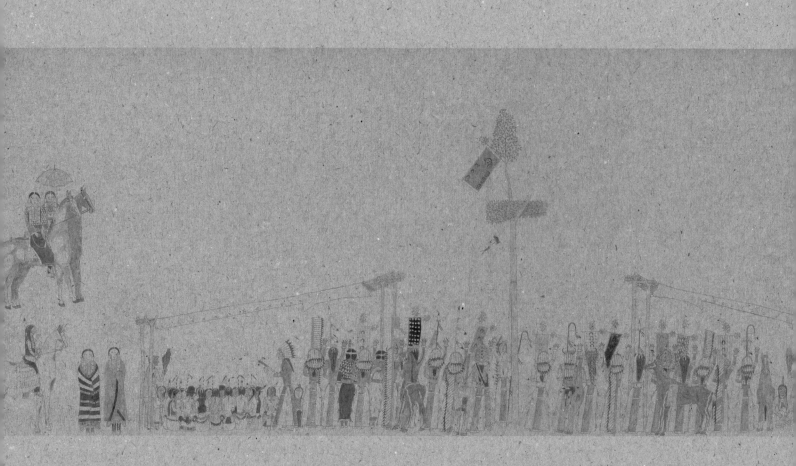

Unidentified (North or South Dakota, Lakota [Teton Sioux]), *Sun Dance*, c. 1895

34

To walk into the installation feels like entering a dance circle or a ceremonial enclosure: immediately surrounded by colour, light, and sound, one experiences the saturated colours of Sioux beadwork, and the sounds of drumming, laughter, conversation, and animals. Multiple images project onto semi-transparent canvas screens hanging from the ceiling and set in a circle. Sometimes the images on different screens coordinate, and sometimes they are dissonant. Quiet electronic music, with a steady drumbeat, accompanies the ever-changing images and recorded conversations. People talk about drum-making, or sustenance by "the three sisters" (corn, squash, and turnips). A young woman makes a parfleche and a dentalium cape. An older woman beads. Another murmurs, "When you have your outfit on, you feel so beautiful." Gwenda Yuzicappi tells the videographer that "every day is a blessing," that seeing a buffalo gives her strength. As she speaks quietly on one screen, buffalo appear on another.

The images on screen demonstrate that people draw strength from the animals, the landscape, and the art that they make. At times, surrounded by close-ups of beadwork upon which are superimposed images of beadworkers being interviewed, I felt that my body and psyche were bathed in beauty—that the installation was meant not only to show precisely what constitutes Sioux aesthetics but also to demonstrate the healing effect such aesthetic practices have on maker and viewer alike.

Claxton's work is a twenty-first century enactment *and* documentation of Sioux practices that have a very deep temporal history. I seek to shape this essay like *The Sioux Project* itself: imaginative, non-linear, and episodic. I hope to give a flavour of what Sioux aesthetics looked like at different points over more than two centuries by highlighting a few special objects and placing them at certain moments in historical time and space, thus providing a space for the reader to *imagine*. While I have taken liberties in suggesting what the makers of the illustrated objects and the people shown in selected paintings and photographs may have done, I do so based on a large body of knowledge about such people and their practices.[1] Thousands of volumes have been written about and by Sioux people encompassing nearly every aspect of culture, history, art, and custom. Nonetheless, most non-Sioux maintain a simple-minded picture of these great people of the American plains and Canadian prairies. I ask the reader to join me in examining instances of *Beauty*, *Abundance*, *Generosity*, and *Performance* that my careful examination of historical images, objects, and texts has convinced me are the underlying principles of a Sioux aesthetic.

Karl Bodmer (Swiss, 1809–1893), *Chan-Cha-Uia-Teuin, Teton Sioux Woman*, 1833

## The 1830s: Cosmopolitanism and Generosity at Fort Pierre

Let us imagine that on a cool June evening of 1833, a Teton Sioux woman named Chan-Cha-Uia-Teuin steps into a dance circle outside the walls of Fort Pierre, a trading depot on the Upper Missouri River.[2] She moves her feet deftly, bobbing in place and taking small steps forward, advancing to the sound of the drum. The tiny metal cones that she just recently sewed to the hem of her dress jingle in a pleasing manner as she moves. The night is unseasonably cool, so she also wears her heavy hide robe painted with geometric designs. It was only the second robe she had brain-tanned herself, staking it out on the dry ground of the prairie with big wooden pegs, as she washed and softened it. She remembers how it pleased her to use her awl to inscribe the guide-lines for the white clay designs, and to paint the red and black pigments atop the

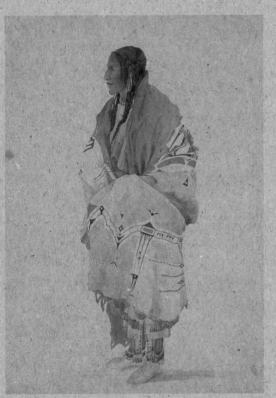

white clay.[3] Her *iná cik'ala* (her mother's sister) had given Chan-Cha-Uia-Teuin the rights to this beautiful pattern at a give-away two summers ago, after the Sun Dance. It depicts spirit figures who guide their family. Chan-Cha-Uia-Teuin has painted them in a slightly different way than her auntie had, to make them her own.

That same afternoon, the *wašíču* (white man) named Bodmer paid her with red cloth for standing still while he painted her likeness. Only the hem of her dress is visible in Bodmer's portrait, but it surely looked something like one of the rarest and oldest Sioux objects extant—a side-fold dress at

the Peabody Museum at Harvard that may have been collected by the Lewis and Clark Expedition of 1804 to 1806. It is made of two brain-tanned hides, and their tops fold over to form a large flap at the wearer's neck at both the front and the back. Thirty long horizontal rows of quillwork ornament the dress, some grouped together in bands of five, and some single rows. The quills come from both porcupines and, more uncommonly, birds. The maker painstakingly dyed the quills yellow, orange, brown, and blue, and punctuated the rows with tiny tufts of red European wool trade cloth. Both the hem and the neck are richly ornamented with vertical lanes of blue and white trade beads. At the bottom, hand-made metal cones, or "jingles," add aural pleasures to the visual ones. The yoke has geometric designs etched into the skin, and amid the beadwork are some three dozen brass buttons.

This dress combines traditional Lakota artistic practices with newly introduced ones — hidework and quillwork join together with beadwork and manufactured metal ornaments to create something original yet distinctly Sioux in its aesthetic. One marvels at the ingenuity of the first Sioux woman who looked at a bristly porcupine and declared, "perhaps I could make art out of that." But the grandmothers say that it was an important Supernatural Being who first taught a young Sioux woman how to use quills, appearing to her in a dream. Dreaming is a noble way to receive sacred knowledge, so the art of quillwork is imbued with special legitimacy because of this origin. After her dream, the young woman requested a tipi, a porcupine, and a prepared buffalo hide. She went out onto the land to find natural dyes of red, blue, yellow, and black. She entered her tipi and worked alone, emerging only for meals. She plucked the porcupine quills, separated them according to length, and dyed them. Eventually she invited one of her friends into the tipi and shared this new form of artistry. Together they quilled an entire buffalo robe, prepared a feast, and invited many other women. They sang sacred songs and explained this marvelous new art to their peers.[4]

Today we look at the side-fold dress and see an object of antiquity and grace. But it is important to remember that in its day it was the height of avant-garde Sioux fashion, as forward-thinking in its time as contemporary Lakota artist Emil Her Many Horses' beaded Christian Louboutin shoes (see illus. p. 45). The side-fold dress reveals the extent to which the Great Plains and Prairies had become part of a cosmopolitan world trade network even before the era of settler colonialism. As Castle McLaughlin has written:

> The dress is ornamented with an impressive array of rare and valuable trade goods that illustrate the scope of the emergent global

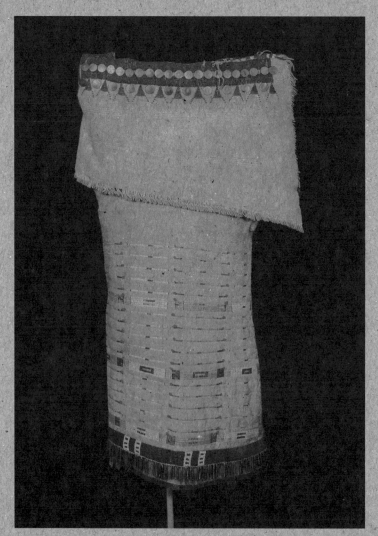

political economy. Here on the central Plains, the woman who fashioned this garment was able to avail herself of blue and white glass beads from Italy, gilt brass buttons from the British Isles, cowrie shells from the islands of the Indo-Pacific, and wool fabric from central Europe. All of these materials were introduced by English, French, and Spanish traders and militia, who competed fiercely for trade and military alliances with Indian people during the eighteenth century — well before Lewis and Clark set out across the continent.[5]

The previous year, when Chan-Cha-Uia-Teuin and her husband came to this same gathering at Fort Pierre, perhaps her husband had traded pelts and hides at the fort to procure the durable blue beads and brass buttons that he knew would please her. She was proud to adorn her dress with them, for when they returned home everyone would know that she had seen extraordinary things and had incorporated these new materials into her clothing. She would tell her younger sisters and cousins all about it, sharing both her new beads and her knowledge with those who had not travelled on this long trade expedition.

Unidentified (Sioux), *Side-fold dress*, c. 1800–1825

In 1832, hundreds of Teton Sioux had also set up camp at this fort at the confluence of the Teton and Missouri Rivers. They brought their buffalo and other hides that fueled the mercantile wealth of early nineteenth-century North America and traded them for iron kettles, tools, knives, firearms, gunpowder, beads, and cloth. Everyone eagerly awaited the second arrival of the steamboat Yellowstone. As artist George Catlin recalled, the appearance of the large vessel "was deemed a wonderful occurrence and the time of her presence here looked upon as a holiday."[6] Soon after its arrival, the Sioux hosted a feast and give-away for the Indian Agent, officials of the American Fur Company, and Catlin himself. Catlin described how the two Sioux leaders (named One Horn and Tobacco) put their lodges together, making a semi-circle "sufficiently large to accommodate 150 men."[7] One Horn, as the ranking dignitary and orator, welcomed the honoured guests and, after giving a speech, he

> took off his beautiful war-eagle headdress, his shirt and leggings, his necklace of grizzly bears' claws and his moccasins and laid them gracefully down at the feet of the agent as a present; and laying a handsome pipe on top of them, he walked around into an adjoining lodge, where he got a buffalo robe to cover his (bare) shoulders, and returned to the feast, taking his seat.[8]

Then the Indian agent made a speech, distributing tobacco and other gifts. Everyone smoked the pipe to mark the solemnity of the occasion, and a feast was served.

The arrival of a boat bearing a year's worth of trade goods was a strategic time for Sioux people to highlight their esteem for the traders and their guests. One Horn's bestowal of his chiefly regalia on the Indian Agent in front of all assembled was a public performance of a contract, sealing a bond of reciprocity. He gave his very best in order to ensure that he and his people would be treated in like fashion. One Horn's shirt was embellished with a quilled rosette on the chest, and quilled panels on the shoulders and arms. Locks of hair were attached to the sleeves. His war exploits were painted on the shirt as visible evidence of his courage and fitness for leadership.[9] To give away such a shirt — along with one's leggings, headdress, bear claw necklace, and moccasins — and walk naked from the assembly was an act that combined humility and largesse. A chief accrued honour by showing such generosity. This is part of a Sioux aesthetic.

In 1833, the German explorer Prince Maximilian zu Wied and the Swiss artist Karl Bodmer arrived on the Yellowstone as it docked for a week at Fort Pierre. While there, Bodmer not only painted

Chan-Cha-Uia-Teuin, but many other Sioux people, too. While Bodmer was painting, Prince Maximilian acquired some fine examples of Western Sioux garments, trading directly with the owners for these items. He bought from Chan-Cha-Uia-Teuin her painted robe and a Cheyenne-style *parfleche* (hide storage box).[10] Perhaps she had acquired it at one of the trade fairs on the plains, or her husband brought it home from a raiding expedition. A vast network of trade made this region a far more cosmopolitan place than we, in the twenty-first century, usually give it credit for. Trade routes had long crisscrossed North America. The historic trade routes from Northern New Spain, New France, and the British and American settlements of the eastern continent followed these ancient trails. As European goods became available, these made their way through many hands, long before most of those in the interior laid eyes on any European trader.[11]

The astonishing amount of goods from global trade that flowed into this region helped to establish the Sioux aesthetic principle of abundance. One historian of the fur trade has pointed out that due to their central location, a mid-nineteenth century Teton Sioux might, in one year, fight the Blackfeet who traded with the Hudson's Bay Company, the Kiowa whose goods came primarily from the Mexicans, and the Chippewa who were supplied by the Great Lakes traders. Thus the Teton Sioux might possess Woodland weapons such as ball clubs, and Hudson's Bay Company knives carried in a neck sheath. They obtained some of these things and more at the local trade fort, where beads flowed in from Venice, while cloth and metals came from England and France.

The first order sent to St. Louis to fill the storerooms of the newly built Fort Pierre listed, among the items desired, the following: 1,500 pounds of blue and white beads, 50,000 white and purple wampum beads, more than 200 bells, 7,200 buttons, 1,130 pairs of blankets, 14,000 rings, 2,000 awls, and 5,000 needles.[12] Trading patterns and aesthetic preferences were set very early; some of these items, of course, continue to be central to Indigenous dress, public display, and gift-giving, even to the present day, as is evident in the narrative of *The Sioux Project*.

Early on, beads were among the most valued trade items. Making art with beads might seem to us to be a painstaking process. But Native women were accustomed to hunting and shooting porcupines, and then plucking and washing their quills and softening them by pulling them through their teeth. The quills would then be dyed and attached to hide with sinew or thread. So beads were marvelously labour-saving. They were durable and, unlike quills, their colours did not fade. Small hanks of beads filled traders' packs at the end of the eighteenth

century, but it is astonishing to imagine that some three decades later, a whopping 1,500 pounds were one year's inventory at just one fort. Beads transformed not only Sioux art but the art of all peoples of the Plains and Prairies. Indigenous ideas and values were, and still are, expressed through the vocabulary of beads.

The lively intercultural trade, gift exchange, and commerce that took place at Fort Pierre in the 1830s makes it clear that both sides eagerly participated, and both felt enhanced by their transactions. The men and women of the Great Plains who wore the beads, medals, coins, peace medals, hair pipes, vermilion, and other items of intercultural trade became the sophisticated cosmopolitans of their time and place. In subsequent decades, the intermarriage that began in the first decades of the fur trade increased, and women who married traders, and the children of those unions, came to form a new cultural group: the Métis.[13]

### 1840–1860: A Sioux-Métis Aesthetic

The Indigenous consorts of successful white traders were often prosperous and able to use materials from diverse sources in their art. Women processed the skins that traders needed in large quantities; a Native woman allied to a trader could effectively marshal the labour of her network of female kin and channel the results to him. Writing about the Great Lakes fur trade, historian Susan Sleeper-Smith has cogently written:

> *Marriage and kinship strategies transformed trade into a social process and mediated the disruptions inherent in disparate and competing economic systems. Indian communities successfully incorporated European traders as well as other strangers, and even enemies through intermarriage. Marriage, either sacramentally sanctioned or "in the manner of the country" transformed French fur traders into friends, family and allies. Kinship transformed the impersonal exchange process characteristic of capitalism into a socially accountable process.*[14]

Successful traders' consorts often had pick of the finest goods. While at Fort Pierre, Catlin painted the portrait of a woman he calls Sandbar, the wife of a Frenchman who worked as an interpreter and trader for the American Fur Company. He noted that she was "very richly dressed, the upper part of her garment being almost literally covered with brass buttons."[15]

In 1851, artist Friederich Kurz described the arrival of a group of Métis travelers at Fort Berthold, another trading post on the Upper Missouri River:

> *All were dressed in bright colors, semi-European, semi-Indian in style — tobacco pouches, girdles, knife cases, saddles, shoes, and whips were elaborately decorated with glass beads, porcupine quills, feather quills, etc., in artistic work done by their wives and sweethearts, but their clothes were of European rather than western cut.*[16]

Métis women were not only skilled in traditional quill- and beadwork, but they also had access to European-style floral embroidery patterns and silk thread. Their expertise at Indigenous methods of hide tanning and quillwork were combined with European clothing styles and floral designs to give rise to distinctive new clothing arts. Travelling widely as buffalo hunters, trappers, and traders, the Métis disseminated vests and frock-coats, buckskin trousers, half-legging, bags, and pad saddles embellished with expert quillwork, beadwork, and silk embroidery.[17]

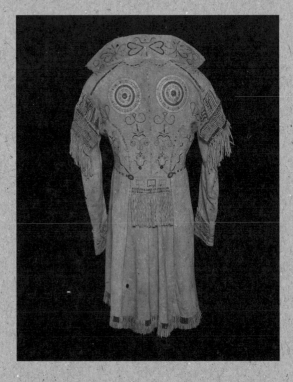

The oldest Métis styles derived from Saulteaux, Cree, Assiniboine, and Ojibwa techniques, but as Métis communities spread across vast regions, their floral designs developed in relation to local styles. For example, in the Dakotas and the Canadian prairie, a Sioux-Métis style arose. A man's coat in the collection of the Canadian Museum of History provides an elegant example. Dating from the 1840s, it is cut in European style: form-fitting, with a collar and inset sleeves. By this era, high-ranking Indigenous men of the Plains and Prairies had, for several decades, received gifts of military-style cloth coats of red and blue.[18] And Indigenous women devised new styles of garments, like this one, based upon them.

Unidentified (Métis/Sioux), *Coat*, c. 1840

This coat is a tour de force of wrapped and embroidered quillwork techniques. Two quilled rosettes, much like those on Plains war shirts of the era, adorn the upper back. Quilled fringe ornaments the shoulders, hem, and the waist at back. The sleeves, cuffs, collar, front, back, and upper hem all sport fine floral-style quilled embroidery. Such garments were principally worn by men who were active in intercultural realms: Native and white traders, white fur trappers, and even those white men who had simply traveled to the west and wanted to show that they had done so.[19] Métis clothing styles developed throughout the nineteenth century. The abundant creativity of Sioux-Métis women has influenced the art in a number of Sioux communities since the mid-nineteenth century.[20]

## 1870–1890: Abundance amid Adversity

The years from 1870 to 1890 were traumatic ones for Sioux people. Confined within reservations in the United States, they experienced the loss of most of their land, their buffalo, and their rights. The Sun Dance and other ceremonies were banned. One slightly bright moment was the unassailable victory over U.S. Army troops at the Battle of the Little Big Horn in June 1876. But a year after that triumph, fearing reprisals from the U.S. government, Chief Sitting Bull (1831–1890) led several thousand of his people north to "Grandmother's Land" (i.e., Queen Victoria's Canada), settling near what is now Wood Mountain, Saskatchewan. Many returned to the U.S. reservations with Sitting Bull in 1881; the remainder formed the nucleus of what is today several Sioux communities on the Canadian prairies.

Sitting Bull's murder on December 15, 1890, and the massacre of dozens of Sioux men, women, and children two weeks later at Čhaŋkpé Ópi Wakpála (Wounded Knee) is often called the end of the "Indian wars." It is one of history's great ironies that out of the horrors of war and its aftermath come some of art's greatest moments, such as Benjamin West's *The Death of General Wolfe* (1770), Goya's *Third of May, 1808* (1814) and Picasso's *Guernica* (1937). In the history of Sioux art, some of the most eloquent objects were made during this era of genocide, starvation, and apparent hopelessness.

Around 1870, all was not yet hopeless. The distinguished Lakota military tactician Maȟpíya Lúta (Red Cloud, 1822–1909) had led successful campaigns against the U.S Army (1866–68), had been one of the signatories of the Treaty of Fort Laramie (1868), which established the Great Sioux Reservation, and had met with President Ulysses S. Grant in Washington, D.C. (1870) on behalf of his people. He had been designated a "shirt wearer" — one of four men of high rank and good character in a Lakota band who helped enforce the

laws. His ceremonial shirt from this era survives today at the Plains Indian Museum in Cody, Wyoming. An aesthetic tour de force, it is made of tanned deer hide. The lower half was rubbed with golden ochre pigment, representing the earth. The chest and shoulder areas were rubbed with blue pigment upon which small checkered beadwork designs were sewn, like stars in the firmament. Upon each shoulder are large strips of blue, black, and white beadwork, with highlights of chalky pink and gold. The V-shaped neck is further ornamented

with beadwork and short rawhide fringes. From the beaded shoulder bands hang 238 locks of human hair and 68 locks of horse hair, all of which have been laboriously wrapped in quillwork. On war shirts, such hair locks often come from slain enemies. Here it is more likely that they are gifts from Red Cloud's beloved female relatives, to honour him. When he wore this shirt, Red Cloud was surrounded by protective beauty — the hair of his kin and the power of the earth and sky.

As mentioned earlier, trade beads transformed the arts of personal adornment, but unlike most other nations of the Plains and Prairies, Sioux women never fully abandoned quillwork in favor of beads. Both appear together on many garments and other items throughout the nineteenth century and into the twentieth. Two pair of fully quilled or beaded moccasins demonstrate the Sioux penchant for opulence and abundance (see illus. pp. 40, 55), for both are ornamented even on the soles. Such moccasins were made for esteemed family members as a way of demonstrating that the recipient was so well cared for that his or her feet need not touch the ground. For a man astride a horse, even the

Unidentified (South Dakota, Sioux [Lakota]), *Red Cloud Shirt*, c. 1870s

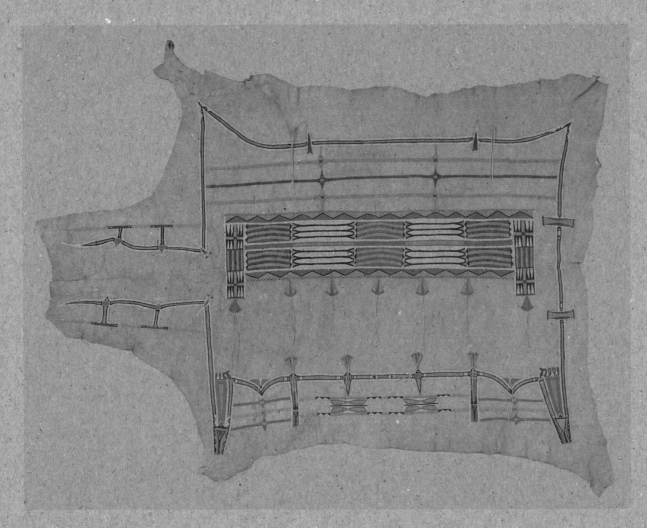

soles of his feet looked good. For a woman sitting with legs to the side in a camp circle, the soles of her moccasins presented a pleasing view to others, and demonstrated that she was beloved.

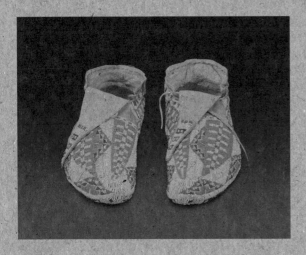

While women continued to paint buffalo hide robes with semi-geometric designs, like the one Bodmer illustrated in his painting of 1833, they also quilled and beaded such robes. The woman who designed this robe (*top of page*) seems to have been experimenting with the boundary between figuration and abstraction. The general outline of the design is reminiscent of a skeletal rendering of the buffalo itself. The border pattern that would have encircled the wearer's legs resembles a series of four standing figures with linked arms. The sky blue, brick red, white, and black beads chosen for this robe present a scheme of colour values that is graphically legible from a distance. As distinguished Sioux anthropologist Beatrice Medicine observed about a similar robe, such beautiful attire honours the individuality of the woman wearing it.[21]

Such graphic legibility seems to be a hallmark of Lakota women's beadwork. A pair of beaded parfleche envelopes (*top of page opposite*) offers a dramatic illustration of this. Parfleche boxes and bags are more often painted,[22] but this maker has laboriously sewn beads in lane stitch to the top flaps of each envelope, and quill-wrapped the fringe. The fringes end in metal cones filled with reddish horsehair, providing a contrast to the crisp geometry of the beadwork.

While women were creating works of everlasting beauty in hide, quill, and beads, men were painting their exploits on hide robes and shirts. By the 1860s, they were also drawing on loose paper as well as in discarded books and account ledgers.[23]

Unknown (Brule Band Sioux), *Robe*, c. 1870

Unidentified (Sioux), *Moccasins*, c. 1890

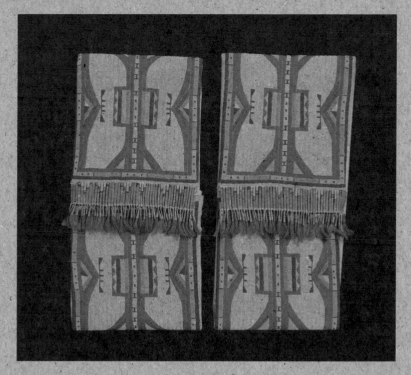

During the period from 1870 to 1890, when Sioux culture was enduring dramatic changes due to military onslaught, as well as the arrival of settlers and mineral prospectors, some men began to pictorially record all aspects of Sioux history, not just their personal war records. I see this as an act of cultural remembrance and validation at a time when traditional lifeways were under siege. Foremost among these was a Sans Arc (Itazipco) Lakota named Black Hawk (c. 1832–c. 1889) who, in the winter of 1880–81, made seventy-six drawings on commission for William Caton, the trader at the Cheyenne River Sioux Agency in South Dakota. The drawings encompass ceremonial and social life, personal visions, courtship, animal studies, warfare, hunting, and historic events.[24] His drawing of a social dance painstakingly records the wool and cotton garments, elk's tooth dresses, bone pipe ornaments, hair decorations, beaded belts, painted hide leggings, and moccasins worn on festive occasions.

That same year, during the summer of 1881, John Gregory Bourke (1843–1896), a military man and budding ethnologist who witnessed a Sun Dance at Pine Ridge, described in his diary what Black Hawk rendered in images. Bourke wrote:

> As the crier began to proclaim the orders of the day, the Indians once more closed in spontaneously around him, forming a great ring 50 or 60 yards in diameter, and 8 or 9 persons deep, and aggregating several thousand men, women, and children. The display was no less brilliant than fantastic. Some were on foot, many on ponies, and quite a number in American country vehicles. Nothing could be added in the way of dazzling colors. Calico shirts in all the bright hues of the rainbow, leggings of cloth, canvas, and buckskin, moccasins of buckskin, crusted with fine beadwork were worn by all, but when it came to other garments no rule of uniformity seemed to apply. Many of the men and women had wrapped themselves in dark blue blankets with a central band of beadwork after the manner of medallions; others gratified a more gorgeous trade by wearing the same covering of scarlet or of scarlet and blue combined. A large fraction of the crowd moved serenely conscious of the envy excited by their wonderfully fine blankets of Navajo manufacture, while a much smaller number marched as proud as peacocks in garments of pure American cut.

> Nearly all the Indians were painted, and wore their hair in two long tresses down the sides. These tresses were wrapped in red flannel, or in otter fur and reached to the waist. The median line of the head was painted with vermillion. Eagle feathers ornamented the crown and wonderful achievements in nacreous shell-work dangled from the lobes in their ears.

Of women's garb, Burke remarked:

> I noticed that they were dressed in all sorts of styles, while there was a decided preponderance of gaudy calico dresses and cheap rainbow-hued shawls. The more conservative adhered to the old-time gown of white antelope skins embroidered heavily with pale blue and salmon colored beads at bust, neck, shoulders, tip of skirt, waist and seams.

Moreover, he observed "fine blue cloth studded with elk teeth, Navajo blankets of the first quality, calico dresses in all the colors of the rainbow, blankets of the deepest blue and most vivid scarlet, and moccasins of fine buckskin."[25]

Another Sioux artist who captured the visual richness of a ceremonial occasion was the unnamed maker of a drawing book in the Detroit Institute

of Arts. Here he has drawn a horse painted for the Sun Dance in alternating stripes of blue and red on his front and hindquarters. Feathers are tied into his mane and tail, and the man who accompanies him carries a small rawhide cut out of a horse that stands for the horses he is offering in ceremony. A number of artists drew such images for outsiders, sometimes in small autograph books or drawing albums.[26]

Another new material for drawing upon was cotton muslin, which some men used to paint epic scenes of battle or history. Sometimes these were used as decorative tipi-liners, or they were painted expressly for sale to outsiders. An early example is a painting of the Sun Dance done by an unknown Lakota artist around 1890 (see illus. p. 34). The Sun Dance, as practiced all over the Great Plains and Prairies, is a rite of renewal in which humans place themselves in spiritual alignment with the forces of the natural and supernatural worlds. Lakota artist and scholar Arthur Amiotte has called this "probably the most formal of all learning and teaching experiences. Inherent in the Sun Dance itself is the total epistemology of the people."[27]

The painter of this muslin has portrayed a ceremony within the enclosure erected from cut poles. Some twenty standing figures wear war paraphernalia and most raise their right hands to the sky as they sing and dance; some wear the buffalo horn and eagle feather headdresses of the most esteemed warriors. Three of the horses within the enclosure are painted for participation in the Sun Dance. Many of the men are shirtless; some are painted blue, with yellow indicating the flesh of the upper bodies. These men have elected to perform the most sacred offering by piercing their pectoral muscles and flesh and attaching themselves to the central pole by ropes. Pulling their bodies away, they are released from the piercing in a sacrifice that aligns them with the potent powers of the sun. A cloth banner hangs from the top of the Sun Dance pole, and leafy cut branches are placed in the crook of the pole. Small effigies of a man and a buffalo, both fashioned from buffalo hide, hang from these branches.

Within the enclosure, at right, are six figures, five seated and one standing. They smoke the sacred pipe and pray for those who will undergo the sacrifice. At left, another pipe holder watches over a drum circle, where the music that sounds like the heartbeat of the earth itself accompanies the ceremony. At far left and far right are vignettes of people, mostly women, riding or walking toward the ceremonial enclosure. Their garments range from traditional quilled and painted hides, at right, to Navajo chief's blankets, wool trade cloaks, and wool dresses embellished with elk teeth, at left. After the U.S. government banned the Sun Dance in 1883, a number of men continued

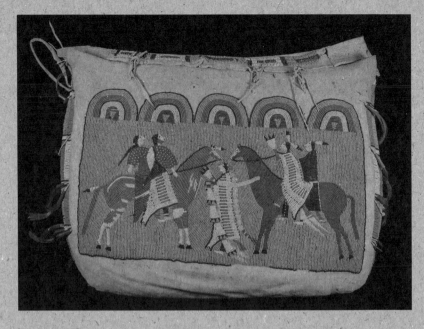

painting scenes of it on muslin well into the early twentieth century.[28] Most were made for sale to outsiders, to commemorate so-called "lost" traditions. Of course, ceremonial practice did not cease despite being outlawed, and the late twentieth century witnessed a resurgence of the Sun Dance.

While women's arts were predominantly geometric, during the early Reservation Era many women started beading narrative scenes on clothing and bags in the style of ledger drawings. Some scholars surmise that men drew the patterns for these, but we have no evidence one way or the other. One fine example is a tipi bag beaded with a scene of courtship. Using the red, blue, yellow, white, and black beads that Sioux women often favored, this beadworker has depicted three men, one on foot, approaching two women on horseback. The women wear elk tooth wool dresses, with robes wrapped around their waists. Two of the men wear beaded or quilled robes, while the third wears a trade blanket. This intensive use of beads, even for the background, became a trademark of some Sioux beadwork at the end of the nineteenth century and into the twentieth.

## 1900–1930: Recalling the Past / Embracing the Future

The late Reservation Era was a time of tremendous social pressure toward renunciation of Indigenous ways in favor of assimilation. Women launched their own subversively defiant response to this by creating some of the most complex beaded outfits ever seen in Indigenous America. Some, especially those made for children, were weighty both in ornamentation and in meaning and have been characterized as a response to extreme

social disruption and the threat of assimilation, for these children would be coming of age in a new and challenging century and would need all the protective power that women's artistry could provide.[29]

Beautiful beaded yokes—the area that covers the chest, shoulders, and upper back—are characteristic of Sioux dresses from the mid-nineteenth to the early twenty-first century. The sumptuous beading on the yokes is often blue, referring to water. The neck and head of the wearer emerge from the watery realm. Wearing such a dress alludes, in an abstract manner, to creation and procreation.[30] Moreover, such garments exemplify the aesthetic principles of abundance and generosity.

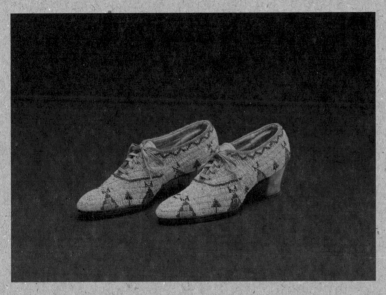

Unidentified (North or South Dakota, Lakota [Teton Sioux]), *Women's Shoes*, c. 1920

A handmade garment is never simply utilitarian. Its functionality extends into metaphysics; its artistry links human and spiritual realms. In the Lakota language, *saiciye* is the term for adorning oneself in traditional fashion in a way that is pleasing to denizens of both the spirit world and the human world.[31] When, at age eighty-one, the artist, warrior, historian, and chief White Bull (Minneconjou and Hunkpapa, 1849–1947), depicted himself in his full traditional finery he was

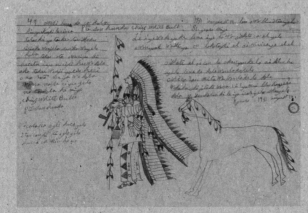

White Bull (Minneconjou and Hunkpapa Lakota, 1849–1947), *White Bull in Ceremonial Dress*, 1931

honouring this sentiment. He has lovingly drawn his long feather bonnet with extra eagle feathers attached to the red cloth edging, his beaded war shirt, and his leggings with dragonflies beaded or painted on them. He carries a peace pipe with wrapped quill ornamentation down its stem.

White Bull also writes his personal history in Lakota on this page of a book that he drew as a commission for a white man. He narrates:

> This is me in my costume which is worn on festive occasions. It looks fine when worn at the gathering of the Lakotas. I wear this while riding in parades… My war bonnet is double-tailed. I have owned three of these, my friend…. The shirt I am wearing is a scalp shirt. It is the shirt of a chief. I am one of them.[32]

Here he is recalling both in text and in illustration his illustrious past, but his use of written Lakota shows him to be a man of the twentieth century as well, embracing literacy and riding in touring cars in parades. Artist Arthur Amiotte illustrates such practices in his many collages that imaginatively depict the first three decades of the twentieth century, a time when modernization and tradition were blended seamlessly into a whole, both in Sioux life and in Sioux art.[33]

Not only did nineteenth-century style garments continue to be made and worn, but, just as in the side-fold dress of a century earlier, modern Western elements were appropriated into Sioux arts. In the first part of the twentieth century, beads were applied to manufactured valises and to commercial shoes, for example. The Lakota woman who adorned and wore these very modern shoes with all-over geometric beading with a white background has completely folded them into a Sioux aesthetic.

## 1980–2018: Contemporary Beadwork

Time-honoured aesthetics of beauty, abundance, generosity, and performance have not only endured but flourished in the twentieth and twenty-first centuries, as exemplified in *The Sioux Project* and the artists chronicled there. While contemporary artists such as Dana Claxton have embraced many new mediums, from photography to multi-channel video installations, others have continued work in quillwork and beadwork. Across most of the Plains and Prairies quillwork died out and was replaced with beadwork, but among the Sioux, small pockets of this tradition survived and were revived in the 1970s. Credit for this renaissance goes principally to Alice New Holy Blue Legs of Pine Ridge, South Dakota (1925–2003). Not only did she teach her five daughters to quill, she also gave workshops across North America.[34]

Maintaining a connection to ancestral ways of knowing and embodying that knowledge through proper relationships with relatives and with the natural world continues to be important to Sioux people today. Making and wearing ceremonial dress is a literal embodiment of ancestral knowledge. The making of a dress or a shirt encapsulates information about the world of animals (how to skin a deer and tan its hide, or how to pluck, dye, and shape porcupine quills into ornament, for example). It articulates the web of relationships among relatives, neighbours, and trading partners. Honouring a child or a new daughter-in-law by making her a beautiful garment or, as we have seen, demonstrating one's cosmopolitanism by incorporating materials from distant realms into a garment, is highly valued. In the old days, trade items came up the Missouri once a year on a steamer, or across the Plains on a pack-horse. Today, artists buy their beads on trips to Venice, or over the internet.

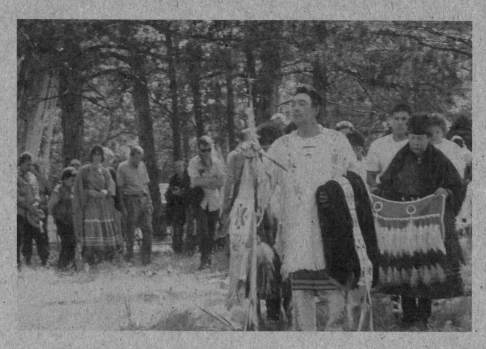

Among the many artists who have maintained Sioux beadwork arts and caused them to flourish and be honoured, I can mention just three. Christina Standing Bear (1897–1984) of Pine Ridge, South Dakota was the daughter of Standing Bear (1859–1933), an artist and man of high rank. He carried on the tradition of painting on muslin, and his daughters all learned to quill and bead (though their mother was a Viennese woman who had met Standing Bear in Europe during his days with Buffalo Bill's Wild West). In her father's old age, Christina Standing Bear beaded him a ceremonial shirt. In her old age, she replicated this design for her grandson, Arthur Amiotte (b. 1942, Lakota), a writer and artist discussed in Carmen Robertson's essay.[35] Amiotte was a leader in reviving the Sun Dance in the late 1970s at Standing Rock, South Dakota and in the 1980s at Sioux Valley, Manitoba. For these efforts, Amiotte was recognized as the modern version of a shirt-wearer (like Red Cloud in his younger years; see illus. p. 39). The shirt made by Christina Standing Bear was ceremonially presented to him by the headmen at Sioux Valley. Amiotte describes the making of the shirt:

*The same hands that made Standing Bear's shirt made mine. But Grandmother said that as she was working out the design in her head, it wouldn't come... She had to pray. She took a blanket and tarp and went up into the hills behind her home, like a little Vision Quest. She offered the pipe and made other offerings. She prayed to her mother: "I need your help." In the middle of the night, she dreamed her mother over and asked her to help with the design. She came back in the morning and was able to commence the work.*

Made of tanned deer hide, the shirt has a beaded neck ornament, and beaded bands over each shoulder. Matching designs grace his pipe bag and blanket strip.[36]

While beadwork and quillwork were customarily women's arts, today a number of men are award-winning beadworkers. Emil Her Many Horses was born in 1954 on Pine Ridge reservation, but his parents, who worked for the Indian Health Service, were posted at Rosebud reservation, where he spent much of his childhood. He remembers watching his paternal great-grandmother, Susie Blunt Horn Matthews (1885–1971) doing sinew-sewn beadwork, making moccasins for each of her many grandchildren. Later, to honour her, he replicated her designs. Her Many Horses also learned from Alice Fish of Rosebud (1900–1984), renowned for having made nine fully-beaded dresses. For many years he studied her skillful and inventive beadwork patterns.[37]

Her Many Horses learned lessons about art-making and generosity when, as a teenager, he began to accompany his maternal grandmother (Grace Pourier, 1909–1988) on the powwow circuit after her retirement, for she distributed gifts wherever she went, sometimes in honour of her grandsons who won prizes at the powwows. Her Many Horses attended a lot of powwows and admired the items of dance regalia he saw there. He concluded that the only way to get them was to make them himself. He has created clothing and regalia in Lakota, Northern Sioux, Crow, and Métis styles. To honour the heritage of the Pourier side of his family, he made a set of beaded parfleche in Métis floral style. "Grandmother Pourier recalled that her grandmother had a notebook of the floral styles used by Josephine Richards Pourier, so these are very old designs that have been passed down," he observed.[38]

Arthur Amiotte (Oglala Lakota [Teton Sioux], b. 1942) in a ceremonial shirt made by Christina Standing Bear (1897–1984), early 1980s, Sioux Valley, Manitoba

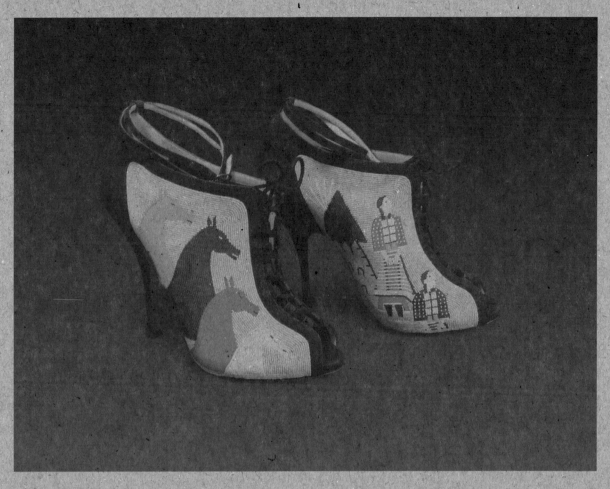

While most of Her Many Horses' artworks are in the style of traditional regalia of the nineteenth and early twentieth centuries, he recently beaded a pair of designer Christian Louboutin's high-heeled shoes with their characteristic red soles. In accordance with customary protocol, the artist requested the right to bead these designer shoes from artist Jamie Okuma (Shoshone-Bannock and Luiseño, b. 1977) who was the first to do so, paying her with a blanket. His work is a twenty-first century high-fashion homage both to his paternal great-grandmother, who often beaded horse imagery, and to Standing Rock beadworker Nellie Gates (1854–?) whose pictorial beadwork is world-famous.[39]

The four horseheads recall the convention in Lakota ledger drawings of showing a group of horses in shorthand fashion by means of a group of heads only.[40] Their colours are the customary Lakota colours for west (blue), north (red), east (yellow), and south (white). On the other shoe, two Lakota women in festive dress stand in front of a tipi painted with horseshoes. On the other side, a young man brings more horses as a gift to his prospective bride. The Lakota title, "Tasunka Ota Win," honours the artist's paternal great-great-grandmother whose name in English should rightly be translated as "Many Horses Woman" but during the enrollment era was transcribed as "Her Many Horses."[41]

Sioux artists bring honour on themselves and their families by their creativity, generosity, and industry. This is as true today as it was two hundred years ago. The ceremonial garments women make for themselves and their loved ones are among the most creative examples of that industry. Such work has always been approached with seriousness and a prayerful attitude. If made for someone else, the amount of labour lavished on an outfit demonstrates the deep respect and love for an individual. If made for oneself, as Jodi Archambault Gillette (Standing Rock Lakota, b. 1959) did with her award-winning dance regalia, it shows one's pride in being Sioux.

Gillette's dance outfit is a tour de force of beadwork (see illus. p. 46). The background of the bodice, both front and back, is a dusty pink that many beadworkers call "Cheyenne pink," with geometric design elements beaded in white, gold, red, and blue. A geometric dragonfly is beaded front and centre on the chest area of the dress. Such dresses are extremely heavy to dance in — on this one, seven kilos of beads are affixed to the dress alone.[42] From the back of the brass-studded leather belt, a knife sheath, small bag, and awl container hang — emblems of a Lakota woman's industry, too. She wears a choker, long drop earrings, and a massive breastplate, all made of bone hair pipes.

Whether working in 1830, 1920, or in the first two decades of the twenty-first century, Sioux people make magnificent works of art. Some are worn by the maker, while others are given away in the spirit of generosity. Some are performed. Some are beaded. Others are drawn on paper or made with digital media. All embody the deep aesthetic principles that are amply documented in *The Sioux Project*.

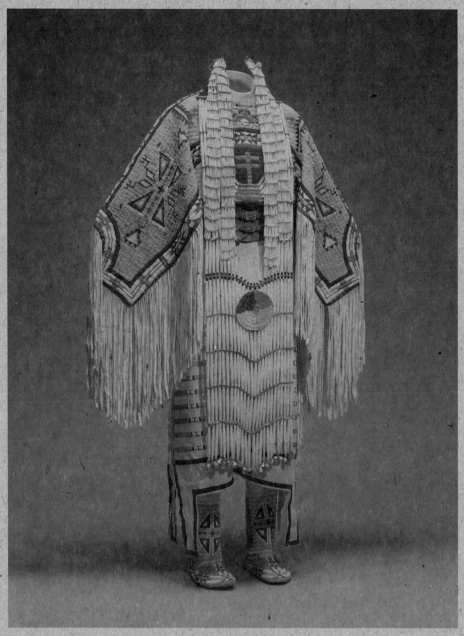

Jodi Gillette (Hunkpapa Lakota [Teton Sioux], b. 1959), *Woman's Dress and Accessories*, 2005.

1. I gratefully acknowledge the Sioux intellectuals from whom I have learned so much. Works by scholars Ella Deloria and Bea Medicine have been foundational for my own. My friendship and collaboration with artist and scholar Arthur Amiotte has spanned more than a quarter-century; his intellectual and personal generosity is unparalleled. In recent years, Smithsonian curator and artist Emil Her Many Horses has been similarly generous with his knowledge. *Pilámaya.*

2. Named in honour of Pierre Chouteau, Jr., Fort Pierre was still being built when Catlin visited in 1832. It was the administrative headquarters of the "Upper Missouri Outfit" of John Jacob Astor's American Fur Company of St. Louis, Missouri, of which Chouteau was the supervisor. The town of Fort Pierre, South Dakota, grew on this spot, with the capital, Pierre, nearby. See Harold Schuler, *Fort Pierre Chouteau* (Vermillion, SD: University of South Dakota Press, 1990).

3. For a colour photograph of this robe, now in the collection of the Linden Museum in Stuttgart, see Gaylord Torrence, *The Plains Indians: Artists of Earth and Sky* (Paris: Musée du quai Branly, 2014), 135.

4. This is my paraphrase of the original myth published in Clark Wissler, *Societies and Ceremonial Associations in the Oglala Division of the Teton Dakota*, American Museum of Natural History Anthropological Papers, vol. 11, bk. 1 (New York: American Museum of Natural History, 1912): 93. See also Janet C. Berlo, "Dreaming of Double Woman: The Ambivalent Role of the Female Artist in North American Indian Mythology," *American Indian Quarterly* 17, no. 1 (1993): 31–43.

5. Castle McLaughlin, "Objects and Identities: Another Look at Lewis and Clark's Side-Fold Dresses," *American Indian Art Magazine* 29, no. 1 (Winter 2003): 83.

6. George Catlin, *Letters and Notes on the Manners, Customs, and Conditions of the North American Indians* (New York: Wiley and Putnam, 1841; New York: Dover Publications, 1973), 1:228. Citations refer to the Dover edition.

7. Ibid., 228.

8. Ibid., 229.

9. A similar Sioux shirt, without the pictorial painting, is pictured in Ted Brasser, et al., *Splendid Heritage: Perspectives on American Indian Art* (Salt Lake City: University of Utah Press, 2009), 32–33.

10. See Stephen Witte and Marsha Gallagher, eds., *The North American Journals of Prince Maximilian of Wied* (Norman: University of Oklahoma Press, 2010), 2:159.

11. The best succinct account of this remains John Ewers, "The Indian Trade of the Upper Missouri before Lewis and Clark," in *Indian Life on the Upper Missouri* (Norman: University of Oklahoma Press, 1968), 14–33. In 1738, the La Verendrye family became the first to explore and trade in the Upper Missouri. In exchange for skins, these Montreal fur traders offered goods ranging from gunpowder and knives to sewing needles. By the late eighteenth century, some Hudson's Bay Company traders had made their way from Lake Winnipeg to the Northern Plains. Their account books list tobacco, vermilion, beads, rings, looking glasses, gunpowder, and guns as their main items. See John Alwin, "Pelts, Provisions, and Perceptions: The Hudson's Bay Company Mandan Indian Trade, 1785–1812," *Montana: The Magazine of Western History* 24, no. 3 (Summer 1979): 20. But it wasn't until the advent of the big riverboats that an efficient means existed for bringing in quantities of trade goods, and extracting bulky buffalo hides and other skins in large numbers and in regularly timed shipments.

12. Harold Schuler, *Fort Pierre Chouteau* (Vermillion, SD: University of South Dakota Press, 1990), 89–91, based on his research in the American Fur Company records at the Missouri Historical Society.

13. The term Métis includes many communities of mixed race people, encompassing British, French, and Scots men, and women from Anishinaabe, Cree, Sioux, and other First Nations. The well-known Red River Colony was established in the early nineteenth century near Winnipeg, Manitoba; other Métis communities developed throughout central and western Canada and the United States. See Ted Brasser, "In Search of Métis art," in *The New Peoples: Being and Becoming Métis in North America,* ed. Jacqueline Peterson and Jennifer Brown (Winnipeg: University of Manitoba, 1985), 221–29; Sherry Farrell Racette, "Sewing for a Living: The Commodification of Métis Women's Artistic Production," in *Contact Zones: Aboriginal and Settler Women in Canada's Colonial Past*, ed. Katie Pickles (Vancouver: University of British Columbia Press, 2005), 17–46; Lawrence Barkwell, Leah Dorion, and Darren Préfontaine, eds., *Metis Legacy: A Metis Historiography and Annotated Bibliography* (Winnipeg: Premmican Publications, 2001).

14. Susan Sleeper-Smith, *Indian Women and French Men: Rethinking Cultural Encounter in the Western Great Lakes* (Amherst: University of Massachusetts Press, 2001), 4.

15. Catlin, *Letters and Notes*, 2:224.

16. J. N. B Hewitt, ed., *Journal of Rudolph Friederich Kurz: An Account of His Experiences Among Fur Traders and American Indians on the Mississippi and the Upper Missouri Rivers During the Years 1846 to 1852*, Bureau of American Ethnology Bulletin 115 (Washington, DC: Smithsonian Institution, 1937): 82–83.

17. Sherry Farrell Racette's research has greatly expanded the corpus of Métis art, documented the work of named artists, and mapped the continental reach of Métis art. See Sherry Farrell Racette, *Sewing Ourselves Together: Clothing, Decorative Arts and the Expression of Métis and Half Breed Identity* (PhD diss., Individual Interdisciplinary Program, University of Manitoba, 2004).

18. The fashion for these so-called "chief's coats" began in the East in the eighteenth century as part of the inter-cultural garb worn by men who moved fluently between Native and white worlds. See Timothy Shannon, "Dressing for Success on the Mohawk Frontier: Hendrick, William Johnson, and the Indian Fashion," *The William and Mary Quarterly* 53, no. 1 (1996): 13–42. See also W. Raymond Wood, William Hunt, and Randy Williams, *Fort Clark and Its Indian Neighbors: A Trading Post on the Upper Missouri* (Norman: University of Oklahoma Press, 2011), 97.

19. Ted Brasser has pointed out that travelers as diverse as the military war hero Marquis de Lafayette and the naturalist John J. Audubon were given such coats as gifts. The artist Rudolph Kurz commissioned one after having encountered the Métis at Fort Berthold. Ted Brasser, "Métis Man's Coat," in *Splendid Heritage: Perspectives on American Indian Art*, ed. John Warnock and Martha Warnock (Salt Lake City: University of Utah Press, 2009), 162. In later decades, American general George Armstrong Custer and showman "Buffalo Bill" Cody both wore such frock coats. David Penney, *Art of the American Indian Frontier* (Detroit: Detroit Institute of Arts, 1992), 176.

20. Racette, "Half-Breed, but not Métis: Lakota and Dakota Mixed Bloods," chap. 10 in *Sewing Ourselves Together*. See also Harry Anderson, "Fur Traders as Fathers: The Origins of the Mixed-Blood Community Among the Rosebud Sioux," *South Dakota History*, 3 (1973): 233–70.

21. Beatrice Medicine, "More Than Mere Coverings," in *Objects of Everlasting Esteem: Native American Voices on Identity, Art, and Culture*, ed. Lucy Williams (Philadelphia: University of Pennsylvania Museum, 2005), 131.

22. See Gaylord Torrence, *The American Indian Parfleche: A Tradition of Abstract Painting* (Des Moines, SD: Des Moines Art Center, 1994).

23. See Janet Catherine Berlo, "A Brief History of Lakota Drawings, 1870–1935," in *Plains Indian Drawings 1865–1935: Pages from a Visual History*, ed. Janet Catherine Berlo (New York: Abrams, 1996), 34–39; Castle McLaughlin, *A Lakota War Book from the Little Big Horn: The Pictographic Autobiography of Half Moon* (Cambridge, MA: Peabody Museum Press, 2013); Candace Greene and Russel Thornton, eds., *The Year the Stars Fell: Lakota Winter Counts at the Smithsonian* (Washington, DC: Smithsonian National Museum of Natural History, 2007); Peter Bolz, "Die Berliner Dakota-Bibel, Ein Frühes Zeugnis der Ledger-Kunst bei den Lakota," *Baessler-Archiv*, N.F., 36, no. 1 (1988): 1–59.

24. See Janet Catherine Berlo, *Spirit Beings and Sun Dancers: Black Hawk's Visions of a Lakota World* (New York: George Braziller Inc., 2000). From 1890 to 1913, another Lakota artist, Amos Bad Heart Bull (1869–1913) was engaged in a project of far greater scope and magnitude. In a large ledger book he had purchased for that purpose, he systematically drew more than 400 pictures, ranging from early Lakota history to chronicles of the Battle of the Little Big Horn, the Ghost Dance, and the massacre at Wounded Knee. See Helen Blish, *A Pictographic History of the Oglala Sioux* (Lincoln: University of Nebraska Press, 1967).

25. Quotes from John Gregory Bourke's diaries were transcribed by Berlo from photocopies at the Center for Southwestern Research, Zimmerman Library, University of New Mexico, Albuquerque, document no. 917.8 B66d, vols. 43–44, abridged from pp. 1460–504; handwritten originals are at the Library of the U.S. Military Academy, West Point, New York.

26. See also Berlo, *Plains Indian Drawings*, 194–97.

27. Arthur Amiotte, "The Lakota Sun Dance: Historical and Contemporary Perspectives," in *Sioux Indian Religion*, ed. Raymond DeMallie and Douglas Parks (Norman: University of Oklahoma Press, 1987), 84.

28. For more on Standing Bear, see Louis Warren, "Prelude: the Life of Standing Bear," in *Transformation and Continuity in Lakota Culture: The Collages of Arthur Amiotte, 1988–2014*, ed. Arthur Amiotte, Louis Warren, and Janet Catherine Berlo (Pierre: South Dakota State Historical Society Press, 2014), 2–8; and Arthur Amiotte, "A Journey of Discovery: Standing Bear's Art Work," 9–23 in that same volume.

29. See Marsha Bol, "Beaded Costume of the Early Reservation Era," in *Arts of Africa, Oceania and the Americas: Selected Readings*, ed. Janet Berlo and Lee Anne Wilson (Englewood Cliffs, NJ: Prentice Hall, 1993), 363–70.

30. Artist Colleen Cutschall references the beaded yoke of women's dresses in paintings from the late 1980s. See Carmen Robertson's essay in this volume.

31. Lakota artist Arthur Amiotte, personal communication to author; see also Amiotte, "An Appraisal of Sioux Arts," in *An Illustrated History of the Arts of South Dakota*, ed. Arthur Huseboe (Sioux Falls, SD: Center for Western Studies, Augustana College, 1989), 124.

32. James Howard, *The Warrior Who Killed Custer: The Personal Narrative of Chief Joseph White Bull* (Lincoln: University of Nebraska Press, 1968), 82.

33. Janet Catherine Berlo, *Arthur Amiotte: Collages 1988–2006* (Santa Fe: The Wheelwright Museum, 2006); and see Carmen Robertson, this volume.

34. Her work was chronicled in *Lakota Quillwork: Art and Legend*, a film by H. Jane Nauman, Nauman Films, Inc., 1985. In 1985 she was also awarded a National Heritage Fellowship by the National Endowment for the Arts, a funding organization of the U.S. government.

35. For more on Amiotte's life and work, see Berlo, *Arthur Amiotte: Collages*.

36. The last time Amiotte wore it was for the Sun Dance he sponsored near Custer, South Dakota in the summer of 1991. The shirt, with its matching leggings and pipe bag, are now in the collection of the Akta Lakota Museum, St. Joseph's Indian School, Chamberlain, South Dakota.

37. The biographical information on Her Many Horses was obtained during informal conversations between 2014–2018.

38. Josephine Richards Pourier (1853–1937) was the half-Lakota wife of Baptiste "Big Bat" Pourier (1843–1928) a western frontiersman of French Canadian heritage. They lived on Pine Ridge reservation during the last decades of their lives.

39. See Ron McCoy, "Fully Beaded Valise with Pictographic Designs by Nellie Two Bear Gates," Notes from the Warnock Collection, http://www.splendidheritage.com/Notes/WC9206020.pdf. See also Torrence, *The Plains Indian*, 250–51.

40. See, for example, Berlo, *Plains Indian Drawings*, cat. nos. 113, 134, and 141.

41. Emil Her Many Horses, personal communication to author, June 2018.

42. Emil Her Many Horses, "Woman's Dress and Accessories," in Torrence, *The Plains Indians*, 297.

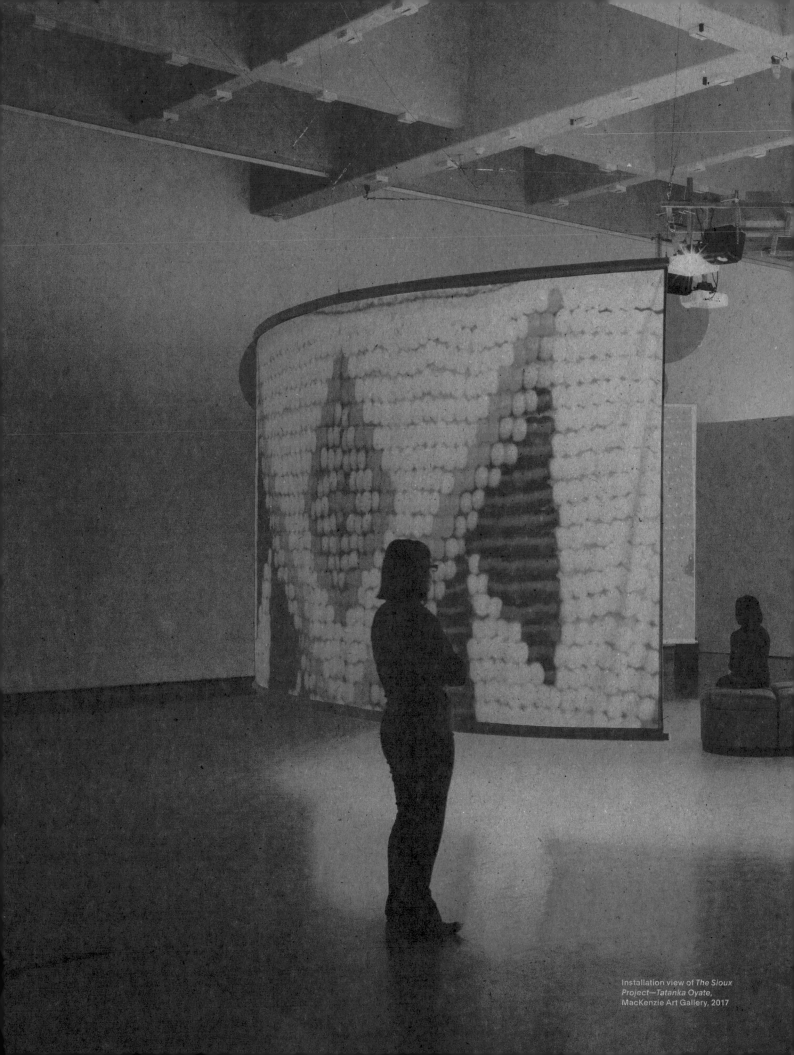

Installation view of *The Sioux Project—Tatanka Oyate*, MacKenzie Art Gallery, 2017

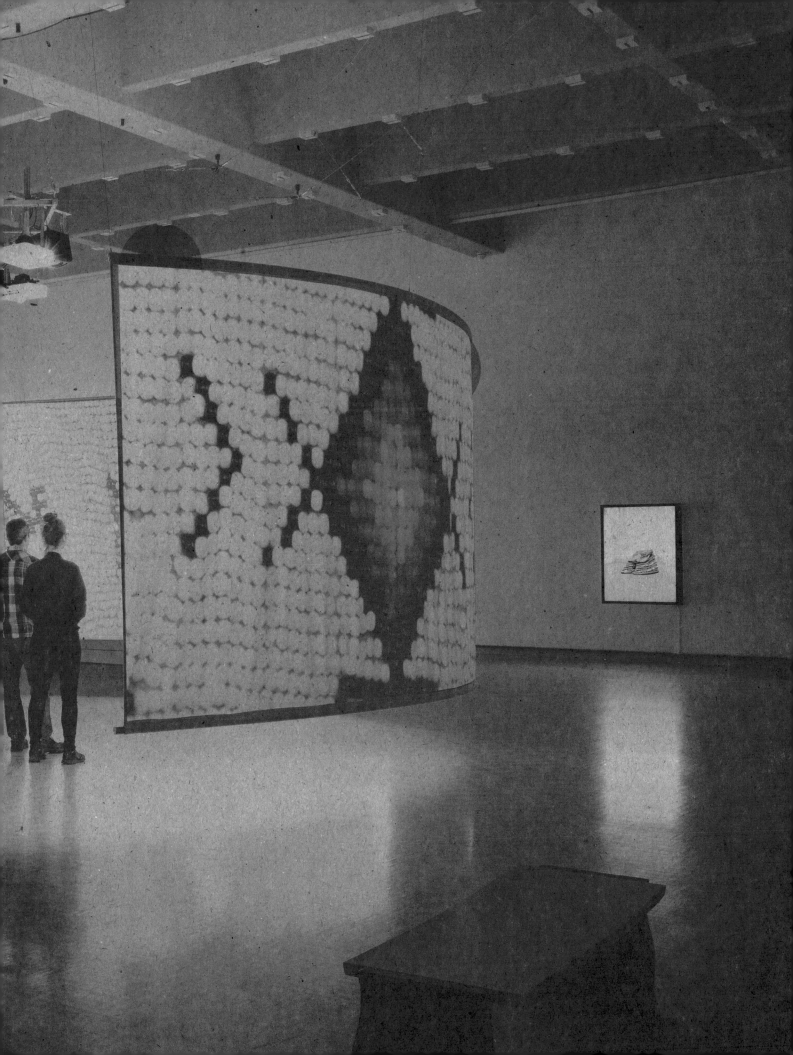

# Dana Claxton's Time Machine

## Timothy Long

DANA CLAXTON: THE SIOUX PROJECT—TATANKA OYATE   SEPT. 13, 2017

Yellow: screens          Black: projectors          + 18′ 5½″
Purple: 2″-aluminum L-bracket   Red: 3/16″ aircraft cable

CEILING HANGING SYSTEM

ENTRANCE

APPROXIMATE SCALE: 1:103.5

Ceiling plan for the screen hanging system, *The Sioux Project—Tatanka Oyate*, MacKenzie Art Gallery, 2017. A double diamond of aircraft cable was used to suspend the aluminum hanging bars for the projection screens, creating a geometric pattern that echoed many of the Sioux beadwork designs in the installation.

When Sitting Bull crossed the border into Canada in 1876, Eadweard Muybridge's first projections of a galloping horse were still three years in the future. But for those accustomed to riding the northern plains, open horizons already afforded a moving 360-degree experience that was superior to any cinema, then or now. Over the years, Dana Claxton's lens-based installations have provided a space that mediates between these two realities—between moving image projection, the preeminent visual technology of the industrial revolution, and the enduring Sioux experience of land, sky, and community. Following a trajectory which she initiated two decades ago with *Buffalo Bone China* (1997), Claxton's *The Sioux Project—Tatanka Oyate* extends and pushes in new directions her consideration of the role of the projected image in articulating a distinctively Sioux worldview.

As the institutional curator working with Dana Claxton and guest curator Carmen Robertson on *The Sioux Project*, I was privileged to take part in the initial discussions around the presentation at the MacKenzie Art Gallery. That conversation focussed on the availability of the Kenderdine Gallery, a spacious sixty-by-eighty-foot room that plays an essential role in the installation. Its twenty-three-foot-high coffered ceiling and maple parquet floors suggest the limitless prairies which encircle the city of Regina. A feeling of expansiveness greets visitors and intensifies the impact of the projections at the centre of the gallery.

Suspended at knee level in the darkened room, the four curved canvas screens form a column of glowing light that is reflected in the polished floor. However, the projections as seen on the outside of the screens have an unexpected appearance. Diffused and softened by the fabric, they exhibit a material quality and colouration that sets them apart from those typically seen on free-standing back projection screens.[1] The curvature of the sixteen-foot screens offers a further material grounding that challenges expectations. The effect produced by the screens reminded me, at least in one respect, of the 2006 installation *Projection Room* by Sean Whalley and Rory MacDonald.[2] Created for *Crossfiring: The Claybank Project*, the installation was part of a one-day site-specific art event at the Claybank Brick Plant National Historic Site in the Dirt Hills of southern Saskatchewan, about an hour's

drive northwest of Claxton's family reserve at Wood Mountain. For *Projection Room*, Whalley and MacDonald transformed a disused gas brick kiln into a giant camera obscura. Using a set of mirrors inserted into the top of the circular structure, the interior of the kiln became a wraparound projection screen which allowed viewers to see the brickyard lane outside. Although happening in real time, the pale figures walking along the street appeared to be from another era, like actors in a silent movie from a century ago. For me, as for many viewers, the passage from outside to inside was a form of time travel.

Claxton's circle of screens suggests a similar temporal shift, though in reverse. While the exterior of the screens is imbued with the sepia-toned aura of the past, the interior is insistently present. Within the circle, the images appear at full intensity and bring us into the current reality of the Sioux nations in Saskatchewan. The experience is immersive in its physicality and intergenerational in its representation of creativity and cultural transmission. A seating area at the centre provides visitors with a comfortable space from which to watch the four-channel video on a two-hour loop. Scenes of buffalo on the land that appeared like postcards from the past from the outside are brought into the here and now. Other images, particularly those generated with green screen technology, extend the time continuum into the future. Significantly, the passage from past to present takes place at entrances that Claxton has deliberately aligned, like the gates of the Sun Dance, with the four directions of Sioux cosmology. Just as the screens are held up by nearly invisible aircraft cable and an unobtrusive suspension system, so the installation supports a Sioux worldview with elegant minimalism.

Because the screens are suspended and separated the passage between exterior and interior is fluid and intersubjective. Visitors are aware of their fellow viewers both behind and between the screens. As I have argued elsewhere, much of the screen-based work of the past four decades has been oriented toward a kind of "theatroclasm," a breaking of the place of the viewer through a disruption of the traditional position of power occupied by the sovereign and invisible viewing subject.[3] Claxton's past work has participated in this trajectory, whether through the broken pile of china that

disrupts the literal and figurative ground of the spectator in *Buffalo Bone China*, or the imposing immersive screen arrangement of *Sitting Bull and the Moose Jaw Sioux* (2003) that overwhelms viewers and contests settler domination of the land. In *The Sioux Project*, Claxton moves beyond these confrontational screen postures and instead presents a configuration that allows movement inside and outside the screen, from object to subject, from past to future. The screens neither possess the viewer nor the viewer the screens. The situation is diachronic, relational, and inclusive.

When Eadweard Muybridge published his first stop motion images of a galloping buffalo in 1887, Sitting Bull had by then returned to the U.S.A., leaving behind Claxton's Wood Mountain ancestors. Claxton's time machine registers the distance traveled since then by *Tatanka Oyate*, the Buffalo People. As her project reveals, hide paintings, star blankets, moccasins, drums, cradleboards, photographs, videos, and just about anything else touched by Sioux creativity are portable screens which glow with the knowledge of the past, reflect the brilliant inventiveness of the present, and arc confidently toward the possibilities of the future.

—

1. Past visitors to the MacKenzie Art Gallery will recall the Douglas Gordon installation, *Play Dead: Real Time* (2003), a work circulated by the National Gallery of Canada in 2008. For a description of the effects created by the back projection screens used in that installation, see Timothy Long, "Theatroclasm" in *Theatroclasm: Mirrors, Mimesis and the Place of the Viewer*, ed. Timothy Long (Regina: MacKenzie Art Gallery, 2009): 25.

2. For a description of the project, see Kathleen Irwin and Rory McDonald eds., *Sighting/Citing/Siting: Crossfiring/Mama Wetotan: Theorizing Practice* (Regina: University of Regina/CPRC Press, 2009).

3. See Long, "Theatroclasm," and Timothy Long and Christine Ramsay, "Telling Tales out of Spool: Introducing Atom Egoyan's *Steenbeckett*," in *Atom Egoyan: Steenbeckett*, ed. Timothy Long, Elizabeth Matheson, Christine Ramsay (London and Regina: Blackdog Publishing in collaboration with the MacKenzie Art Gallery and Strandline Curatorial Collective, 2018): 29–46.

# The Sioux Project:
# A Journey through Generations

Cowboy Smithx

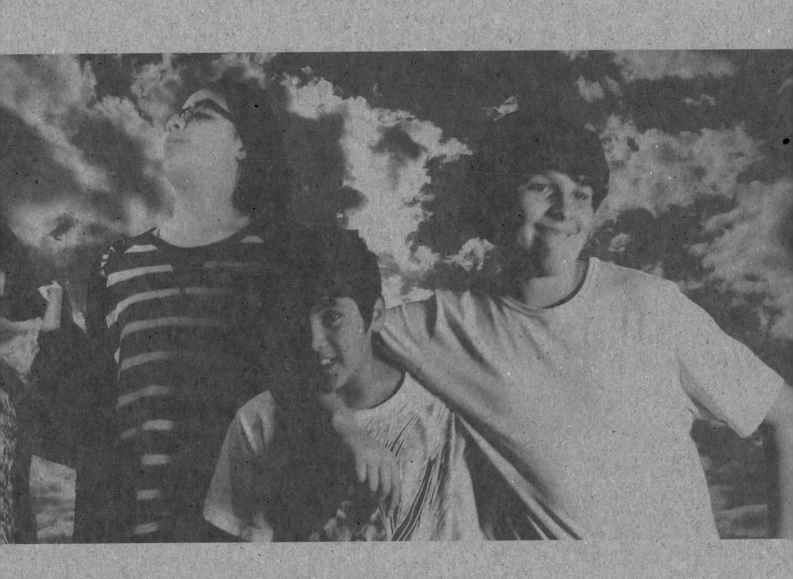

The prairies can feel like an infinite landscape, a seemingly lonely place for the neurotic person or a peaceful place for the attentive mind. A young elder once told me to always be aware of the sundogs, for they only visit in times of great importance. I had the pleasure of working with Dana Claxton on *The Sioux Project* in the summers of 2015 and 2016. During the winters, I saw many sundogs in the prairie sky, reminding me of my visits to several Sioux communities, where we explored Sioux visual culture through both contemporary and traditional lenses. The land has always informed Indigenous means of expression; they in turn have served as a conduit for the frequencies of the land. Through song, dance, ceremony, regalia, and contemporary art, the Sioux image system has had a global impact. Chief Sitting Bull and Chief Standing Buffalo had the foresight to prepare their people for colonial times, by way of beadwork, songs, and stories. Maintaining a strong connection to traditional Sioux expressions was one of *The Sioux Project*'s key mantras. Our visit to Tatanka Najin (Standing Buffalo) had a deep and meaningful impact on me. I had the pleasure of hearing old stories from beautiful elders in the community. Our brief encounter with the Buffalo on a ridge near the Standing Buffalo school will always remind me of how important the Bison were to all the Indigenous peoples who called the plains their home. The *Tatanka* ("Buffalo" in Sioux) or *Iinii* ("Buffalo" in Blackfoot) helped us maintain a symbiotic relationship with the land. Modern economists looking at our people would have observed an aggregate economic efficiency of nearly 100%. Our sustainability and stewardship were off the charts. Elders often say that we are a post-apocalyptic people: life, as we once knew it, ended when the settlers arrived with their unsustainable thirst and hunger for resources.

My generation and many before mine missed out on that massive, all-embracing connection to our ancestral lands. As a child growing up on the reserve, I quickly recognized something was amiss. How could we go from roaming free amidst our vast territories, to being confined to a reserve of land? The Sioux defeated the U.S. Army at their own sick, violent game at the Battle of the Little Big Horn in 1876. Treaties were made in Canada to ward off any potential violence with the Anishinaabe, Cree, Sioux, and Blackfoot. The great ceremonial pipes were smoked during the signing of these Numbered Canadian Treaties; we were supposed to learn from the failures of our American counterparts, but Canada had bad intentions from the beginning. All things considered, our survival of genocide and the sacrifices our ancestors made for this generation are what fuels my fire and keeps me moving forward. The spirit and intent of my work is rooted in the inherited responsibility I have to new generations. I've been working with and for youth for over eighteen years now. I see great importance in capacity building and teaching young people how I've attempted to connect to the past through technologies of the future. Working with the Sioux youth of Standing Buffalo, Whitecap, Saskatoon, and Regina will have long-term impacts. *The Sioux Project* team had the pleasure of teaching the fundamentals around video-making and photography throughout the various Sioux communities. We shot beautiful images of Sioux-style beadwork, regalia, and contemporary art. We travelled hundreds of kilometres across the vast Saskatchewan prairie in search of young Sioux imaginations to collaborate with. I can remember when I took my first film workshop, and how excited I was to learn about cameras and lighting. The youth we worked with were just as curious and excited to create new images of Sioux visual culture. A lot of fun and entertaining moments took place during our workshop series, giving the youth an experience to remember. It's important to note that this next generation, growing up in a mostly digital world with social media, streaming video, and blockchains, will be the most educated generation we've ever seen. That's why *The Sioux Project* is so important.

We finally had a chance to see *The Sioux Project* come to full fruition in the fall of 2017. Seeing all of the videos we created with the youth as a full 360-degree installation at the MacKenzie Art Gallery was a catharsis of pixels for days. Watching the museumgoers process all of the beautiful and fascinating imagery we captured almost brought me to tears, and I rarely cry. My broader appreciation for the arts overflowed on opening night. The memories, images, and legacy of Dana's incredible body of work are what make all of her Sioux ancestors so proud. I was very happy that day. Time flew by during the three years we developed and created *The Sioux Project*. From the days we spent in Regina at the North American Indigenous Games, where our Sioux Project booth took a beating from a powerful summer storm, to the last days of filming at inner city Saskatoon's PAVED Arts media hub, the entire experience was amazing. Working with Lynne Bell and Dana Claxton was a daily treat; I really appreciated the space they created together, protecting me and my team from the arthritis of academia. I'd love to take this opportunity to thank those who helped along the way: Damian Eagle Bear, Chris Ross, Jarrett "Buffalo Top" Crowe, Rio Mitchell, Elder Barbara, the Yuzicappi Family, and finally the late Lacy Morin-Desjarlais, who was teaching me more about the prairie landscape and its frequencies than my brain could handle — she left us far too early.

My final experience with *The Sioux Project* was the symposium hosted at the MacKenzie Art Gallery, where I presented my work to the people of the land. After my presentation, Dana's sister Kim said "Cowboy is the smartest person I know," which is far from the truth. For the record, Dana is the smartest person Kim knows. I'm just a child of the apocalypse trying to shake off an intergenerational genocide-concussion, still learning, still listening. Our ancestors deserve all the credit for the cool things we do as humans in 2018.

Dana Claxton has been carving out new algorithms for future generations; she has been a great mentor not only to me, but also to the young people of the Great Sioux Nation. It's been an honour to bear witness to Dana's "process." Watching this go from an idea to an entire installation and symposium has been a powerful journey for me. The sundogs are coming — may we greet them with beautiful art.

# Lakota Views of "Art" and Artistic Expression

## Bea Medicine

Perhaps, we as anthropologists and art historians have spent too much time categorizing dimensions of Native art within a Euro-American context. With the current trend in attempting to get "insider" views, it may be more appropriate to consider how Aboriginal peoples view artistic expressions of all sorts. In researching where the statement, "there is no Native word for Art," I can possibly attribute it to the ATLATL conference in the 1980s. I am grateful for Gloria Webster Cranmer, who, as discussant to the session at the 1999 NAASA conference stated she used it in a conference in 1973. However, this is a rather incomprehensible all-encompassing statement, considering the more than one hundred Native languages and dialects which are still used in Native North America. Many of us have spent our lifetimes attempting to rid ourselves and, yes, "Others" (Euro-Americans and Euro-Canadians) of the monolithic "North American Indian" which obliterates the tribal diversity which characterizes this continent.

It is this cultural diversity which is reflected in Native place, society, and individuals which must be examined in assessing Aboriginal art in the present time. I prefer not to get involved at this time in the conundrum of "will the real Indian artist, please, stand up" syndrome, which seems to permeate many aspects of Native art today. Indeed, the American Indian Arts and Crafts Act of 1990 attempts to confront this issue. It specifies that only federally recognized (enrolled on a reservation) Natives are considered "Indians." This has led to cries of "card-carrying" Natives, or pedigreed blood quantum.

In the interest of furthering the dialogue, I will concentrate upon the views of artistic expression among the Lakota people—mainly the Hunkpapa and Sihasapa bands. For within the linguistic dialect of this Siouan language, there are subtle differences in the Lakota language—commonly referred to as the "L-speakers." Other dialects are Dakota and Nakota—which are mutually intelligible. The Dakota dialect is pervasive in the northern part of Standing Rock reservation.

Philosophical and linguistic domains as it applies to art forms are functional according to the Native people who use them. Another blanket statement plays into the essentializing of the many vibrant traditions in the artistic production of most Indigenous groups. That is, all Indians are "artistically inclined." These types of statements seem to contribute more to the homogenization of our peoples, which seems to be occurring in the present emphasis on multicultural education in all fields. When anthropologists and art historians resort to such sloganizing statements, one may give to an observing majority audience in museums, galleries, tourist shops, and classrooms, a convenient handle to again place Native peoples in a subordinate position in contemporary society. Patronage seems predominant.

Originating from and returning to one's natal community has weaknesses and strengths. One does not have to worry about rapport and who might be a reliable "informant"—excuse me, the in-term is now "consultant." A weakness is that many people do not know what returnees have done in the "White" world. So, it is relatively easy to ask questions. More importantly, it is easier to listen and remember. Thus, in a discussion to delineate worldviews a male elder stated, and I translate—he said—"To know what WOLAKOTA means…it means art, music, aesthetics, philosophy, and the way of life (Douglas Fast Horse)." To him, way of life meant this definition indicates an inter-relationship of all intangibles of Lakota life. While the English word ART represents a compartmentalization of an aesthetic framework, Lakota worldview represents an integration which is difficult to delineate into discrete entities.

I also asked an individual who might be viewed as a tradition bearer in my community. He defined art as *taku gaxape na ohola pe*—"what is made and cherished." This may include songs, beaded or quilted items; and such mundane things as WASNA (pemmican), which changes when used in special contexts—naming ceremonies, the Sun Dance and adoption ceremonies such as *Hunka* (making of relatives). Thus an ordinary food of survival becomes *wakan* (sacred) in a sacramental context. These things are WOLAKOTA—"honored by the Lakota."

In order to obtain gender equality in elicitation, a female elder stated: *Taku waste'la ka pi na ga xapi* — "whatever we (Lakota) make and admire." The integrative aspect of art in a Native perspective appears to negate segmentalized thinking in realms of arts and crafts.

One can say there is possibly no correlation between the English word ART, and the sterile binary compartmentalization ART and CRAFT. There is, at least among the Lakota speakers and their worldview, a greater inclusiveness of the vitality of Native life — even in the supposed wasteland of contemporary reservations. One must look to functional verbalization in communities and elicit linguistic terms of appreciation and appraisal to delineate Native aesthetic views. Many of us who have spent precious years teaching about Native cultural diversity cringe at many all-encompassing ideas in multicultural education and museum displays which are still tied to a "culture area" approach.

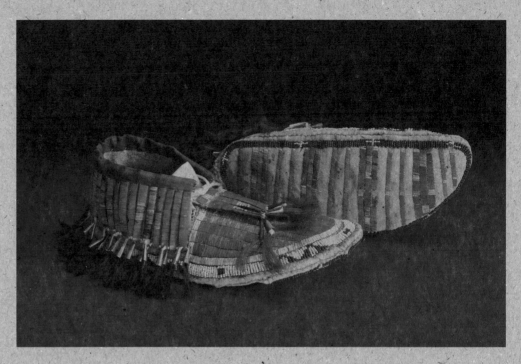

> A word for ART is yu gla ke ke — *"going across — to draw."*
> yu o swa ye — *"going down."* Basically, the process describes sketching and painting contemporarily.

This utterance is the one used for painting on parfleche (raw hide) containers. The term for this artistic expression is *ae ba zu* — "to mark on surface." Since these designs tend to be geometric on rawhide containers, called *phun*, the standard evoked here is straight lines, pleasing colors, and symmetry especially in matched pairs. In some of the newer shapes, which have added wool flannel binding, the color of desire is most commonly red wool, and neatness of attachment is important. Painting of men's shields was vision and/or dream-based, and only the maker can evaluate them. Recently, I was researching Clark Wissler's letters to Franz Boas in the archives of the American Museum of Natural History, New York City. His letter of 3 August 1902, written from Pine Ridge stated:

> The "dream design" were the work of wakan *(mystic) women chiefly; though shields were often carved and decorated according to dreams or visions experienced by men. No one was permitted to use plant designs except a few* wakan *women. This is said to be an "ancient custom."*

> *Formerly, there were magic blankets supposed to have power in seducing women. Art was very realistic — warrior deeds on buffalo robes.*

> *From the data I have on hand now, there are two kinds of "dream" or vision figures and a kind of "sign writing." The former is largely feminine, the latter masculine. That is, the women cannot, or will not explain the sign writing, for it belongs to the profession of a warrior.*

Although Wissler refers to the Oglala, it is difficult to find "raw data" before an analysis, thus this quote seems significant. I am not aware of any assessment criteria for these in recent times. Indeed some Lakota ritualists do not want shields and pipes in exhibits.

Perhaps … there is no word for "art" in American-Indian languages. It may be simply another dimension of deficit models by "Others" which have plagued American Indians/Alaska Native linguistic and philosophical systems for too long. It also appears to play into the simplification of the many vibrant traditions in the artistic production of many nations of Indigenous peoples in North America. It may also negate the rich linguistic variation in our cultures. The negation of linguistic terms does not take into account contemporary revitalization movements in the Plains quill work and parfleche objects. What seems imperative is a concerted effort to elicit Native terms for any artistic expression.

Another greatly neglected area in Native art is gender variance. Lakota analysis must also consider Art of the *winkte* — "two spirit" people, some of whom still do artistic work, and have Native linguistic appraisals.

Oscar Howe, the well-known Dakota artist, viewed art and philosophy as *ini* (to live) — "in art I have realized a part of a dream." The school gymnasium in a BIA school on Standing Rock reservation displays the wondrous drawings of Art Amiotte. He labels these as:

> woyuonihan — *honor/respect/responsibility*
> wo wa cin tanka — *thoughtful, great thoughts, wise*
> wa on sila — *compassion, humility*
> wok sape — *intelligence*
> ohitika — *brave, courageous*

These are the four cardinal virtues that underlie Lakota life. Douglas Fast Horse of Rapid City states: *Wolanota ki* means "art, music, aesthetics, a way of life." Joe Flying By, a Hunkpapa ritualist, uses *wiconi* to include the above categories — the expressive elements of Lakota culture.

—
From *Ablakela: a performance work* by Dana Claxton, CD-ROM, texts by Bea Medicine and Glenn Alteen, Vancouver: Grunt Gallery, 2001. Reprinted by permission.

Unidentified (Northern Plains, Sioux), *Moccasins*, c. 1890

# Visual Histories/Contemporary Stories

Carmen Robertson

Entrance to *The Sioux Project—Tatanka Oyate*, MacKenzie Art Gallery, 2017

Walking up the grand staircase to view *Dana Claxton: The Sioux Project—Tatanka Oyate* at the MacKenzie Art Gallery in Regina, Saskatchewan, visitors first encountered a work from the MacKenzie's permanent collection by Oglala Lakota artist Colleen Cutschall (see illus. p. 62). The placement of Cutschall's small but powerful contemporary painting outside the exhibition space drew attention to a larger circle of contemporary Sioux artists whose art helps define Indigenous spaces in galleries today. Like Claxton's immersive video installation, Cutschall's painting underscores contemporary Indigenous art that draws from the past, contends with the present, and looks to the future in ways that signify enduring concepts of Sioux aesthetics. Imbued with narratives of land and relations, the visual stories found in Sioux contemporary art continue to promote, nurture, and maintain good relations, collapsing time to allow stories about the past to remain a living part of the everyday.

Countless Sioux artists in addition to Claxton and Cutschall on both sides of the Medicine Line have created art informed by the cultural traditions of *Oceti Sakowin* (People of the Seven Council Fires known as the Sioux Nation) whose traditional homelands stretch from Minnesota through North and South Dakota, Nebraska, Montana, Alberta, Saskatchewan, and Manitoba. Oscar Howe and Arthur Amiotte along with Cutschall and Claxton have together charted a course for understanding the most recent art history of the Sioux. Sioux art today takes many forms and typically speaks of presence, endurance, relationships, history, and myth. These four noted artists owe much to aunties, grandmothers, uncles, and grandfathers who have come before them and intergenerational knowledge resonates in their works. Together they have helped to shape the landscape of contemporary *wouncage*, a Lakota term for "our way of doing," by making art and educating new generations in a way that brings together the past, present, and future in an expression of Sioux aesthetics.[1]

In many ways, Colleen Cutschall, Oglala Lakota, from Pine Ridge, South Dakota, serves as a pivotal link that unites the four. Cutschall, who has spent much of her career teaching at Brandon University in Manitoba, had the opportunity to be mentored by both Yanktonai artist Oscar Howe from Crow Creek reservation in South Dakota and Lakota artist Arthur Amiotte, who also grew up on the Pine Ridge reservation. Howe is considered the *Tunkashila* or *Lala* (grandfather) of contemporary Sioux art and began showing his art in galleries in the 1950s. Amiotte followed Howe, carving out new forms of art while studying and teaching succeeding generations about Sioux culture. Both Howe and Amiotte were early leaders in arts education. Similarly, the careers of Claxton and Cutschall

coincide in a number of key areas. As professors at Canadian universities, Claxton and Cutschall serve as mentors to new generations of artists. As female artists, they make art that references themes from colonialism to Sioux mythology, but they do so by incorporating female experiences into their work. Female bonds differ from those of men, as do the arts traditions of Sioux women. Both artists, in their own ways, celebrate the intimate and communal relationships shared by women as they draw on stories to build artistic spaces of understanding.

Arthur Amiotte, who has widely shared knowledge about Sioux art through his teachings and writings, understands the collective power of Sioux women artists. Having grown up immersed in the stories and teaching of Sioux oral traditions, he explains how the maintenance of art and culture remains inextricably bound to the artistic efforts of Sioux women. For him, traditional concepts applied to contemporary Sioux art resonate as a form of active presence. He notes in a recent essay that "to make, receive, inherit, own, and wear quilled items indicates fidelity to the ancient tribal ethos of *Lakol Wicoh'an* (the longevity of tribal identity)."[2] Amiotte translates the ceremonial concept of *Saiciya*, which means "to paint oneself with red pigment," as "these adorned ones represent the best of the culture" in contemporary times.[3] Writing about the drawings of Lakota artist Black Hawk, who created ledger art in the early reservation period of the 1880s, Amiotte finds that "the individual and collective psyche—permeates and threads itself into forms, images, and symbols...[to] become visual manifestations of cultural continuity and are distinctly characteristic of 'Lakota-ness.'"[4] Art historian Janet C. Berlo similarly recognizes that the narrative styles of Lakota graphic artists in the late nineteenth century "provide the foundation for Lakota visual arts of the twentieth century."[5] Just as Black Hawk adapted earlier traditions of visual storytelling done by men on hides to ledger art, so artists today find inspiration in visual storytelling for diverse contemporary expressions.

Concepts of *Saiciya* and *Lakol Wicoh'an* reverberate through contemporary works and intergenerational transmission of cultural stories informs understandings of contemporary Sioux aesthetics. Over the past seventy years, Oscar Howe, Arthur Amiotte, Colleen Cutschall, and Dana Claxton have together helped formulate a corpus of contemporary Sioux art that marks artistic pathways for contemporary Sioux artists.

## Blazing Trails

It is impossible to study contemporary Indigenous art history without recognizing the significance of Oscar Howe (1915–1983), a trailblazer who expanded creative directions for Indigenous art by taking

a stand against confining formulae established for contemporary Indigenous arts production in 1930s America. First labeled a "Native Modern" by art historian Bill Anthes, Howe's innovative style of art and vocal resistance to confining ways of judging contemporary Indigenous arts situate him within the burgeoning discourse on Indigenous modernism.[6] I view Howe as a cultural warrior.

Born on the Crow Creek Indian Reservation in South Dakota and a member of the Yanktonai *tiyospaye* (extended family group), Howe was the first Dakota artist to attend the now famous Studio School in Santa Fe, New Mexico under the direction of instructor Dorothy Dunn from 1933 until 1938. He learned to paint in the School's flat, confining, pseudo-traditional style of two-dimensional art using opaque watercolours. Collectors sought this type of art because it, in part, reproduced romanticized, frozen-in-time imagery of ceremony and life. Howe began experimenting with his own unique visual vocabulary in his arts practice after leaving the school and serving in World War II. After the war, Howe studied at Dakota Wesleyan University and the University of Oklahoma and then accepted a teaching position at the University of South Dakota in 1957 where he taught for the remainder of his career. Howe began developing an abstract style of painting that many critics and art historians viewed as being influenced by cubism. Rejecting the claim, the artist argued instead that the vertical forms found in his developing style were rooted in traditional Sioux aesthetics.[7] Howe adamantly described his art as "a visual response to the Dakota language," explaining that his contemporary paintings served as a continuation of the geometric designs found in traditional quill and beadwork.[8] Howe's experimentation with distorted diamond-shaped motifs forged an individualized contemporary approach with a clear relationship to Sioux traditional aesthetics.

As he worked to shape a contemporary arts practice informed by Sioux cultural forms, Howe found he needed to stand up to established norms that bore little connection to his own aesthetic understandings. In 1958, Howe wrote a missive that changed the ways museums and galleries understood contemporary Indigenous art.

Since establishing himself as an artist, Howe had taken full advantage of the few avenues available to show his artwork in the postwar period. The Philbrook Museum of Art in Tulsa, Oklahoma notably established a national competition in 1946 for Native artists and its annual juried exhibit became one of the preeminent places for mostly Studio School style work to be exhibited. As noted in a 1947 catalogue for the Philbrook exhibition, one of the aims of the annual exhibition was to "retain some of the

traditional manner of presentation that deals with ceremonial or mystic themes relative to the life or thought of their ancestors" and to contribute to the progress of contemporary painting.[9] Howe was awarded the Grand Prize in the 1954 annual exhibition for *Victory Dance*. While in *Victory Dance* Howe continued to conform to accepted themes promoted by the Philbrook, the painting demonstrates the artist's self-assured departure from the Studio School aesthetic

and demonstrates his own visual vocabulary. Compositional elements, including the male body, regalia, and feathers, fuse and form an interconnected whole made up of enfolded vertical elements, giving unmistakable evidence of his move toward abstraction.

In 1958, the Philbrook jury committee rejected Howe's submission *Umine Wacipe: War and Peace Dance* because they felt it did not adhere to the prevalent style acceptable at that time, even though the work was surprisingly similar to *Victory Dance*.[10] As a result, Howe wrote a pointed letter to Philbrook curator Jeanne Snodgrass challenging the jury's decision. Today this famous letter is viewed as a manifesto because he questioned the established norms for Indigenous art. Howe states:

> *Whoever said that my paintings are not in the traditional Indian style has poor knowledge of Indian art indeed. There is much more to Indian art than pretty, stylized pictures. There was also power and strength and individualism (emotional and intellectual insight) in the old Indian paintings. Every bit of my paintings is a true, studied fact of Indian paintings. Are we to be held back forever with one phase of Indian painting with no right for individualism, dictated to as the Indian has always been, put out on reservations and treated like a child, and only the White Man knows what is best for him?*[11]

The controversy prompted by Howe caused the Philbrook to add to the competition the following year a new category labeled "Category II" or non-traditional that made space for new styles of art (though it came with less prize money than "Category I" traditional).[12] Howe's letter not only changed this one institution; it has also inspired generations of artists to question confining labels associated with Indigenous art.

Howe's actions and mentoring influence extend to both Arthur Amiotte and Colleen Cutschall, who each attended Howe's summer workshops at the University of South Dakota and were inspired by his actions and his art. Howe's close relationships with the young artists illustrate the ongoing impact of his ideas.[13] Cutschall describes her connection to Howe with this reminiscence:

> *One of the things that Oscar Howe had impressed on me was that work should be authentic, something that you knew about or had experience with. It did not at that time mean racially authentic but that became an issue later on with separate Indian Art shows where you had to provide documentation of your degree of blood. They were the only place an Aboriginal artist could get their work exhibited.*[14]

Oscar Howe (Yanktonai Dakota [Sioux], 1915–1983), *Victory Dance*, c. 1954

Like Cutschall, Amiotte similarly benefited from his interactions with Howe. Amiotte shared the importance of Howe as his mentor in the 2014 exhibition catalogue of his work, *Transformation and Continuity in Lakota Culture*. He notes that after attending one of Howe's workshops at the University of South Dakota in 1961, he began to paint like the senior artist prior to formulating his own unique style.[15] After receiving undergraduate and graduate degrees, Amiotte taught Sioux cultural arts at Pine Ridge at the same time as serving as an apprentice to tribal elders in order to study cultural knowledge. Experimenting with his own artistic style in watercolours and oils, Amiotte soon began to work in collage, a unique mixing of image and text in a style influenced by the paintings of Standing Bear and by ledger art done by other Plains men from the 1870s to the 1930s. In a detailed description of his painstaking collage technique, Amiotte stresses that this work "is a tribute to the ancestors and the artistic patrimony they bequeathed to the younger generation."[16] Like Howe, Amiotte created a style of painting based on looking back in order to create something new.

Claxton and Cutschall also serve in their own ways as trailblazers. Both as makers and teachers, they have made space for Sioux aesthetics in the larger national and international sphere of contemporary arts. Expressing the specific concerns of women within their contemporary arts practices situates them within a small but significant group of Sioux artists. As some of the first Indigenous women to show their work in contemporary art galleries in Canada, the United States, and Europe, each has contributed to a larger dialogue informed by Sioux aesthetics. Steeped in intergenerational knowledge transmission and shaped by colonial realities, Claxton and Cutschall weave cultural ways of knowing into their contemporary visual stories.

## Storytelling

Sicangu Oglala Lakota storyteller Joseph Marshall calls Lakota stories, "markers on the road of life."[17] Story unites these four artists. The mythology and history of the *Oceti Sakowin* merges with recent histories related to colonialism and imperialism. Utilizing diverse media including painting, collage, and video, these four artists shape their practices around story in ways that mark the Sioux experience and generate productive narratives of futurity.

Oscar Howe adapted pictorial traditions for representing history and autobiography as practiced by men throughout the Plains. Using his unique style, Howe connected culture, ceremony, and history to contemporary media in order to convey visual stories of Sioux life at the time of contact. Colleen Cutschall forged strong links to her Lakota teachings especially in her early works.

She notes that in addition to Howe, Arthur Amiotte was a significant mentor. He was a "big influence, not so much in terms of style but in terms of content," explains Cutschall. "Through him and my own research, I became extremely knowledgeable of Lakota myth and traditions and that became the subject matter that most intrigued me for over a decade, maybe two."[18] Knowing about the influence of Howe and Amiotte helps viewers understand more fully the Cutschall artwork which was on display during *The Sioux Project* exhibition. Rather than sew and decorate an actual dress, a traditional artform of many Sioux women, Cutschall translates the designs found on a Lakota woman's dress into brushstrokes in order to tell a very old story. *The Third Time: The Judgement of Skan*, painted in acrylic on canvas, mimics the yoke of a Lakota women's traditional dress as depicted from a bird's-eye view. Cutschall meticulously renders the storied designs in ways that provide understanding of the sacredness of an actual quilled yoke for a traditional Sioux dress. *The Third Time* remains an excellent example of how her experimentation with simulations of bead or quillwork in the 1980s deepened her illustrations of Lakota mythology.[19] This example of visual storytelling, both aesthetically and conceptually, includes aspects of the micro- and macrocosm of Lakota ontology to express the complex dimensions of mythic traditions. The title of the work, along with the symmetrical design on the yoke and other precisely rendered motifs, refer to the sacred Lakota story of Škáŋ, the powerful spirit being created to give motion to the universe.

Amiotte utilizes collage to create a multilayered form of narration that reaches back to traditions of visual storytelling practiced by men on the Plains. Janet C. Berlo, who has worked closely with the artist and written extensively about his and other Lakota artists' works of art, explains that his collages serve importantly as "mnemonic works of cultural memory that unlock narratives of personal and collective survival so that such memories can live once again for all who see the artworks and listen to their stories."[20] The artist, who grew up on the Pine Ridge reservation, was born in 1942 to the great-grandson of Standing Bear (1859–1933), a Lakota man whose life and art influenced Amiotte. Rendering scenes from the past in a traditional style reminiscent of men's hide painting, Standing Bear's paintings on muslin offer a significant record of this period. Amiotte similarly captures the past and present in his contemporary works.

Amiotte's commitment to intergenerational knowledge transmission is easily detected in his collages, which signify mobility and adaptation and echo Lakota cultural tenets. In a number of collages from the 1990s and 2000s, an image appears of an antique touring automobile filled

with drawings of ledger-style warriors — an image inspired by a 1910 photograph taken by John Anderson of six Lakota men in full regalia posing in a car. Lakota historian Philip Deloria argues in *Indians in Unexpected Places* (2004) that the photograph is a portrayal of "the ways in which Indian people have created distinctly Native spaces that are themselves modern."[21] Amiotte reproduces the image in many of his works to achieve what Deloria suggests, but also to reinforce the importance of mobility within the culture. In *Us and Them Together* (1992), for example, the collage juxtaposes his iconic black car, top down and two figures riding inside, with a photo of a cowboy mounted on a white horse. Behind the horse and car, Amiotte has added an early twentieth-century colour advertisement for an Overland touring car with a text announcing, "Spring is Here!" and "Order Your Overland!" for "$1075.00." In front of the ad, which features a group of carefree upper-middle-class Americans driving through an avenue of cherry blooms, Amiotte situates two warriors sitting in the artist's own rendition of a touring car. An American flag appears in the top portion of the collage. Written in cursive script in pencil between the top three red stripes are the texts, "We like to ride in those automobiles" and "We like our horses better." Questioning notions of progress and movement, Amiotte pulls no punches as he juxtaposes the two groups and two modes of

Colleen Cutschall (Oglala-Sicangu Lakota, b. 1951), *The Third Time: The Judgement of Skan*, 1989

Arthur Amiotte (Oglala Lakota [Teton Sioux], b. 1942), *Us and Them Together*, 1992

transportation to confound the binaries at play in the work. Visual storytelling articulates notions of mobility and adaptation in Amiotte's collages.

Using very different media, video and photography, Dana Claxton records and mixes visual stories employing strategies of digital collage in both the process and outcome of her immersive videoscapes. In *The Sioux Project — Tatanka Oyate*, Claxton performatively engages both ontological and epistemological aspects of storytelling throughout her process: from the initial design of community involvement in the project, to the editing, to the stitching together of segments of video with sound, to the final projection onto four large circular canvas panels. The glowing result combines images, music, and story and pulls together a number of themes. Like the star blanket makers working in Sioux communities, Claxton seams colourful fragments of video into interlinked stories. As in the works by Cutschall, Howe, and Amiotte, a pattern of cultural and artistic ideas emerges that aids viewers in understanding the dynamics of Sioux culture and art today.

### Story as History as Art

The outcome of the Battle of the Little Big Horn on June 25, 1876 changed history for all parties involved in the event, but for the Sioux it signalled a dramatic end to a way of life that had been under threat for more than a century. On that day, a growing community of more than 5,000

Sioux and Cheyenne people who had camped by the Big Horn River in eastern Montana thwarted an attack instigated by the United States Army, including the Seventh Cavalry under the command of General George Armstrong Custer. U.S. military casualties exceeded 270 and included Custer himself.

For the United States as a nation, the loss of the battle became a mythical moment in their creation story, one which demanded retribution in the form of violence against the Sioux and others who took part in the battle that day. For Sioux peoples, it was to be their final victory, one that resulted decisively in the end of a way of life defined by free and open movement across the land. Sitting Bull, in an effort to escape the violence and imminent reservation settlement, led a large group from the battle site across the border into Canada, seeking safe haven near Wood Mountain in what is today Saskatchewan.

The history surrounding the battle and ensuing events culminated with the Massacre at Wounded Knee on December 29, 1890. On that day, the U.S. Seventh Cavalry descended on Wounded Knee Creek near Pine Ridge Agency where they killed approximately 200 men, women, and children, mostly members of a band of Minneconjou Sioux led by Chief Spotted Elk also known as Big Foot. The Oglala Lakota medicine man Black Elk, who witnessed the Battle of the Little Big Horn, considered the enormity of the massacre later in his life: "I did not know then how much was ended. When I look back now from the hill of my old age, I can see the butchered women and children lying heaped and scattered all along the crooked gulch as plain as when I saw them with eyes still young."[22]

Howe, Amiotte, Cutschall, and Claxton all creatively respond to these historic acts of imperialist aggression against the Sioux in various artworks utilizing visual storytelling.[23] While the stories connect to historic events, the representation and retelling disrupts the linear understanding of time, resituating them in the present. Such collapsing of time and space underscores the significance of the oral and visual telling of these stories.

The lasting repercussions of the Battle of the Little Big Horn punctuate the art and life of Dana Claxton. Her family came to Canada with Sitting Bull and eventually settled at Wood Mountain First Nation, a Lakota reserve established near the southern Saskatchewan-U.S. border, after the Chief returned to South Dakota. Claxton's 2004 multi-channel immersive video project *Sitting Bull and the Moose Jaw Sioux*, makes direct links to this history and its continued impacts in an artwork that considers the diverse Lakota histories in the Moose Jaw area in the late nineteenth and early twentieth centuries.

arving and barely surviving Sitting Bull's tribe for a few years, they said

Dana Claxton (Hunkpapa Lakota, b. 1959), *Sitting Bull and the Moose Jaw Sioux*, 2004

In 1994 Claxton made *I Want To Know Why*, charting new directions in Indigenous film by creating a video in a format that mimicked the emergent music video genre in order to explore conceptions of colonial trauma. Anishinaabe curator Lisa Myers notes that in the film, "Claxton re-appropriates and layers imagery of 'Indian' iconography within an urban architecture setting to respond to traumatic injustices endured by her ancestors."[24] Accompanying the montage of stereotypical images of Indigenous people, Claxton's voice-over begins quietly and then escalates into a haunting scream as she questions both personal and national atrocities triggered by colonialism. When Claxton shouts out, "Mastincala, my great-grandmother, walked to Canada with Sitting Bull starving, and I WANT TO KNOW WHY!" her words echo the experience of many Sioux people living in both Canada and the United States, but it also adds a female voice to an episode that has most often been cast as a masculine event, focused on warriors and male chiefs such as Sitting Bull. My own great-grandmother Hudutawin with her two young daughters took part in the same exodus and, for me, the film gives voice to generations of Sioux women displaced by the move and also by the patriarchal realities of the Indian Act that further shaped the experiences of these Indigenous women. Claxton's form of embodied storytelling reveals the Battle of the Little Big Horn as a significant moment that continues to shape the lives of contemporary Sioux men and women.

Claxton's recent short film *Hunkpapa Woman in Black* engages directly with the Wounded Knee Massacre through song. The short four-minute film captures the starkness of the events with its minimalist mis-en-scene — a white chair and a black back drop. Claxton's performance of Johnny Cash's 1972 song "Big Foot" retells the story of that day. The artist, dressed completely in black and playing an acoustic guitar, manipulates the image using a staggered video sequencing overlay, to poetically recall the tragedy of that cold December day. The song begins:

> But the land was already claimed by a people
> When the cowboy came and when the soldiers came
> The story of the American Indian is a lot of ways
> A story of tragedy, like that day at Wounded Knee,
>    South Dakota[25]

Like Claxton, Cutschall also engages with historic events in Sioux history in her art. After winning the commission in 2002 to create a public sculpture for the newly renamed Little Bighorn Battlefield National Monument (formerly the Custer Battlefield National Monument), a politically charged space, she completed *Spirit Warriors*, a sculptural

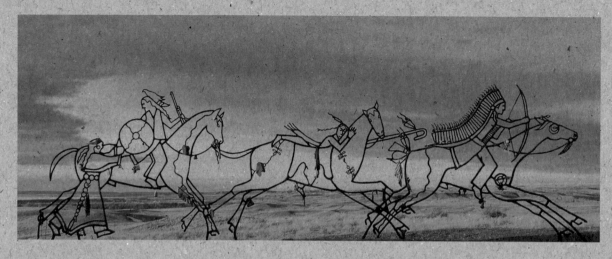

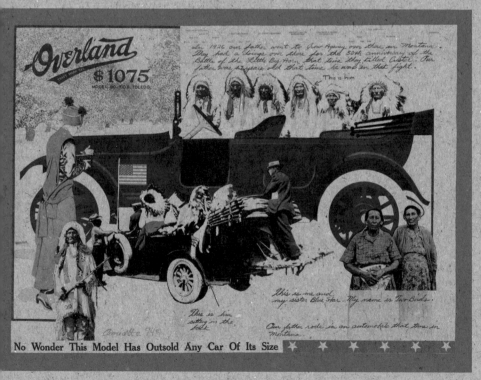

Designer: Colleen Cutschall (Oglala-Sicangu Lakota, b. 1951) / Sculptors: John R. Collins and Christopher S. Collins, *Spirit Warriors*, 2003

Arthur Amiotte (Oglala Lakota [Teton Sioux], b. 1942), *The Reunion*, 1994

three-dimensional form of ledger art drawing. In *Spirit Warriors*, Cutschall translates the linear style of ledger drawing into large-scale figures in cast bronze that appear to have been drawn across the land. With this pivotal commission she pushes the boundaries of what has been widely viewed as a male style of Indigenous art and adapts the iconic drawing form to a site-specific monument. When Cutschall added an image of a woman to the design, a decision that seemed natural to her, the female form proved to be contentious. The overall concept for the sculpture competition required tributes to the Sioux, Cheyenne, and Arapaho warriors who took part in the battle, but omitted any reference to women. Cutschall considers the addition of a woman into her drawing a natural one, explaining that the female figure "is a reminder that even the bravest warrior came into this world through a woman. Her moon cycles are recalled in the thirteen conches of her belt ... and

her placement at the rear of the third horse and warrior demonstrates her effort to assist a warrior" in handing him his shield.[26] In the end, the artist was able to keep the design intact though it sparked much controversy.

Cutschall successfully embedded into the public monument the integral role that women played in the battle and beyond, shifting the masculine formula originally envisioned for the commission. Curator Richard Pearce, who explains the drawn-out political process around the final design and site in his book *Women and Ledger Art*, contends that Cutschall's *Spirit Warriors* has become a key part of the effort to restore the battle site for Indigenous descendants, noting that *Spirit Warrior*, complete with the female presence, "has re-visioned the history of the Battle of the Little Bighorn."[27]

Arthur Amiotte draws oblique attention to the Battle in a number of his collages with the inclusion of reproductions of historical photos. *The Reunion*, completed in 1994, concerns the fiftieth anniversary of the Battle and includes a photograph of several chiefs who attended the celebration, including Amiotte's grandfather Standing Bear, who fought in the battle as a young man. Amiotte reproduces this same photograph in a number of his collages. The artist also made three collages that commemorate the Wounded Knee Massacre. Amiotte struggles to understand the enormity of the events that fateful day as he pays homage to Standing Bear's wife and child who were killed at Wounded Knee while Standing Bear toured Europe with Buffalo Bill's Wild West Show.[28] In Amiotte's *Wounded Knee III*, created in 2001, Berlo points out that Amiotte, in addition to reusing images found in his first versions of *Wounded Knee*, places a historic photograph of Standing Bear with his back turned away from a reproduction of a poster advertising for soldiers to enlist in the Seventh Cavalry (the U.S. military troop commanded by General George Armstrong Custer) "to avoid the draft."[29]

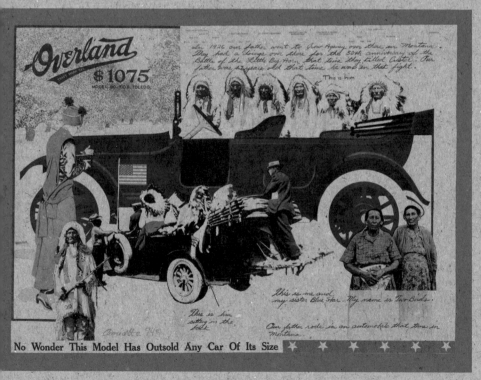

Arthur Amiotte (Oglala Lakota [Teton Sioux], b. 1942), *Wounded Knee III*, 2001

Oscar Howe (Yanktonai Dakota [Sioux], 1915–1983), *Massacre at Wounded Knee*, c. 1959

The artist frames the complex layers of collaged images with an article from an 1876 newspaper, reprinted for the U.S. Centennial, reporting that Custer and his men were killed at the Battle of the Little Big Horn. Amiotte's use of the newspaper as a framing device for the collage, explains Berlo, "reminds the viewer that, despite the Indian deaths on December 29, 1890, the earlier [Battle] victory lives on in the memory of Lakota people."[30]

Oscar Howe similarly tackled this history with a painting in 1959 that shifted his subject matter from traditional cultural concerns to a confrontation with colonial issues. A direct descendant of Yanktonai chiefs who fought on both his mother's and father's sides of the family, the artist's strong familial connections to the events surrounding the Battle of the Little Big Horn and Wounded Knee moved him to paint *Massacre at Wounded Knee*. This disquieting and politically-charged work is now part of the collection of the Dwight D. Eisenhower Presidential Library & Museum in Abilene, Kansas. In it Howe graphically portrays on canvas the horrific event that occurred in December 1890 in ways that diverge from his typical style. Organized compositionally in horizontal bands of red, white, and blue, the painting reveals symbolically the bloody path of American imperialism by implicating the U.S. flag directly in the painting. The stratified representation of the battle site includes in the lowest band of red the gravesite filled with the writhing bodies of warriors mired in a pool of red blood. In the middle section of white, a troop of soldiers stand guard with guns pointed both downward to the grave and upward to the sky. The top band of blue serves as the sky and is pierced

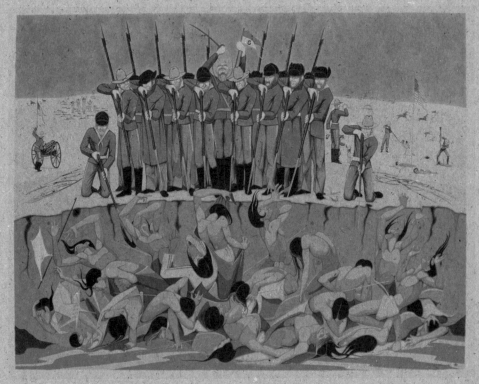

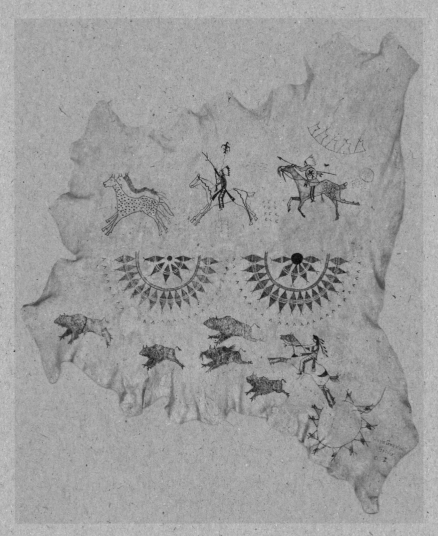

## Conclusion

While pausing to consider the work of Colleen Cutschall at the top of the stairs at the MacKenzie Art Gallery before visiting *The Sioux Project*, a second piece of art from the art gallery's permanent collection beckoned viewers. Wayne Goodwill's *Untitled*, a drawing of a hunting scene on hide from circa 1970, connects visual storytelling to artistic and cultural traditions.

A local Sisseton Dakota/Teton Sioux artist from Standing Buffalo First Nation in Saskatchewan, Goodwill utilizes hide, a medium that preceded ledger art, as a way to reconnect with Sioux men's artistic traditions. During a trip to Paris, France where he was invited to perform as a traditional powwow dancer at the then Museum of Man (Quai Branly) in 1969, Goodwill was shown the museum's impressive Plains art collection.[33] Until then Goodwill had not seen traditional men's art done on hide. Viewing the historic works held in the French collection inspired him to create his own hide paintings and to tell visual stories as his ancestors had done before him. Despite diverging from the work of Howe, Amiotte, Cutschall, and Claxton in that he uses an Indigenous medium, his art similarly promotes intergenerational knowledge transmission about land and relationships. Goodwill's presence in Claxton's video installation, in which he discusses his life and art, reminds audiences of the rich ways in which Sioux aesthetics have flourished in Saskatchewan.

only by the vertical lines of the bayonets and a lone American flag.[31] Situated in the centre of the composition, a military commander surrounded by his men lifts his head and raises his sabre to the heavens. The work is an unromantic account of the military's complete disregard for *Oceti Sakowin*. Howe's passionate articulation of this period in Sioux history shapes contemporary Sioux culture and art. *Wounded Knee*, like other works by the artist, represents a foundational contribution to contemporary Sioux art in its use of an artistic vocabulary that reinforces enduring aspects of Sioux aesthetics. Howe notes that "The straight and broken lines [in his paintings] derive from quill work and also from old Indian belief that a straight line symbolizes unrelenting truth or righteousness."[32]

The Battle of the Little Big Horn and the Massacre at Wounded Knee prompted each of these artists to look back and move forward, exercising both responsibility and a keen sense of individuality. The historic moments captured in these works of art not only uncover the past and bring attention to the present, but they also show respect and responsibility for all relations as a healing discourse that looks to the future.

Visual narratives in contemporary works promote, nurture, and maintain good relations while confronting and transforming ongoing colonial realities. Sioux art from the late twentieth and early twenty-first centuries epitomizes mobility, signifying continual movement of Sioux peoples on the land as well as active conceptual movement. Dynamism is key to healing nations. Anishinaabe literary theorist Gerald Vizenor advances the theoretical concept of "survivance" to inform contemporary Indigenous storytelling. He borrows from Sioux epistemology to help explain survivance, drawing on Dorothy Lee's text *Freedom and Culture* about the organization of Dakota culture. Vizenor uses this example to explicate Indigenous futurity,[34] suggesting that the concept of being related to and therefore responsible for all things, in combination with an acknowledgement of freedom of expression, is central to understanding future success for communities and individuals. "Original, communal responsibility, greater than the individual, greater than original sin, but not accountability, animates the practice and consciousness of survivance, a sense of presence, a responsible presence of natural reason and resistance to absence and victimry," states Vizenor.[35] Traditional teachings meld with stories

of the present and together reverberate as a form of cultural dynamism that shapes contemporary Sioux aesthetics.

Amiotte, Claxton, Cutschall, and Howe have over the past seventy years carved out significant Indigenous spaces in galleries and institutions by enacting and embodying fundamental aspects of Sioux aesthetics. Part of a vibrant community of Sioux art producers living and working on both sides of the Medicine Line, they continually inspire new generations to draw from the past in ways that serve as a platform for a strong Indigenous future. Subtle intimacies resonate across time and space in the shared aesthetic experience of Sioux art. *Mitakuye Oyasin* — everything is related.

—

1. See Luther Standing Bear, *Land of the Spotted Eagle* (1933; reprint, Lincoln: University of Nebraska Press, 1978).

2. Arthur Amiotte, *The Plains Indians: Artists of Earth and Sky*, ed. Gaylord Torrence (Paris: Skira Rizzoli, 2014), 39.

3. Ibid., 37.

4. Amiotte, "Foreword," in Janet Catherine Berlo, *Spirit Beings and Sun Dancers: Black Hawk's Vision of the Lakota World* (New York: George Braziller, Inc, 2000), x.

5. Berlo, *Spirit Beings*, 23.

6. I resist using the term "modern" in this discussion of Howe's work. The destructive force of the West's project of Modernity upon Indigenous cultures resides in such terminology. That said, Indigenous modernism remains a popular construction. See Bill Anthes, *Native Moderns: American Indian Painting, 1940–1960* (Durham: Duke University Press, 2006); and Peter Bolz and Viola König, *Native American Modernism: Art from North America*, exhibition catalogue (Berlin: Verlag, 2012).

7. Anthes, *Native Moderns*, 159–160.

8. Howe, quoted in Anthes, *Native Moderns*, 163.

9. Bernard Frazier, "Foreword," *American Indian Painting*, exhibition catalogue (Tulsa: Philbrook Art Center, 1947).

10. Stephanie Peters, "Creating to Compete: Juried Exhibitions of Native American Painting, 1946–1960" (master's thesis, Arizona State University, 2012), 45.

11. Oscar Howe, letter to Philbrook Indian Art Annuals Jurors, 1958, quoted in Edward K. Welch, *Distinctly Oscar Howe: Life, Art, Stories* (Phd diss., University of Arizona, ProQuest Dissertations Publishing, 2011), 121.

12. Peters, "Creating to Compete," 49.

13. Amiotte also attended graduate school at the University of Oklahoma, based on a recommendation from Howe. Amiotte, "Artist Statement," *Transformation and Continuity in Lakota Culture: The Collages of Arthur Amiotte, 1988–2014* (Pierre, SD: South Dakota State Historical Society Press, 2014), 34.

14. Colleen Cutschall, conversation with the author, 9 April 2018.

15. Amiotte, *Transformation*, 34.

16. Ibid., 41.

17. Joseph M. Marshall III, *The Lakota Way: Stories and Lessons for Living* (New York: Penguin, 2001), xiv.

18. Cutschall, conversation with the author.

19. Richard Pearce, *Women and Ledger Art: Four Contemporary Native American Artists* (Tucson: University of Arizona Press, 2013), 78.

20. Janet Berlo, "Giving Voice to the Ancestors Through Art: Hybridity, Memory, and Imagination in Arthur Amiotte's Collage Series," in Amiotte, *Transformation*, 64.

21. Philip J. Deloria, *Indians in Unexpected Places* (Lawrence: University Press of Kansas, 2004), 136.

22. Black Elk, quoted in N. Scott Momaday, *The Man Made of Words: Essays, Stories, Passages* (New York: St. Martin's Press, 1997), 100.

23. A 2018 traveling exhibition, *Takuwe (Why)*, focusing on art about the Massacre at Wounded Knee by thirty Sioux artists from five of the seven Lakota nations, including Dana Claxton and Arthur Amiotte, demonstrates the enduring power of such events. The exhibition took place from March to October at the Heritage Centre, Red Cloud Indian School, Pine Ridge, South Dakota; Akta Lakota Museum and Cultural Center, St. Joseph's Indian School, Chamberlain, South Dakota; and South Dakota Art Museum, Brookings, South Dakota.

24. Lisa Myers,(2014) reprinted in Miranda J. Brady and John M. H. Kelly, *We Interrupt This Program: Indigenous Media Tactics in Canadian Culture* (Vancouver: UBC Press, 2017), 105.

25. Dana Claxton, dir., *Hunkpapa Woman in Black*, 4-minute film, Hunkpapa Films, Vancouver, 2018.

26. Pearce, *Ledger Art*, 82.

27. Ibid., 85.

28. Janet Berlo, "Wounded Knee #III," *The Plains Indians: Artists of Earth and Sky*, ed. Gaylord Torrence (London: Skira, 2015), 132.

29. Ibid.

30. Ibid.

31. The compositional structure of the painting may have been influenced by a photograph taken at a few days later at the scene by George Trager. See Michael Zimny, "Oscar Howe's Wounded Knee Massacre, a Rarely Seen Masterpiece," South Dakota Public Broadcasting, 13 May 2015, http://www.sdpb.org/blogs/arts-and-culture/oscar-howes-wounded-knee-massacre-a-rarely-seen-masterpiece/. Accessed 22 October 2018.

32. Oscar Howe, quoted in Robert Pennington, *Oscar Howe: Artist of the Sioux* (Sioux Falls, SD: Dakota Territory Centennial Commission, 1961), 36.

33. Interview with Wayne Goodwill, *ArtSask*, "Wayne Goodwill: Artist Profile," http://www.artsask.ca/en/artists/waynegoodwill. Accessed 10 June 2018.

34. Gerald Vizenor, ed., *Survivance: Narratives of Native Presence* (Lincoln: University of Nebraska Press, 2008), 18–19.

35. Vizenor cites cultural anthropologist Dorothy D. Lee's examples of Dakota culture from *Freedom and Culture* (Englewood Cliffs, NJ: Prentice-Hall, 1959). Vizenor, *Survivance*, 18–19.

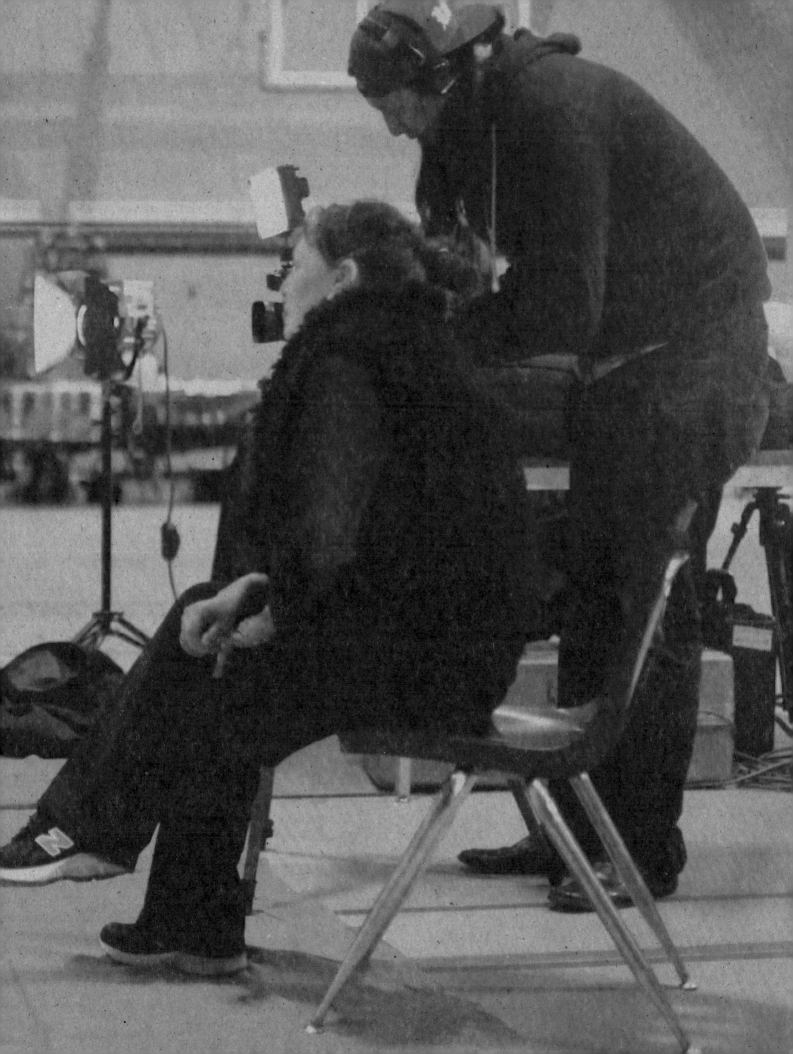

# Excerpts from Video Interviews

**Barbara Ryder**
**Standing Buffalo Dakota First Nation**

We used to hear all that from the hill. And then somebody else would start like that, you know, the Elders, and on top of the hill over here, too, was another old couple. She used to sing, her and her husband. And they had sharp voices that you're singing for the sun coming up, praising, praising, you know, for a new day, and that was really wonderful.

I said, "One of these days I'm gonna go on the hill here and I know some songs that they used to sing, one anyway." And he said (my son), "Your dogs will get scared of you!" [*laughs*]

I am sorry that I missed lots of years in between after I came out of residential school, and I lost easily about forty years. A big blank.

It makes you feel good knowing that your ancestors were great, in those days, and how great they were, and it makes you feel like you're part of that. And that's how I feel when I read something about South Dakota or something. It makes me feel like I'm there and it's a really happy feeling to be a Dakota Indian.

**Joely BigEagle-Kequahtooway**
**Ocean Man First Nation**

My grandmothers have been my mentors and they would make star blankets and patchwork quilting, and I just always wanted to learn how to do that.... My mother was a part of the Unity Ride that was happening down in the States and part of it in Canada where they go horseback riding for like sixty miles a day and they do it for a month. She asked me to allow my daughter to be a part of it and at that time I think my daughter was five when she started. And it was a five year commitment to go for like almost a six-week period in the summer.

It was kind of the beginning of understanding our culture with Orville Looking Horse and the Lakota people down at Green Grass. A lot of people that I know that were learning their culture, they were going to Green Grass to gather that knowledge and to attend ceremonies.

*Tatanka* is a big influence, the Buffalo. Building this rainbow buffalo design is part of that—combining the prayers that are put into each of those colours in those ribbons, combined with kind of the blood memory of the importance of buffalo to our culture, and gathering strength from that buffalo, because buffalo were our sustenance, they were our food, our shelter, our clothing, they were everything to us. And to have them ripped out of our culture, I know that there's a lot of hurt there.

**Debra Maxton**
**Whitecap Dakota First Nation**

I've been dancing since I was five years old. It was just something that I always wanted to do, and even so to this day I dance, I dance women's fancy, and I loved dancing. My children dance, my daughter dances, my son dances. It's just something that I have a passion for. And sometimes when I'm dancing, I get those happy tears. I don't know if you've ever seen somebody get those happy tears, but when you're dancing and you really feel the song, and you get tears, and you're like so proud, it's an awesome feeling.

Being a powwow dancer too, you gain respect. You gain respect for your surroundings, for the people you meet. You have respect for people, their belongings. You have to have patience when you're making regalia. You can't have any negative thoughts when you're making your regalia. And, well, it doesn't take me that long anymore. Before I got a sewing machine, it used to take me days, but now that I have a sewing machine it only takes me a couple days. When I make my regalia, my daughter sits in with me.

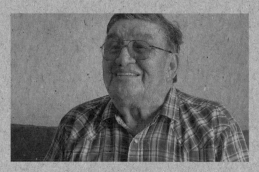

**Wayne Goodwill**
**Standing Buffalo Dakota First Nation**

Gives Away the War Bonnet, that's my First Nation name. The Dakotas here have two designs. The Santee do the floral design of beadwork, and I remember my grandma and them, they did beautiful pipe bags and all that in floral designs. And the Sioux claim they never use black, and other tribes like black, but we didn't use them 'til the later on…you know, cultures change a little bit. The Tetons from Wood Mountain mixed into the tribe here. We're using geometric, so the geometric was coming in more modern than Santee flowers. So that's how they were introduced here and the moccasins changed from Santee to Tetons geometric design moccasins. And my grandmas, sisters and all them still do the geometric moccasins.

There's a little story about the geometric. One time a young man wanted to marry the chief's daughter, but he said, "You have to get me something that I never seen." So he went out hunting and couldn't find anything. So one morning he was laying down, and it was a nice morning, a spring morning like this, and there was a lot of dew on the ground. And he just happened to look at the sunrise, and he said there was a dewdrop just about ready to drop from the leaf. So he happened to look through that dewdrop, to the sun, and he seen a geometric design. So he came back and he said, "I seen something that we don't have here and you never seen." And then he drew the geometric design on a hide, and he said, "This is what I seen." So the chief said, "Yeah, I guess you can have my daughter. That's what I wanted to see, so we're gonna use this from now on." So that's how it was introduced.

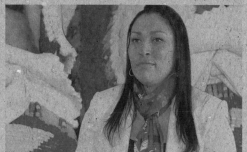

**Paulete Poitras**
**Muscowpetung Saulteaux Nation**

I didn't start calling it artwork for like a really long time. I hung out with a majority of artists and I didn't feel like I qualified. I just did work for whoever asked and it was something that I did for myself to begin with. Nobody taught me how to bead or sew or do anything, and it was just something I picked up because for thirteen years I stopped dancing. And then I wanted to pick it up again, and my grandfather passed away, and I did a wiping of tears ceremony and a giveaway.

He was my biggest inspiration to want to get back into dancing again, because he used to come to the powwow, sit there and watch me and my sisters. We were young girls dancing powwow. He was always so proud of us. And he would always tell us, "You know, you're Dakota. You walk that way. That's how you walk when you're out there. That's how you dance. You dance from your heart." He would always tell me, his saying to me was "*chante was'te*" meaning "you got a good (*was'te*) heart (*chante*)." Anything you do with a good heart always has good intentions, you'll always do well.

I would dream of beadwork and I'd look at it in my dreams, being able to see it, and then being able to make it. And that's the spiritual element of being able to create anything for myself or anyone else around me, is that I would always ask for *chindi*, which is tobacco, from the person. And I would ask that in exchange, because there's gonna be that spiritual exchange of information from their spirit to mine, and the majority of that would come through dreams.

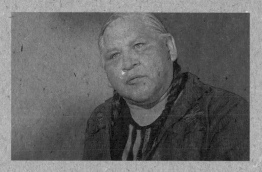

**Calvin McArthur**
**Pheasant Rump Nakota First Nation**

The Ocean Man people are Nakota Assiniboine. And mine are a mix of both Dakota and Nakota. White Bear First Nation is Dakota, Nakota, Cree, Saulteaux. You got the Wood Mountain people of the Lakota, I believe those are the Teton, the Wahpeton people known as well as Mdewakanton, the Wapahaska, I believe, were also Wahpeton and Mdewakanton, I could be wrong though, and Standing Buffalo is also those ones as well as some Ihanktonwan in there. We have been in this area since the beginning of time. This is our traditional territory of the entire Oceti Sakowin. To the outside people, we were known as the Tatanka Oyate. The women would say, Oyate, the Buffalo Nation. So that is a good title for your project, the Buffalo Nation people, that is who we are. That encompasses all of them, all dialects. Our territory is said to have run as far north as the Churchill River, as far east as the Lake of the Woods in Ontario, as far west as the Iyahe, the Rocky Mountains, and as far south as Nebraska. That is our traditional territory. Our traditional territory predates colonialization, it predates all the treaties. We are aware of the original treaty between the Buffalo and the Rabbit Nations. We are the Buffalo Nation.

The descendants, the Wapahaska, Wahpeton, Standing Buffalo, Wood Mountain, those people are all descendants of the Battle of the Little Big Horn, of the actual warriors who fought in that battle. They were not hang-around-the-fort Indians as referred to in the States, but they were actual descendants of them. And to preserve their own life, they came to what was another part of their original territory. A lot of people believe that the Dakota are refugees. We are not refugees. This is their home. And they came back to claim part of their home.

By bringing the language back, by following the traditions, by living the seven sacred laws, by following the seven sacred rites, we can survive. It's gonna be a hard road, but we can do it.

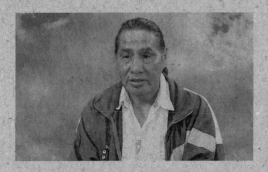

**Derek Whiteman**
**Standing Buffalo Dakota First Nation**

My dad was a singer for the old Standing Buffalo Singers and I've always had a dream to sing with him. But he passed away when I was five years old, so I'm trying to get my children to start singing to keep the tradition alive. But my oldest boy is kinda shy yet, but my youngest boy, he sings round dance. He stays out in Kawacatoose with his mother. The drum makes me feel so good, the power it has. Each time I sing a song, that feeling, there's so much positive you feel from it. I just enjoy singing for the people.

I also sing inside the sweat lodge, too. I love singing for the people. My late adopted uncle, he taught us to respect the drum, how to respect it, and he said that drum will take you all over the place. And it did. I'm just amazed at the power it has, singing with it. There's so much power in that drum. I just love it. I'll probably sing right 'til I pass on. I love singing for the people. It makes me feel good. I went to a ceremony once and that grandfather buffalo spirit told me never to give up singing, and never give up singing inside the sweat lodge, too, he told me. Us on this side, he said, we hear you. We know that help you need, so don't ever give up singing. So when I went to that ceremony and that grandfather buffalo spirit talked to me, it even made me want to sing more, because I know those ones out there are listening.

I was told that when that animal gives up his hide, his body, and we make that drum, you get it blessed, so nothing bad comes when you're singing, and that's what I've been told. I've even seen drums coming to a sweat lodge, before they take it out on the powwow trail, bring that drum into the sweat lodge, and pray for it.

**Gwenda Yuzicappi**
**Standing Buffalo Dakota First Nation**

My name is Tatanka Hota Wi which means Great Buffalo Woman, so I'm with the Tatanka Oyate. For me, living, waking every day and being a part of what the Creator has planned for each one of us and for myself, every day's a blessing. And every morning, every time that I say a prayer, I always walk. They always tell me when you walk, walk in prayer. And make sure that when you're having a hard day, take your shoes off and walk in that dirt, and that will give you a balance — a balance of who you are as a person, balance in your thoughts, your mind, your body, and your soul. So for me, I am very proud. I practice a lot of my culture.

I don't know if you know, but my daughter went missing. And within those two years and ten months of not knowing where my daughter was, I had the buffalos, the deer, the *tahcas,* the eagles, the hawks, all the dogs — all these animals were coming to me and being a part of my daughter's life. And when they found a little of my daughter's remains, there was this buffalo that came right up behind my house and he stood there. And when I came out and I offered that tobacco to the Buffalo Nation, so when I seen that buffalo I took my tobacco and I went as close as I could and thanked that buffalo for whatever strength, message they were bringing to me. I spoke to my helpers and he told me they're coming to bring you strength, there's something coming. That night, the police had contacted my family and told my family that twenty-four percent of my daughter's remains were located, and that was amazing to have that buffalo come and give me that strength so I was able to be strong enough to accept that information. Two weeks later, the police were still searching for the rest of my daughter's remains and three buffalo came. Once again I did my offering, said my prayers, and called a helper, and he said, "They're coming. They're preparing you for a message." And then what they were looking for in my daughter's remains, they found, and I was so happy that the buffalo were right there. They were my helpers. They're my everything.

**Willis Royal**
**Whitecap Dakota First Nation**

To me being a Dakota is that we had — them war years made us that way, I guess — we had to fight back in order to keep our land. And most of the time we get raided on. All the community, where it's mostly kids and grandmothers and babies and all that, the United States cavalry used to just come riding through, holding down teepees and whoever was in there. They just shoot 'em all, I guess. And that's where they dug that big massive grave where they threw all the bodies in there. And after that, well, most of the time they were attacked anyway and so they had to just get out of there. But before that happened, General Custer decided to go out there and he told his commanding officer that he was gonna go out there and get them savages, meaning us, I guess. So he went out, but he never returned. At that time, they knew already that they were coming, so I guess they sent all the women and young ones out with a few of the braves taking them north, before this happened...just the men left. So there were around us...and they approached them into that camp, but they couldn't find anybody there. So, anyway, I guess they turned around and were gonna leave, but then here the braves came over the hill. That's where they got surrounded. General Custer got shot right there, including all his men. But there's only one person left to tell a tale. He could be wounded, or just rode out on horseback, or he walked, I don't know. He got back to his post, told his commanding officer what happened, so I guess that was after this happened. You don't doubt it. You see nothing but all blue ground — that was the colour of their uniform. The ground was all covered in blue.

So them days they used to have maybe assembly of making a whole bunch of them because they're all, lots of these young people, young boys maybe, were into it too. And you got to keep the arrowheads going, because if they get into a war with the white men, you need all the bows and arrows, and then maybe spears. Again, you need that arrowhead in there. Clubs, that's what they used, so then that was passed down. That's how we started making them.

**Pasapa Family (Doreen Pasapa, Denise Lonechild, Tawachiyana Lonechild-Pasapa) White Bear First Nations**

*Doreen:* I guess at one time I only recognized the Nakota part because of my dad. And I grew up with my dad, so I learnt more about the Nakota than the other parts that I have. I don't know if there's any full blood Nakota anymore, but to me that was always the tribe that I identified with — just in my being raised and taught the philosophies of the Nakota people, in my blood. I went on the Unity Ride about probably over ten years. And I learnt a great deal with the songs and the ceremonies and history, and I guess feeling related to all the, not just the word, but feeling that I was related to a lot of the people that were initiating the Unity Ride. And the purpose of it was to get to know our relatives, to get to know other tribes. It was successful — taking the children on the rides, too — to recognize lots of the things that we lived with in our history, like the generosity and the spirituality of the events that happened when we were on the Unity Ride.

*Denise:* The horses and the teaching, yes, exactly, the relationship with the animals and the land, that was a huge. Oh, there were so many beautiful memories. Waking up and having the whole camp taking care of one another, that's something you just think is too old to ever come back, but during that experience it was very much alive.

*Doreen:* I was praying that I was gonna be able to get to where I wanted to go, to the medicine wheel. And I did, just like my lungs opened up and I made it up to the medicine wheel. And we wanted to have a ceremony up there and we did. It was probably at least fifty people that made it up there — the riders and the walkers and all of them. And we had a ceremony and everything, just when the sun rose. They just aligned perfectly, you know, with how the rocks are put out.

For three months we lived outside. We stayed in the snow and the kids stayed in the tent in the snow. And we were through wind storms and tornadoes, and all of these things, all the things of nature, and then to learn to respect all of those things.

*Tawachiyana:* Being outside in nature is like a teaching, to learn like the earth. Sometimes I've been outside just listening to the sounds of the trees and hearing the wind blowing. All I know is that I'm a spiritual being on this earth — walking, learning different things. Like learning about the animals or how the earth is growing, or listening to different kind of sounds.

*Doreen:* He's our fireman at home.

*Tawachiyana:* I'm really close to fire 'cause I know it's a spirit to look after. So it's like a bond type thing. When you start fire it's like you're bonding to it ... your spirit is getting locked onto the fire. It's telling you things, what it wants — like putting wood on it, like feeding it.

*Doreen:* I was a single parent, so I also had to learn the things that a man usually teaches. But my dad taught me and my brothers, and so it was with the hunting in the bush and 'cause we live in a real forest area. And it was learning those things and how to be respectful before the hunt, you know, smudging and asking, just not going out and killing anything and for fun, and teaching them it's just like a ceremony in itself, going for the food. And so my sons also learnt.... One doesn't hunt bird, and he has his reasons why he doesn't hunt birds. And they still trap, my son still traps and hunts in the winter. And then he [my brother] helped him out this spring, he went and checked his traps. I asked my brother after my dad was gone — I told my brothers, my older brother, that it was their responsibility to also help me to teach my boys.

*Denise:* Her first successful hunt was a moose, when she was, I think she was twelve years.... She started when she was about eight or nine.

*Doreen:* Trapping beavers, weasels, muskrats ...

*Tawachiyana:* Otters.

*Doreen:* ... otters, coyotes. Yeah. Depends on what for, you know.

I work in addictions in our community, and one of the things that I felt, like from the people I work with — so many of them have such dynamic histories, in their lives, in their beauty, in the way I see, but lots of times they don't see it. We started Sacred Art Hill Writing Group in our community and now we have all of the writings.

*Denise:* You know, that's how when I understood that I knew that we hadn't lost anything, it's just a matter of just relocating, resurfacing what we already know. And then, when it comes to our spiritual memory, we have ties, we have ancestral ties, that will bring and strengthen us to understand who we are as Nakota people. And those teachings are always with us. It's just a matter — there's a lot of distractions, society provides a lot of distractions. And it can be also an illusion that we are a lost people, but we're not.

**Allison Whiteman Standing Buffalo Dakota First Nation**

I drew it from an old photograph that my dad had, so it was always around. And I grew up — we have a portrait that Sanford Fisher had painted of him in oil, in my house, so he was like kinda always this essence in life of our growing up. That's really all I knew about being Sioux. So this is definitely an experience-and-a-half here right now. A few more of him from images that I found, like this image is in the archives here in Saskatchewan, but my dad also had a copy, colour, so this one kinda got damaged on the bottom. After I drew them, I guess some pretty neat stories started coming out, and I started learning more about him. And like, this woman, this woman in this picture was, my dad, they told me that was one of his women. I think it was his third wife or something maybe [*laughs*] — you know how Sioux guys [*laughs*] — but uh, no, a cool story that came out. 'Cause when I was drawing and I had a tough time with this one, and I never really seemed like I could finish her — I didn't, I didn't even know her name, I still don't — and it's like, I couldn't finish her, but a story that I heard about her after was that there was a house fire and she passed away in that fire. And like, I couldn't get her with the charcoal, so eventually I just kinda stopped.

I grew up away and I'm not from Standing Buffalo. I don't really know my family too well. Starting now, it's pretty neat, and then I drew another picture of — my dad always had a photo of this, his uncle, Joe Peters, Whiteman. His name's on the Standing Buffalo Veterans' memorial. He was killed in Vimy Ridge, and he was his son, too. So you know my background. So I just thought that I'd come by and show my portraits of these Sioux people with you today.

**Kristen Buffalo**
**Whitecap Dakota First Nation**

I am an aspiring photographer. Usually when I take photos I walk around our lands and this is just something that I found interesting, a little ladybug on a berry. I thought this one was funny because it's of my boyfriend. He's Cree. He's on a motorcycle, or a dirt bike, and my dad's in a jeep behind him. He's kind of blurred out but you can see him and he's a Cree man and it's your typical rivalry between the two.

This one, this is of my sister. She had modelling jobs here and there, and I was like, hey, I'm a photographer, can you be my subject? And she was my favourite subject to photograph because she took direction really well and she's just really easy to take photos of. And I don't know why she doesn't do it anymore 'cause she's really good at it. She's really natural. She's really beautiful. I'm really proud of this photo shoot. This is my first pregnancy photo shoot I've ever done. I really like this one just because of the moccasins and her bracelets are beaded. It looks kind of traditional, I guess, 'cause that's not too often that you see these types of maternity photos with little moccasins on a belly. [*laughs*]

Well at first I didn't realize I wanted to be a photographer. It just kind of hit me one day. I was kind of struggling in life. And I was like, Why not photography? I put myself into a photography program and now I'm in a business program as a foundation to eventually set up my own studio. And I feel like photography is kind of a healing thing for me.

**Nathaniel Deegan**
**Standing Buffalo Dakota First Nation**

I first started when I was fourteen. I got taught by a man named Tim Wide Eyes. I started early. I wanted to really know like how to do it. I heard about it and I really wanted to learn. And this guy came with me and asked me if I wanted to learn. I was like, yeah, I'm in. So the first thing I started was a quilled strip.

I make scalp locks and I make medallions. I make medicine wheels, strips…panels, pipe bag panels. I feel very creative when I do quillwork. I have to have an open mind to do it. I can't be negative and work on stuff—just have to have a good mindset and patience to do stuff like that.

Takes about a half hour to pluck a porcupine. They're covered in quills, their whole back, their tail, everywhere.

I love doing it 'cause it puts me in a good place, a good mood. Sometimes I don't get motivated, but some days I feel like I really want to quill and it's a really good feeling.

You wrap it, it's just like, like knots, kinda. You have to fold the quill and put the quill in there. It's like making sevens, a bunch of sevens over and over, like little sevens.

It's the first art form of Native people, like before they had beads. It's pretty traditional. Yeah, it's before beads, 'cause Europeans brought beads, and we had quillwork before, so yeah, it's pretty, pretty way back there. [*laughs*] I don't know where it came from. [*laughs*] I like that, yeah, it's old school style. It's a good teaching, a good knowledge to have, too, for your grandkids to know. And it's really traditional, I think, yeah, spiritual. I think it's spiritual. Good knowledge.

**Dorothy Joyea (nee Yuzicappi)**
**White Bear First Nations**

This is the moss bag—our baby goes in there—and the moccasins and the star quilt. So I have projects that are running to teach the young mothers how to make them themselves rather than just go out and buy them, eh. The reason why I started in this area of work was I've worked with the tribal council for many years, and within that time I've seen a lot of young mothers and their children, whether they were in care or not, but I knew that with the teachings of the star quilt, it would help. It would benefit them in their life's daily living. I've always known how to make moccasins. I guess we were taught when we were younger how to make moccasins. I, and—but the star quilt is what really intrigued me into wanting to pass on what I know about the star quilt, eh.

I don't know if it was a dream or not, but this lady came to my home, sitting there. And she was talking, and I was way at the back and made my way to the front. And she was pointing to each diamond, like that, and I couldn't hear her so I went closer, and she was saying look at them, they're all different colours, and she had a multicoloured star quilt. She said they're multicolours, but they're all the same. And you put 'em all together and they make one big star. Our four nations, we're all different colours, but yet we're all one, okay. I make the large blankets as well, but I really got interested in that after I seen that lady. In order for me to continue making these, I would have to understand a little bit more about why people cherish so much the star itself, eh. I liked what I found, about our beliefs towards the star itself and the star people, star nation. And then I liked the idea of the lady telling me that because we're all one, we should treat one another as we ourselves want to be treated, okay.

**Nora Joyea**
**Whitecap Dakota First Nation**

So this was the very first beadwork I made, for my oldest. She's fourteen now. This was for the first time she danced at Standing Buffalo powwow. There's actually a reason behind the beadwork. Her Indian name that she was given was Blue Butterfly woman, so hence the reason why there's the blue butterfly and the other one is just pink and flowers, just because it's very girly. I have three other children, two girls and one boy, so all my other daughters have each worn these.

I'm a busy mom of four. I work, I go to school full time, I'm just busy. So a lot of my kids' powwow outfits have been made by my mother-in-law. She's actually the one that kinda got me started into doing all the beadwork in the first place. She herself dances powwow. Her daughter, so my sister-in-law, dances powwow, and my daughter. My son, he hasn't gotten the powwow bug yet, so hopefully soon, maybe he'll start dancing or singing or something.

I like watching my kids dance. Every time I watch my daughter dance it's just kinda hard to describe. It's…there's pride too, but it's more or less like a happy feeling, your heart is happy.

The powwow…it's a place for people to come together, meet new people, make new friends, just display your own culture. I guess maybe because powwow's been kind of a big part of my own life, we used to always go powwowing every summer, like every weekend we were gone. My dad was a powwow singer, so like I said we were gone every weekend and I enjoyed it. So I want my kids to grow up knowing what the powwow is about.

**Melinda Goodwill**
**Standing Buffalo Dakota First Nation**

I'm a jingle dress dancer. I started dancing in 2001, four years after I lost my mother. Jingle dress dancing is a healing dance and it is the original style of dance. And I know the contemporary dance was out there and everything, but I wanted to bring back the old style. So I decided to get started with the old style of dancing and that's what I did. And so that's why there's such a difference in the styles of my dresses, 'cause I started with the old style, and sometimes I have to compete with the contemporary.

I started doing the old style original dances for healing. So any time that we get out on the dance floor, I think we can say for almost all dancers, is that's what dancing is all about. We feel good about ourselves, visiting with family friends, making new family friends, just putting whatever it is aside and just out there dancing. I've been asked a number of times to take part in the actual healing dance itself. There's a special dance, a sidestep dance, that we are asked to pray for an individual person.

I've been asked to lead those dances a few times, and it's such an honour, because that's what the dance is originally about. That's what it's for.

I was always being taught about respect, respect in what we wear. A woman is to always be covered, covered from head to toe, not showing any part, and that's what I do with my dresses. That's why my dresses seem quite long. I know the contemporary jingle dancers wear them quite a bit shorter, so when they're dancing and turning and stuff you could see their legs, but I know my mother's always taught us never to wear our dresses like that. We're supposed to respect ourselves as well as the elderly and other people out there.

**Aisha O'Watch**
**Carry The Kettle Nakoda Nation**

I'm finishing my grade twelve right now and I really enjoy having a school on our reserve because I know in white schools you don't learn. Like if you take a Native studies class and history in white schools, like our small town Indian Head nearby, they don't learn any Native history. In our school I enjoy learning our Native perspectives and our Native worldviews — learning right from my reserve, 'cause I know that didn't happen like twenty years ago, ten years ago, and having our First Nation teachers too. I'm happy to say that I graduated from my reserve. I applied to go to the First Nations University of Canada and get my Bachelor's of Science and go on to medical school and maybe one time, one day, find a cure to diabetes that really affects our people.

I'm a mixed because my grandma's a full-blooded white woman, so that me being more light-skinned was different from my darker friends. My grandpa being a traditional man, I was took to a lot of ceremonies growing up, but I started to focus growing up more on my academics and trying to take that strain off that was put on us by the white man. My grandfather taught me a lot of values and morals, respect being one of them, because I see a lot of youth don't have respect. Like a lot of us are affected by gangs and I think that a lot of people aren't taught things because of the system. Growing up, my grandpa would sit there and he would talk to us and tell us things and say, like my mom told us, and my grandma told us, my grandma taught us, so he would teach us to be respectful and you respect your Elders. I'm very proud to be a First Nations person, especially being a Nakota woman.

I just hope that in my future that eventually one day we will have a hospital on our reserves for our people, or an old folks' home. We're actually in the making of an old folks' home on our reserve, because all our Elders go to the surrounding towns. So I hope that one day we have all the resources right on the reserve so that we wouldn't have to leave and go out. And I know that the Elders would appreciate it probably.

**Angelo Wasteste**
**Sioux Valley Dakota Nation**

We started a drum group back in 1987 called Elk Whistle Singers. I was just thirteen. It was about the time my uncles asked me to start to train and they taught me how to sing back then. One of the biggest things was keeping me out of trouble, for sure, I mean giving me a focus. And certainly now that I'm in my mid-forties, passing it on to my children—I got grandchildren now—realizing what I was being taught was for a purpose and I was gonna have my turn to pass that on someday. So I'm glad I paid attention and hopefully I can, not only my own children, my own grandchildren, but for the past twenty years I've been working with youth, at-risk youth in particular, so it's served me well. And I try to teach them, you know, as a First Nations person, that's your right, that's something the Creator gave to our people. Everything we do, there's drum, there's song, and we don't even call it song, we call it prayer. I know every continent almost, the drum is integral to their culture. And we believe that that's what attracts the spirits to when we're trying to do ceremony and when we're trying to say prayer. The beat of the drum alone will attract the positive spirits that we're trying to pray to. So that's a very central belief that we have.

So the drum, sing the song, pray the words, and then that's how the spirit nation that we pray to acknowledges our prayers, along with offerings of tobacco, coloured print, food, and things like that. So it's all part of a system that we use to depend on the spirit nation for our health and guidance.

**Connie Wajunta**
**Standing Buffalo Dakota First Nation**

Because I was raised this way, it's something very common that I had. And I look at myself and see that I'm in good health. I was raised with dry foods. I wasn't raised with over-the-counter food, fast foods. When I do teach, I explain to them what I was told growing up. You need to take care of this food. It's sacred. And you only plant from north to south. So when I start, I start going north to south, come back, north to south, and north to south, 'cause that's what they said they had to do. So I do that. I offer my tobacco when I'm first gonna plant, because I was told that you have to pray. And so I put my tobacco down, then I start north to south, and I usually do fourteen rows. My grandfather used to always say it's twelve months and remember there's two moons, so he said there's fourteen. It's for me very emotional. I'm thinking about the old people—how did they know?

I think it's something that we have to have. It's been brought to us. I always say, they talk about the three sisters...there's corn, squash, and turnip, eh, so those are the three sisters that are part of our First Nation people. We've had youth camps....We did step-by-step and everything, and nobody took interest in it. So I said, Well, I'll keep on doing what I learned. So just my daughter-in-law has just learned how to make the corn now, so I'm thankful somebody's learning. But when they all say, Well, why don't you make corn soup?

**Angela Buffalo**
**Whitecap Dakota First Nation**

Some of my beadwork that I have done for my daughter and some regalia that I have made for my daughter and my two nieces. I like beading because it's relaxing and it helps me to de-stress, I guess. And I just like to make stuff for my daughter and my nieces so they could dance. And they like dancing powwow, so I want to keep them dancing. I guess powwow culture, when someone's dancing, they like the feeling of dancing.

I danced when I was a child. It felt really good. It made me feel good and proud inside that I was First Nations. Now I just like watching and I like to make regalia for my daughter and my nieces to keep dancing. Well I think that them dancing, it just brings them pride for themselves and for their culture and to represent the culture of dancing powwow. When I choose the colours it usually comes to me after I go to sleep. I wake up and then I kind of think and have an idea of what I want to make and the colours to put together. The designs, that usually comes to me when I'm sleeping. I wake up and I just have an idea in my head. And I just draw it out, just so I don't forget it. I guess I'm just trying to keep culture in my family alive. And well, my daughter dances fancy, so I made her her stuff with the help of others, like to do the fill-in, but for the design and stuff, I did that. And I started about six years ago. And then I really just started to learn how to sew things together better and make more designs. I kinda just taught myself, but I did learn some of the stuff from my mom.

**Nadine Deegan**
**Standing Buffalo Dakota First Nation**

I also do dentalium and I do a variety of beading and I do quillwork, also sewing. I started beading when I was about twelve, when my mom worked and we wanted stuff for our outfits. So we just started making little things and from there just kept on beading. And so I just learnt by watching her. And then throughout the years I just learnt different skills, how to do different things, meeting, travelling, meeting people and just learn. They pass on their knowledge to us too.

The dentalium, this is a cape and some hair ties that I wear, and then some earrings. It's something that the Dakota, the Sioux people, used to wear — the ladies wear them from here. And long time ago they, the chief's family had them, the daughters, the wives, and they show how well off they were, 'cause they had the means to trade. 'Cause they come from the West Coast, and they're shells, and so they get traded, and they would come all the way over here to the Dakota, the Sioux territory.

And then when you bead, you're putting your mind, your soul, like, into what you're making. So that's where it just takes you away, you're putting so much of your energy into what you're making. Some stuff takes a lot of time, so you put a lot of yourself into it. [laughs] I like to show the younger ones how to quill, how to bead. They could really get experienced, get really creative with it, and they could be self-sufficient. And also by them making their own regalia, the powwow is also a big part of our cultural identity.

It [the dentalium cape] is pretty heavy. It's hot, 'cause we dance out summertime, so it's pretty, pretty hot. So it takes a lot of getting used to. Then we have the hair ties that we wear up here, up on our braids, so everything's just pretty heavy. But once you have it on you feel so beautiful. [laughs] Yeah, you just feel, it's just a total different feeling when you have your outfit on.

**Jason Wasteste**
**Standing Buffalo Dakota First Nation**

My drum group is Elk Whistle. It was formed back in 1987 by my late father Gordon Wasteste. Everything in our culture we do for ceremonies. We use the drum and there are certain songs for it. So us singers, we have to know these songs and we have to know our language, so that we know these songs and what they mean, because those songs are prayers. They're speaking to our relatives above us. And so we travel around and there's lots of drum groups around North America. And there's many powwows and many celebrations, so we try and hit the ones that need the drums, I guess, because without the drums a lot of our celebrations couldn't happen.

Each drum group usually composes their own songs. So my older brothers usually make a lot of our songs for us, and me and my little brother, sometimes we have some, one or two songs. Some of the local boys from Standing Buffalo, they have lots of songs. But I'd have to say ceremonial songs are the songs that I like the most. There's powwow songs and then there's songs for ceremony, celebration, and for healing. The healing songs all seem to make me have a better feeling when we're done, or when I'm done hearing those songs. So I'd say the ceremonial songs are for me.

Certain Elders or warriors, they would compose songs. They'd make songs and they'd talk about their journey, their battle, or what they have done. And they'll make a tune with the words describing what they went through. I got to see a lot because of that drum, so I'm very thankful for that drum being in my life. And I encourage any other young men, young women, to sing, to learn to sing. And I promise you it'll sure make you feel better and it's like a personal healing. So it's a really good feeling and I'm so glad I got into it. All my kids are already singing with us.

**Sharon E. Yuzicapi**
**Standing Buffalo Dakota First Nation**

Well I usually do it when someone requests one. They buy the material and sometimes they buy the fringe, or I buy the fringe on my own, and depending on what colours they want. Like I've started doing it for about ten years now, for family mostly, 'cause my niece over there has a daughter and I started making shawls for her. And then there's other people that come and request what colours they want or what colour of material they want. So I just do whatever the request is.

Some of them use them for ceremonial purposes, like for the Sun Dance. So for the girls, usually they have to have a white one with white fringes, or for other people it depends on what colours they want. Like they can have their material different colours with different colour fringes like these ones. Like for the Sun Dance they usually just put them around the waist like, and not on the shoulders. But if they're for traditional dancers, they usually carry them on their arm at the powwow. Depending on what they want it for, I'll do different things, for Sun Dance or powwow, and whatever colour they want, and whatever colour of fringes they want.

I feel good making shawls. I enjoy doing it. This is how I was taught how to do it, is to cut fringe by fringe by fringe, and then put them on. So that's how I do it.

My late mother, she was into beading and Siwash sweater-making, and all these different things she did. Like she did a lot of beadwork and stuff. So I don't know, I get a satisfaction out of doing it for family and other people, depending on what they want. So it makes me feel good, doing them. Well it's kind of hard to get the fringe around here, so the dollar store in town, I took one spool like this and I showed it to them, and I said it would be easier if they could get it in. So she started bringing the fringe. So now we just have to go to Fort Qu'Appelle to go and get it, which is about eight kilometres into town. So it's easier now to get them.

**Noreen Deegan**
**Standing Buffalo Dakota First Nation**

**Whitney Yuzicappi**
**Standing Buffalo Dakota First Nation**

**Shana Pasapa**
**White Bear First Nations**

I've been beading and sewing for about thirty-seven years now. I started out way back in about 1977 and I progressed to what I am now. I was a student in 2000 and then—you know how students really struggle, you never have enough money or anything to survive, you have to make ends meet—so then I started taking craft really seriously then, because I needed the money to have food in your fridge. I knew I could make all this stuff. I started out small and then I progressed. And then I became a business in 2005. So I get a lot of my business from all over Alberta, Saskatchewan, Manitoba. And three of my grandchildren dance, so that gives us the motivation to participate. My grandson, the one that does the quillwork, he's a traditional dancer as well. And she's a jingle dress dancer, my daughter's a traditional dancer. And my other granddaughter is another traditional dancer, so we have four in our family that participate in the powwow trail. Because we're all involved and we all participate, they participate in the powwow, and then I'll participate by being in the craft vendors and stuff like that. So then we all pack up and we're all ready to go and it makes it like a family outing basically. [laughs] They're out there dancing and participating and makes it really interesting and fun. It's something we look forward to. All summer we'll be doing that.

It's important because I want our people to know their culture and I want them to participate in their traditional knowledge and their values, which are really important for our people to understand where they come from. We have been going to powwows like thirty plus years now. So after they grew up, and then they started their families and they started having children, so then we started the grandchildren next.

This one I made for my auntie and I just made what I thought that she would like. Yeah, the birds, and the flowers, the buffalo, and the horse, and the dragonfly. 'Cause she's... old style like that. I made for my sister Kristen and, well, you've seen her dresses. She dances, so I just kind of made it fancy—all geometric design in the middle and the colours, I just kind of put in there myself. They weren't her colours, but just made up my own. This one I made for my Auntie Annette and, well, she likes horses.

I started out small, but then I started to dream big, 'cause my designs were starting to get bigger. But I used this... edging from... parfleche edging, I used that idea and I put it on here, instead of like cutting out the frame and putting it on a glass, behind glass.

I did beading before when I was younger. Well, my mom taught me, so I find painting easier than beading. You get to come up with an idea and just put it on canvas and the colours come easier. I do them in pairs. I don't really, well, I'm trying to work on a bigger picture, just do like one whole picture with the same things but a lot more detail in them. Yeah, actually do my walls, too. I just started doing them 'cause I ran out of canvases or... other paper, anything to draw on. I just ran out of that stuff, so I started doing it on my walls.

So I've been training jiu jitsu for about four years now. I just received my blue belt in jiu jitsu last December and I have some competitions coming up that I'm training for and I started helping with the kids' training at the gym. I had a goal for weight loss. Like four years ago, I was about thirty-five pounds heavier than I am today. And I've also been really interested in MMA and muay thai, jiu jitsu, all that, me and my brother and my uncles were all really into that. My stepdad, I grew up kinda watching him doing workouts in the basement—my family's a big influence.

Being First Nation, I know that fighting is not something that we have every day in our tradition, our teachings and things. But I know the physical activity is really important, to live a healthier, positive, strong life. My kids see it, my brother and sister see it, so I think it's good for everybody that's around me.

And in jiu jitsu, there are like a lot of our teachings in it, too. Like there's perseverance, trust, trusting your training partner, different things that I've learnt along the way that kind of just made me a stronger person, too, that go well with our own teachings.

I've been beading since I was about eleven. It started out because I wanted to dance and my mom, she ordered a full beaded outfit for me and it was really expensive. And she said, "My girl, if you're gonna want to dance, we're gonna have to learn how to do this ourself." And we sat down at the table and just tried it out. It was just a good feeling after I was done. And during, too, you can go through your thoughts and figure things out, and it's just a good time to relax and put really good energy into it.

I started out beading just for myself for dancing—hair ties, accessories, leggings, moccasins. And then I wanted to like challenge myself, so I started taking orders and now I'm making like full grad orders, for beaded ties, and bracelets, accessories. I'm also finding like different techniques that aren't really traditional to our people, and I'm kinda like mixing it in. I dance jingle and hoop.

**Bernice Yuzicappi**
**Standing Buffalo Dakota First Nation**

My granddaughter was a princess with the Standing Buffalo powwow, so she wanted four star quilts, and that's where I started making the bigger star quilts and then the baby star quilts. Everybody wanted a star quilt. They'd send me an order and I try to keep some on hand, but I couldn't … if somebody passes away or we need one for bingo or something and I give them away or sell them. I dream about them, but before I start making my star quilts, I smudge, and I pray before I make them. And I have my Sun Dance CDs on, or tapes, listen to that and it inspires me, and it brings me the colours. It makes me think of the old ways. I think mom gave me that inspiration. Her star quilts are the ones that are so inspiring. It's like an art — when you're an artist you want to draw.

Well I come to that point where I want to make. I see colours, and I think this would go good here and to match them with different prints. Black Elk said that the people live in a circle — birds make their nest in a circle, our life is in a circle — so I started stitching my quilts in a circle. They talk about the star people and how the Dakota came to be on earth. Remember that woman that was pregnant up with the star people and she wasn't supposed to dig *Timpsula* wild turnips? She did, and she fell down, and she had a little boy. I think that man, whoever was up there with her, came down, but she didn't want to go back, so she stayed down here, and that's how the Dakota people came. And then they look up and see the stars, so they use the star to honour — honour a birth, a death, or marriage, or any honouring ceremony…. You show respect and honour to people that you give them a star quilt. Like at the Sun Dance … when you have to go to *hambalecha*, you have to have a star quilt that connects you to the star people…. And that's the star quilt that represents all these different universes that are out there, and we seem to revere them and honour them. But now that's our buffalo hide, is the star quilt….

I had that dream again that I had to make a white buffalo star quilt for the baby, and it seems like when I finish them that's when they come…. I was thinking why a white buffalo star quilt for a boy? They're usually meant for girls. So she was a girl. But I'll never make another one again on my own unless I'm told to by the Creator. I thought it was impossible, but nothing's impossible.

**Jason Whiteman**
**Standing Buffalo Dakota First Nation**

I'm attending my first year university. I was surrendered to the care of social services when I was about a year and a half and I became a permanent ward, and I was put up for adoption. So I stayed here in Regina in this one foster home until I was five years old. Then I got adopted by *wasichus*, and I moved up to Uranium City. But there was a lot of neglect and abuse in the adoption, and they broke down and they finally surrendered me back to social services when I was twelve, and I bounced around from foster home to foster home up around Prince Albert. I was told that I was from Standing Buffalo, and I was told my last name. So one of the social workers asked me if I would be interested in tracking down my family. They brought me out there, and I have three brothers and three sisters. So going from an only child to having three brothers and three sisters was pretty neat. It was nice to meet them, and I finally felt like I had belonged somewhere. We were split up, and we did not know each other existed. Social services wouldn't tell you anything. Then it was at the powwow, I met my father, and [after our visit] I remember watching his truck go up the hill, and thinking, Will I ever see him again? Unfortunately, I never did. He passed away a few years after that.

I just woke up one day, I said, I want to go see mom, and she was in Winnipeg. So we were hitchhiking, and this woman stopped, and it turned out to be Susan Aglukark's personal manager. And she used to be a social worker before, and we were explaining to her that I wanted to go meet my mom. And she said, we'll take you back to Regina, take you to the Greyhound, and buy you two one-way tickets to go to Winnipeg.

They didn't let anything on. She was just glad to see her other daughter, Alberta. Then I came 'round the corner and she says, "Mom, guess who that is?" "My god, is that Jason?" She started crying and then I started crying and I hugged her — little short woman — and so, yeah, I got to meet her. She moved down from Winnipeg to Regina and then she had all of us together that one time…. She said, "I feel so lucky, all seven of my kids are home under my roof." She had a house over here on Toronto Street and we used to stay with her…. She passed away from alcoholism, and so we lost her in 2001…. I'm proud to be native. My philosophy is being a positive role model for my son.

**Patti Yuzicappi-Buffalo**
**Standing Buffalo Dakota First Nation**

My cousins and my uncles were all involved with the powwow. And so every year it was a flurry of events before powwow season — my aunties, my mom, everybody fixing regalia, making new pieces and my cousins coming, my male cousins asking can you make things. So being around artists, to me that's where that comes from, being creative. I teach traditional Dakota parenting, and I go to different Dakota communities and the cradleboard teachings are all so important. I do the teachings and talking about how they were used to bring up our children, why they were used, and some of the benefits. I decided to make the little miniature cradleboards.

To me, the whole powwow culture stems around spirituality. We started learning about the cradleboard, and how when you're raising children — because our children are so sacred — they just came from the spirit world. And the name itself, *Wakanheja*, tells you what kind of people we are, because that name is very sacred. We have to respect our children, and babies should not be placed on the ground. And that's one of the reasons why they had the cradleboard, because children are never supposed to be below us.

The grandmothers used to carry them on their back. That's how much they respected the babies, that they always had them higher than them. So with the cradleboard teachings, that's one of the things that they used to help for parenting, because it's convenient, and there's lots of care that went into that. When a woman was pregnant, the family didn't start right away until the baby was born. But it took a lot to make the cradleboard — all the womenfolk, the grandmas, the aunties, her sisters — and they beaded this cradleboard to present the mom with when the baby was born. I think they could start then.

Dakota culture, or Sioux culture, they have the fully beaded cradleboards that told a story of who this child was, or who they were going to be. A long time ago, children were spaced. They didn't have babies right after another, because they needed to have enough time where that child was ready to go on to be looked after by the grandparents. And so by that, then they can have another child. But the focus was always on the children. When a woman was pregnant, she's doing something sacred…. That little *Wakanheja* is coming, so all the care that was taken — all the ceremony that was done before the child was born — [is] for the mom and the dad.

**Beverley Yuzicappi**
**Standing Buffalo Dakota First Nation**

**Kristen Yuzicappi**
**Standing Buffalo Dakota First Nation**

I stayed mostly with my grandmas and grandpas 'cause my parents used to work in the local town of Fort Qu'Appelle. They talk to each other in Dakota, but they never talked to us and one time grandpa Goodwill said, "*Takoja*, grandchild, you're not gonna need it. You're gonna listen to the *wasichus* talk, the white people, and that's the way you're gonna learn." So my grandpa Goodwill, he married a lady from Wood Mountain, Mary Lethbridge. I teach our language, our seven sacred rites, like, respect, courage, bravery, prayer. That's the one thing I really stress in our school is respect.

I'll say, at a powwow, what would you hear? *Wachi, owachipi, onawotapi iit*, the *anahokta'*, listen up dancers, the dancer would say, *akichita'*, our veterans. So I teach them the words that they'd hear at a powwow so they'll know. I said you respect when you hear the *gichidaya*, the veterans are gonna be dancing and when we go out for walks, this is *enamaka*, you're walking on mother earth. *Ea, ea* has a spirit, too. Lot of you kids throw rocks, but that has a spirit. And I tell 'em, we use those for sweats, *Inipi*, and I said that we depend on that rock spirit to help us, and water, *Mni*, so when we go from *Pajee'*, they know all.

I pray every morning to the Creator and say, Give me something to work with, what do I teach today? I started dancing again. It's a good feeling when I come out into the powwow. All the children have Indian names or spirit names — that's a circle. You start dancing, they bring you in, they honour you — that's another circle. So you already belong to a spirit name circle, you already belong to the circle you brought in, when you have that tiny tot. And then you have the youth, you turn teenager. You're brought into another circle to have a big giveaway for you. And so a lot of cultural things were all done in circles and we all belong.

I said you feed your loved ones that have gone on. Then if you said their Indian name, or ask your relatives for help, they will help you. Our grandmas and grandpas loved soup and bannock, so you put a little bit away, in that spirit dish, or you put it outside — they'll come as a bird, or as an insect. That's one thing I want to bring back to Standing Buffalo, is fixing flower day. I take my grandchildren, and I do all my relatives. My grandma, she had a brother, grandpa Pete Lethbridge from Wood Mountain. I do his grave. We have Julia Lethbridge, so I do her grave. I'm very proud to say that I am Lakota and Dakota.

I make jingle dresses. My grandmother taught me how to make my dresses. I've been dancing jingle since I was seven, and I'm thirty-two now. When I have extra money… instead of buying clothes or makeup or anything like that, I usually go to the fabric store, and I'll buy about two and a half metres. That's enough for a dress for myself. I like the sparkly material. I dance in the women's category. We usually dance at night. There's the lights and then the dresses sparkle — then I would add on some appliqué designs.

I like to dance because it's my comfort zone. It's something that got me through everything in life. Anything that was troubling me or I was having a hard time, I would just go to a powwow and dance. It's a way for me to just be calm and just be myself and enjoy life. I travel with my family. I'm the mother of two children, and my husband sings. My daughter is a jingle dress dancer and my son is a chicken dancer, so I also sew for them and bead. As a Dakota woman, jingle dress dancing really helps me to pass my ways on to my daughter. So when you're wearing your jingle dress, there's a certain way that you carry yourself, every day. The way you walk as a woman is almost sacred. You treat people basically the way you want to be treated. If you don't have anything nice to say, don't say it, just treat people with respect. But when dancing, it's basically the same thing, but it's more personal — just walking a certain way of life — not drinking, not smoking, eating healthy, taking care of your body, being a good example for my children and all the younger women in the community.

There's times where I don't dance for about six months, and I just feel like things just aren't right with me. I need to go dance and enjoy myself. And then once I get out there, it feels like that's where I'm supposed to be and all my hard work with my dresses and my beadwork, it just all comes together. Nothing else matters. And when I'm dancing, that's what I hope too, that when people watch, if they have worries or problems, that they could just forget about that….

My grandma taught me how to dance and she's passed on, it'll be a year in August. She basically told me what moves to do, how to do it, what not to do, how to carry myself, and how to walk with my dress, how to behave…. I'm a grade two teacher, and when I was going to university, making dresses is how I made money that would help me support my family. I have made maybe a hundred and fifty dresses.

The Sioux Project—Tatanka Oyate

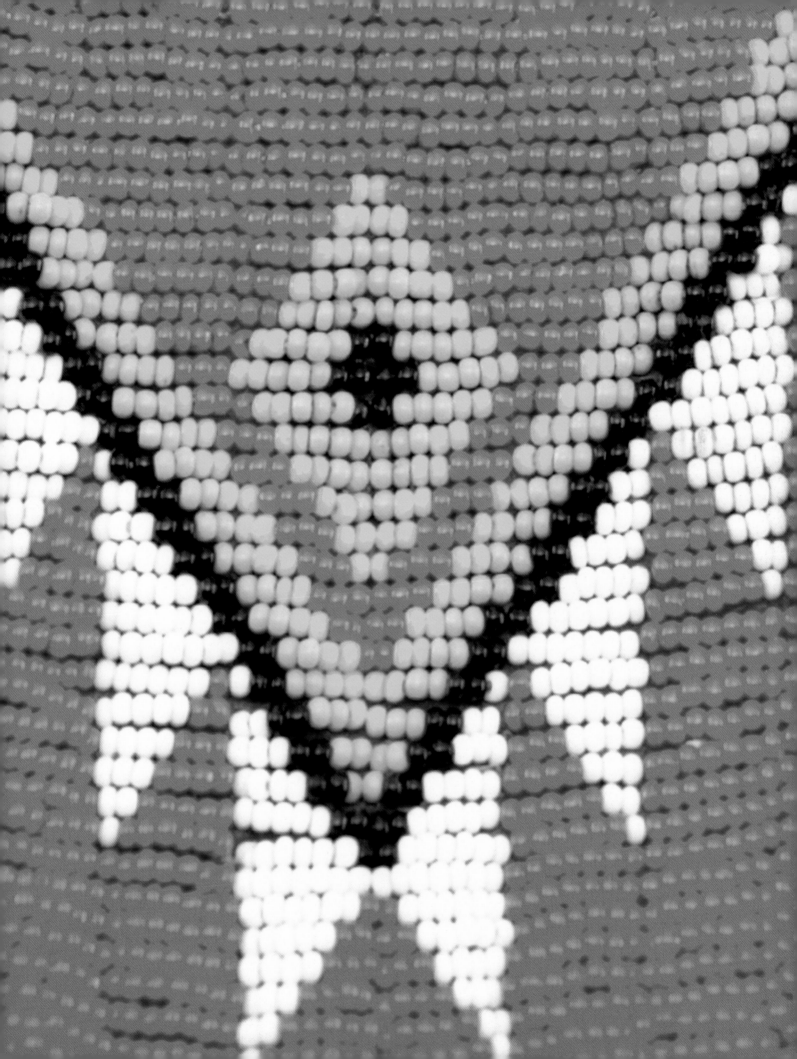

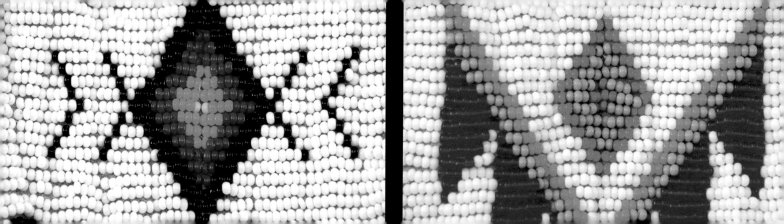

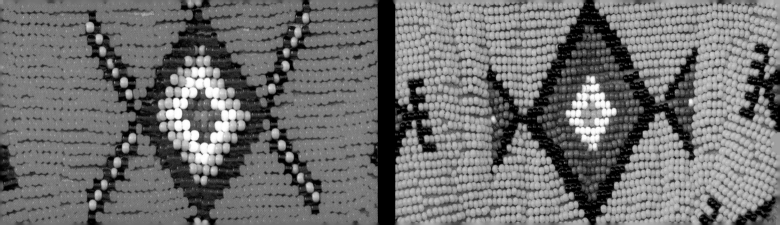

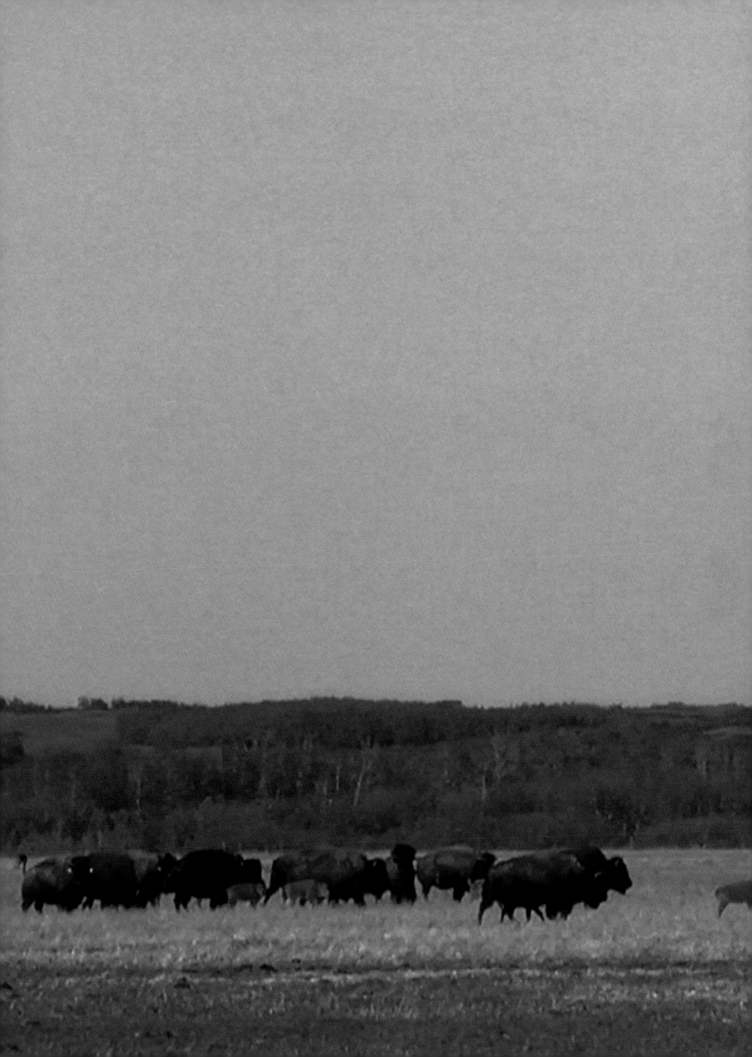

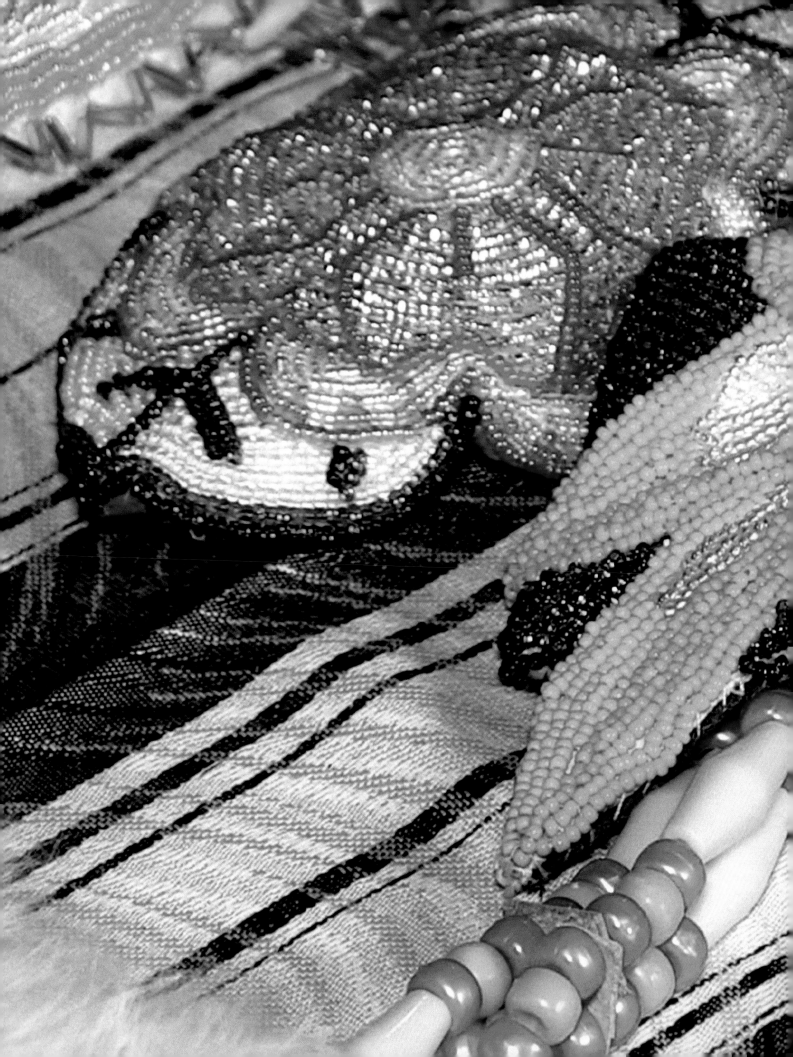

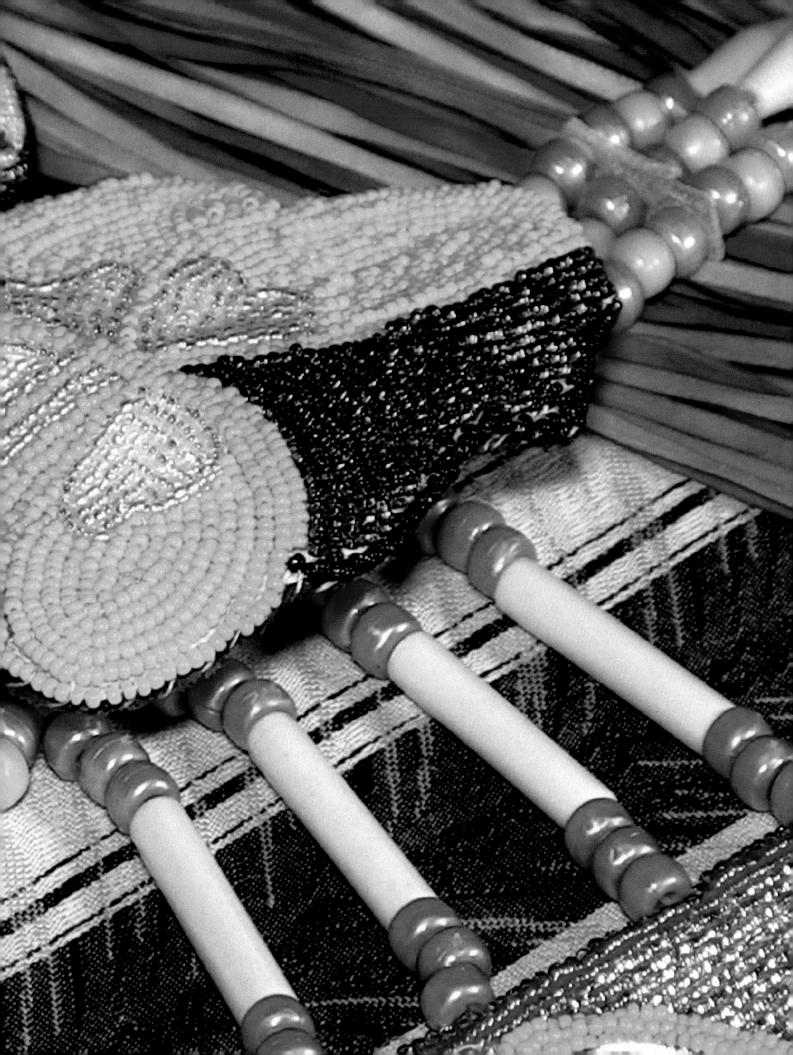

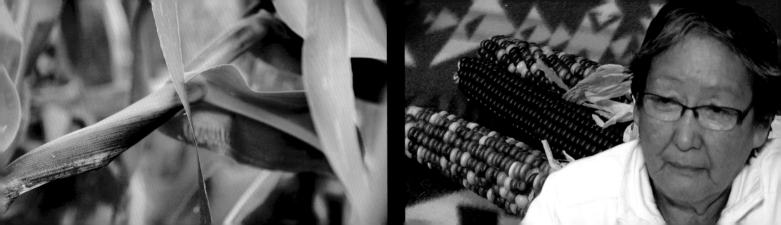

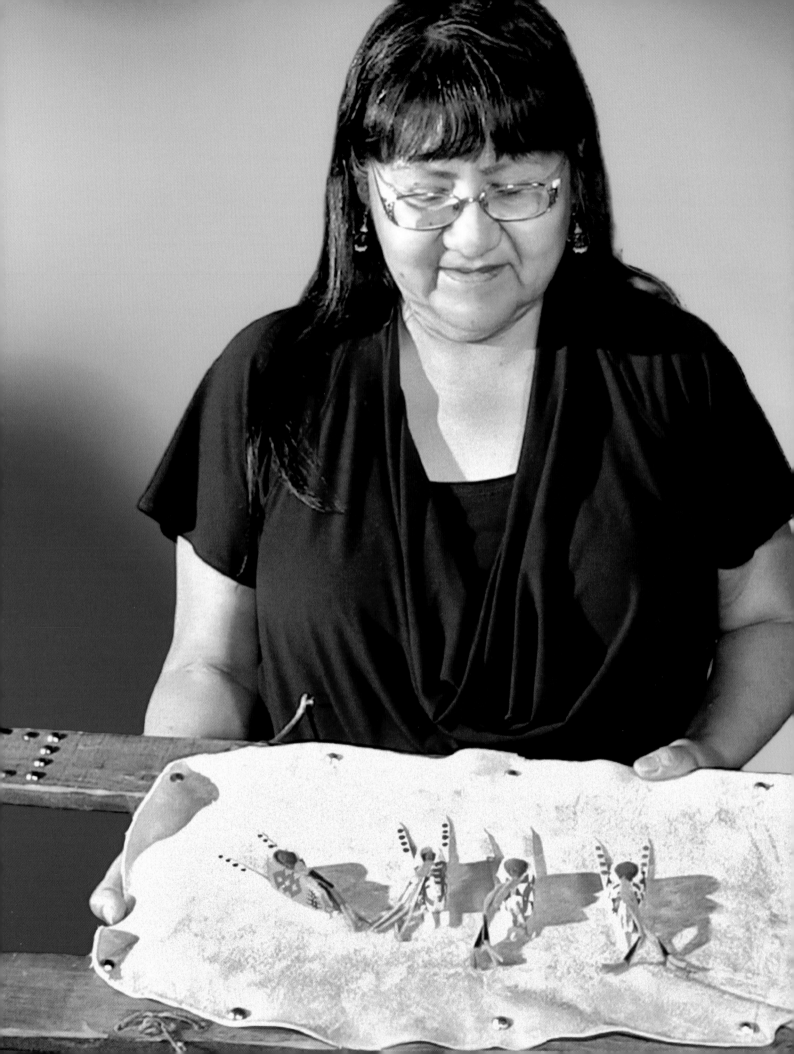

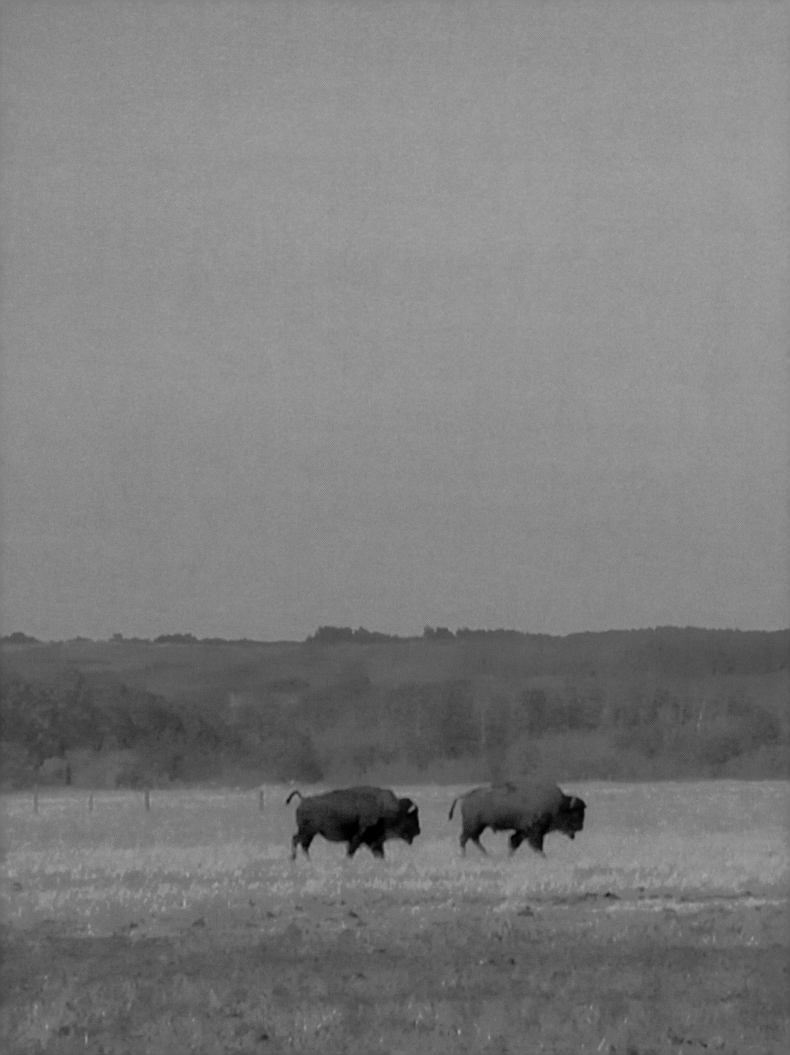

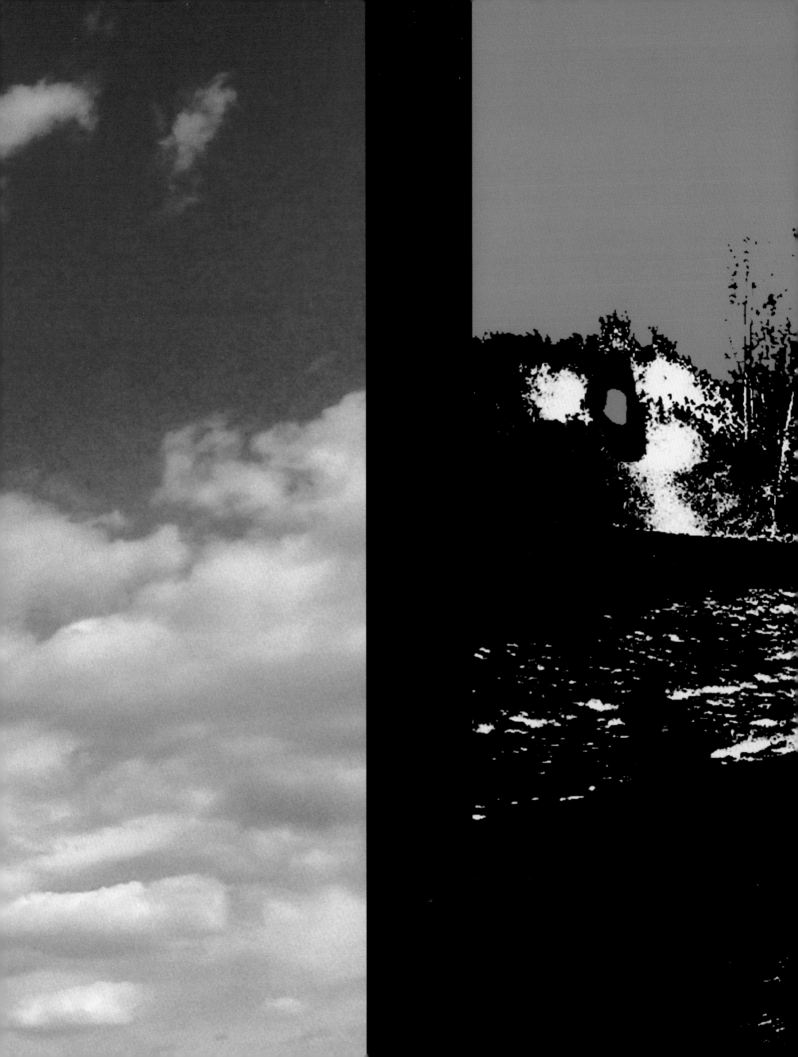

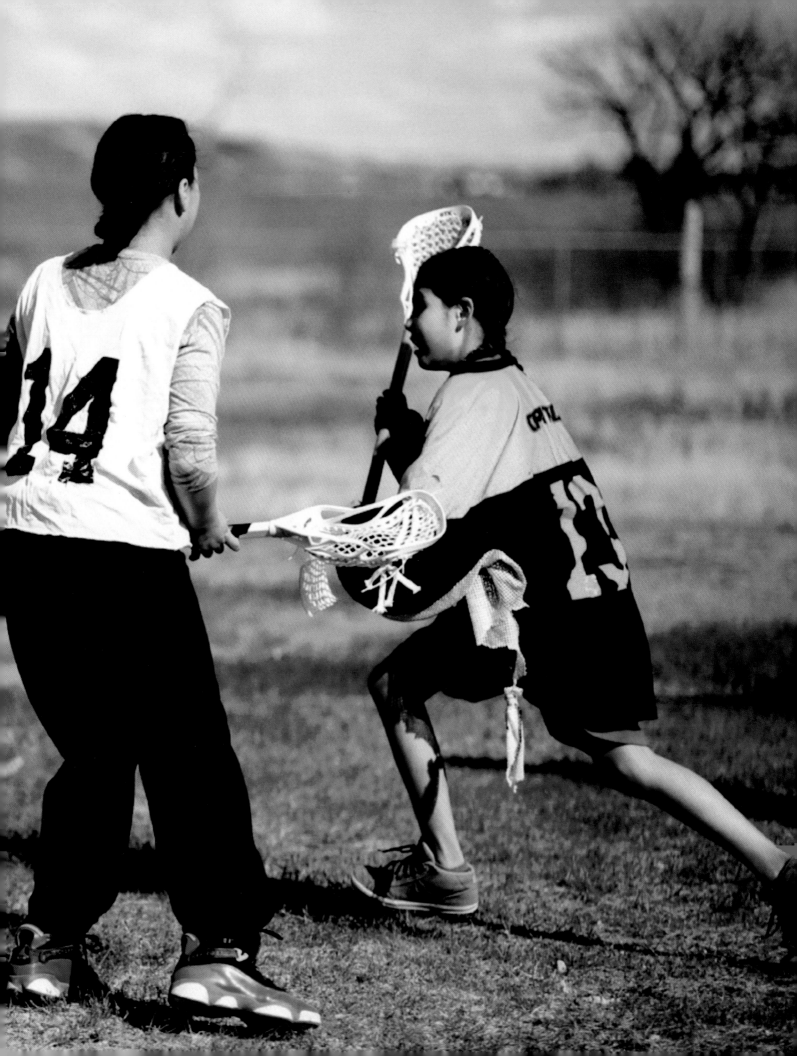

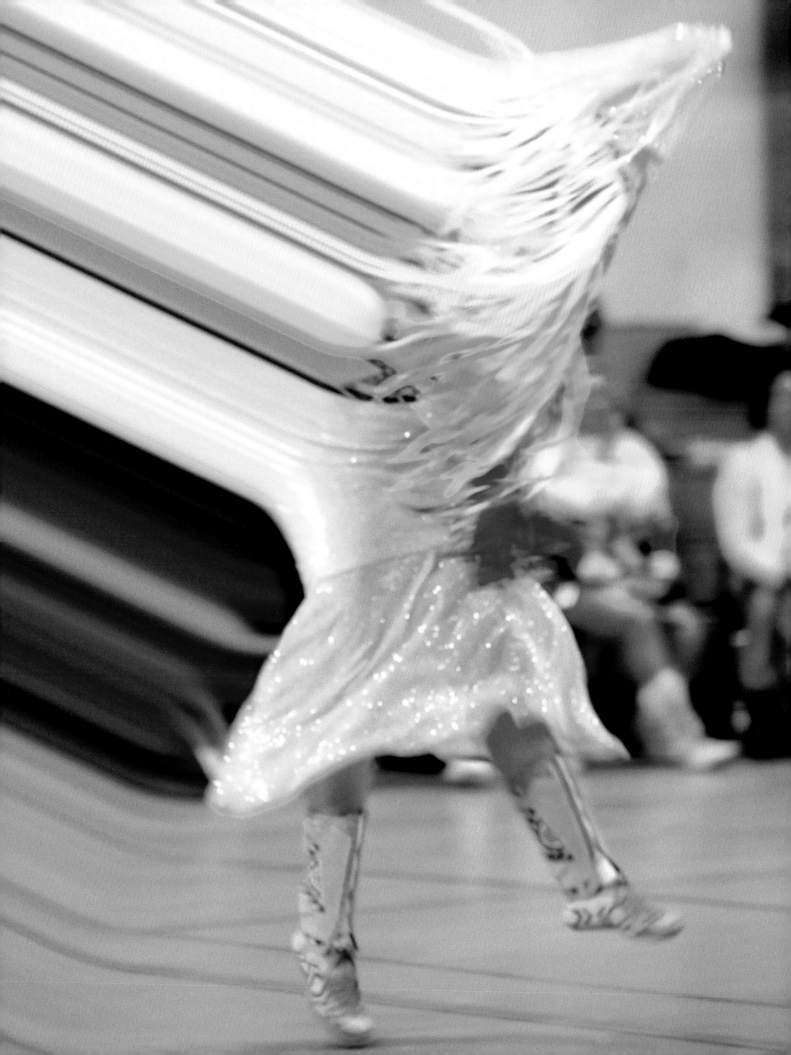

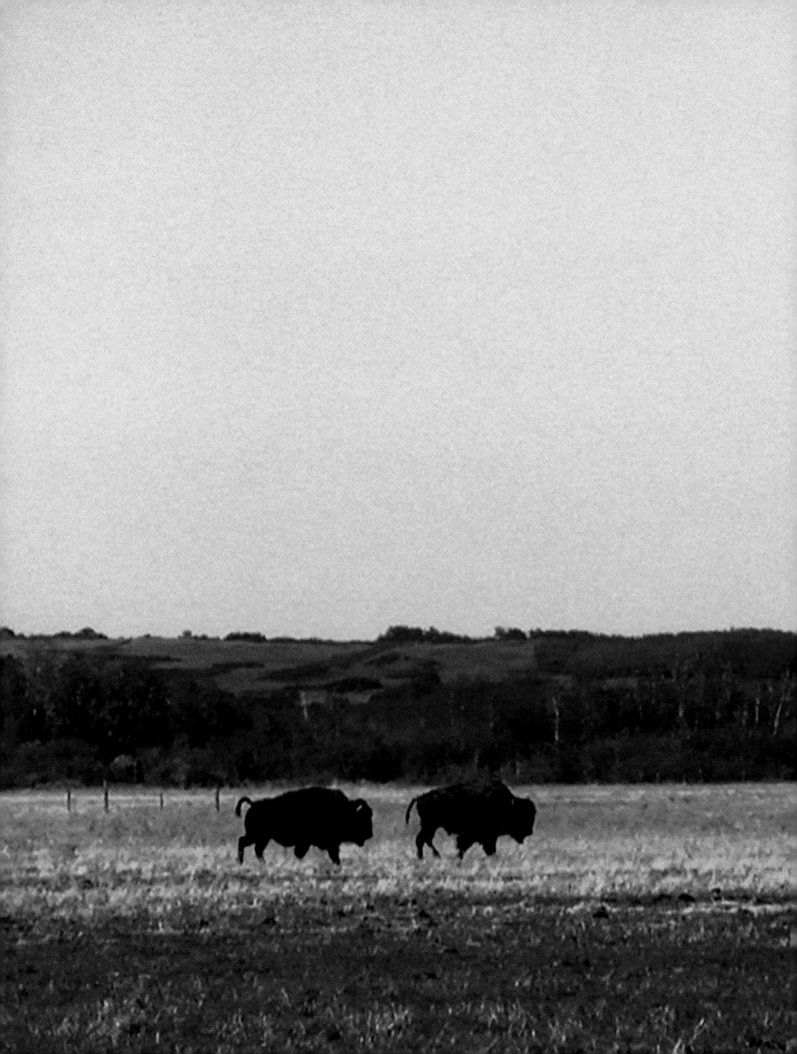

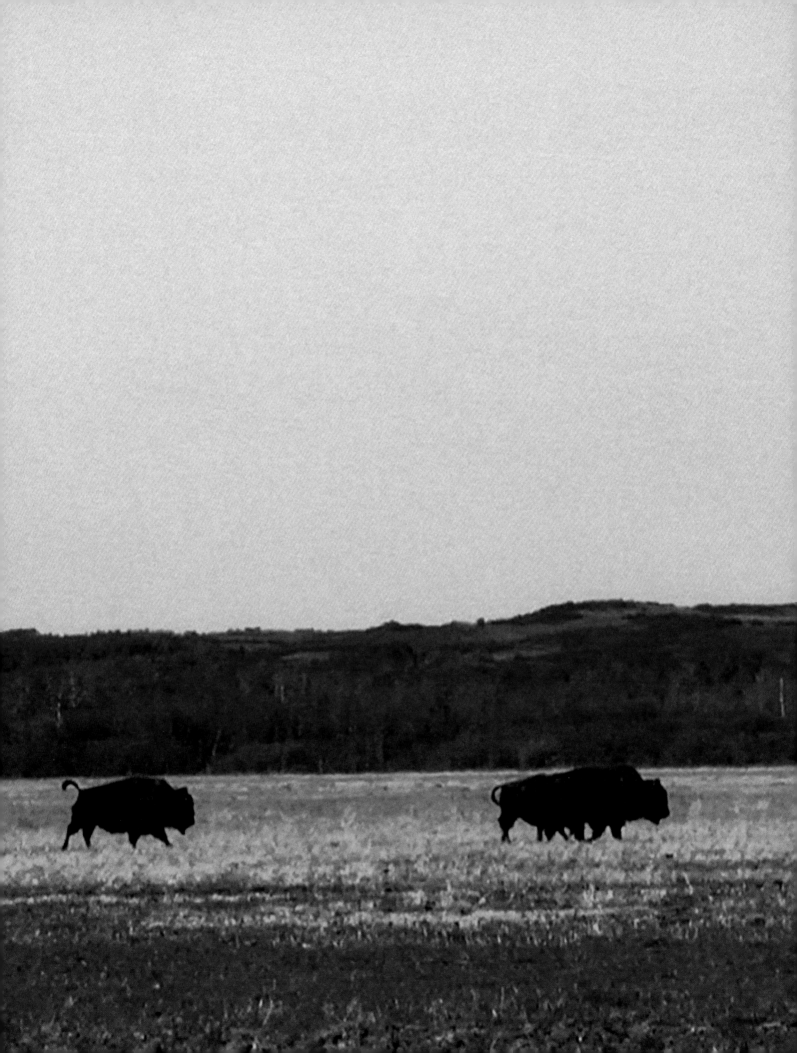

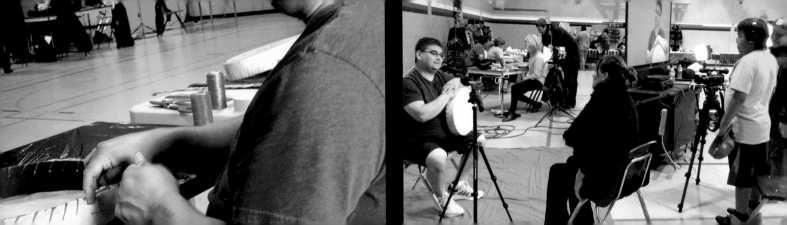

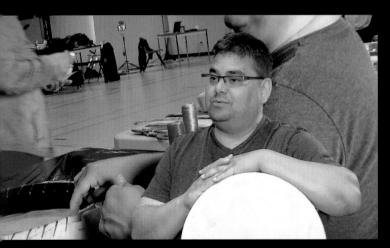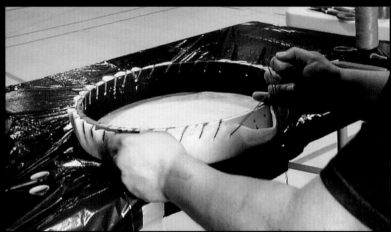

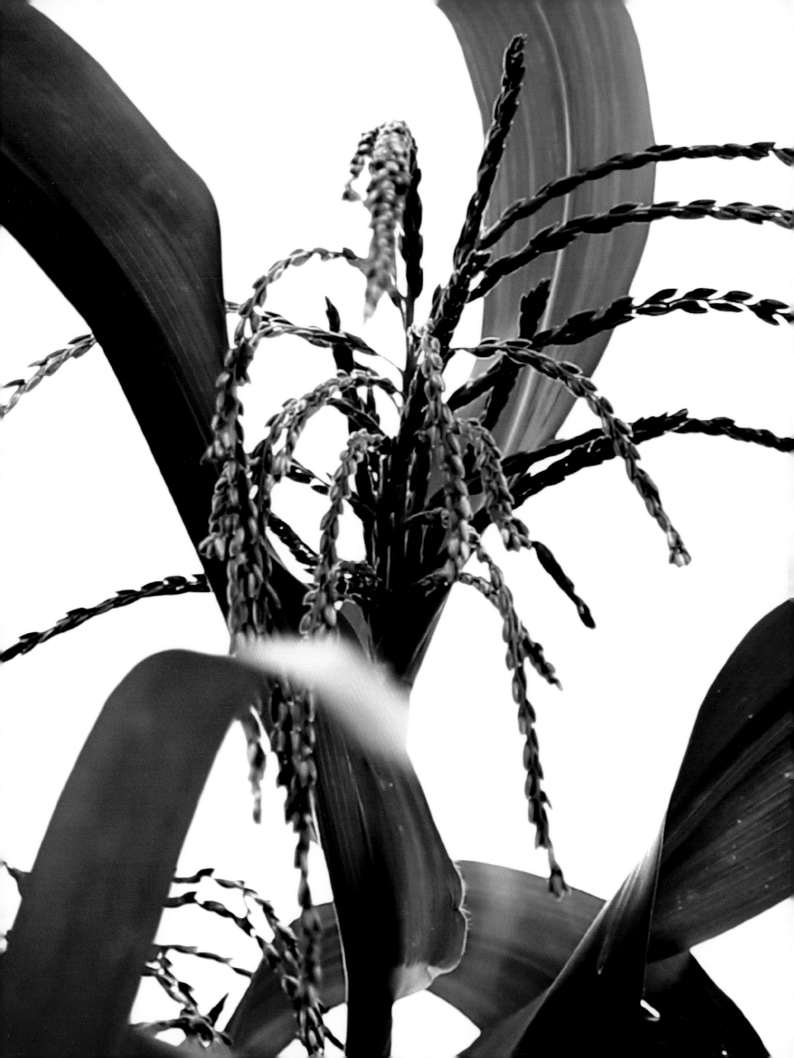

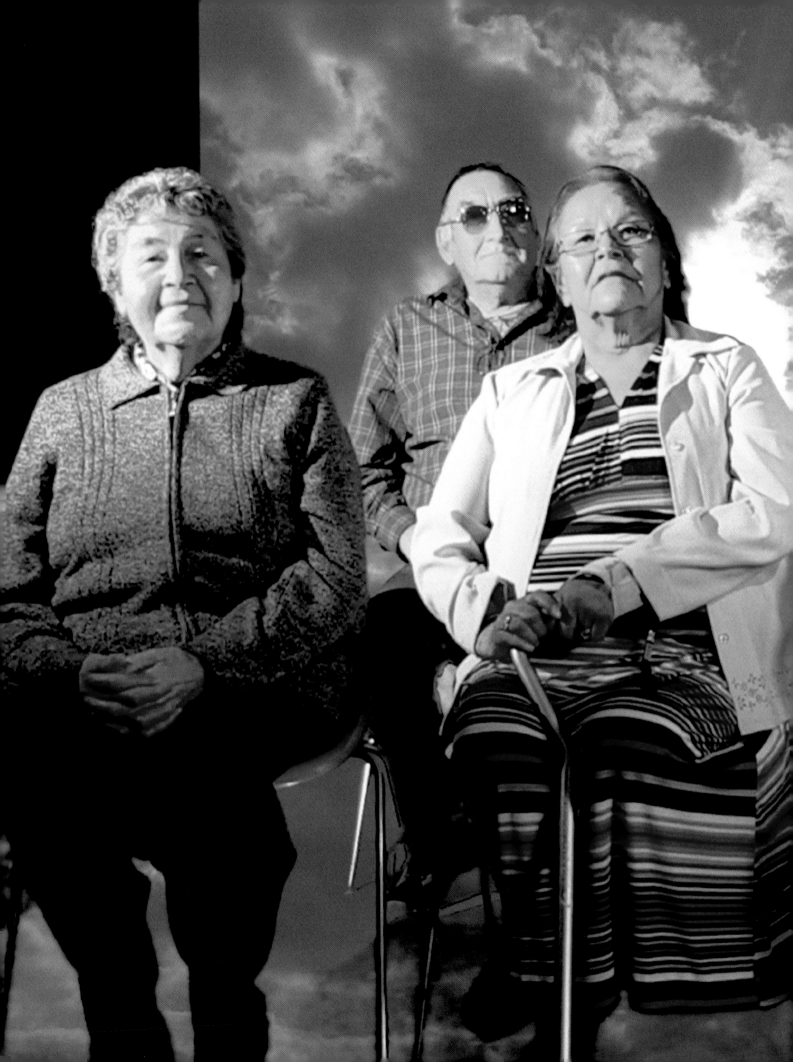

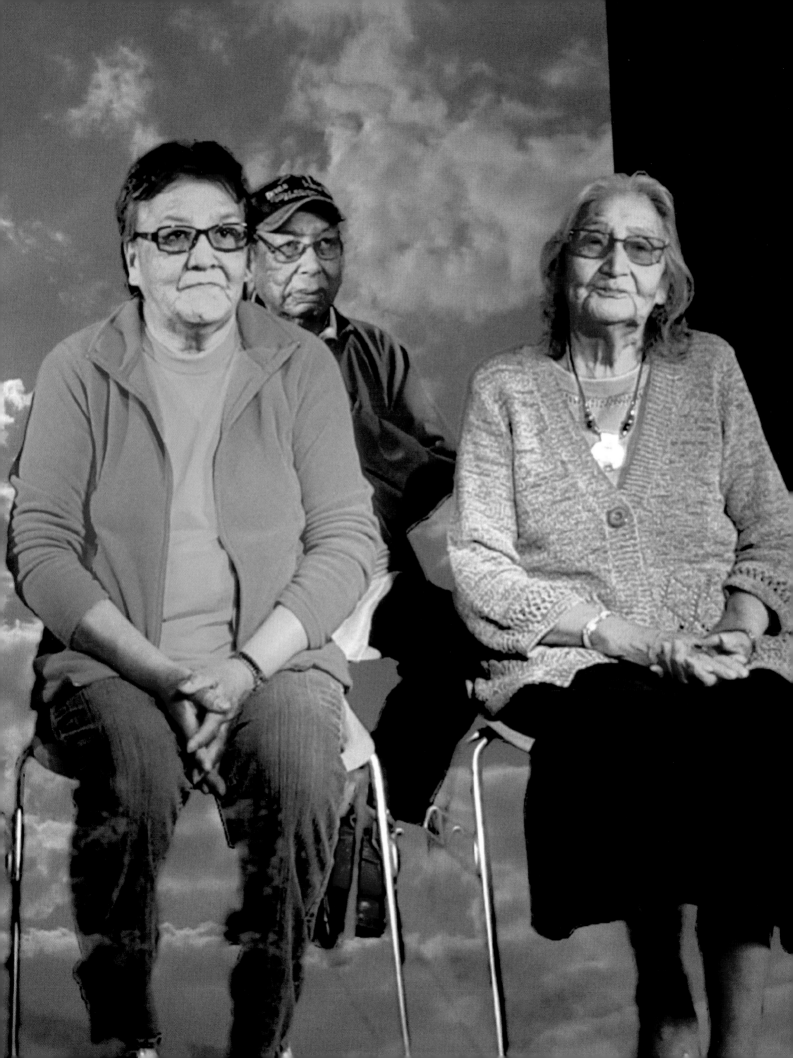

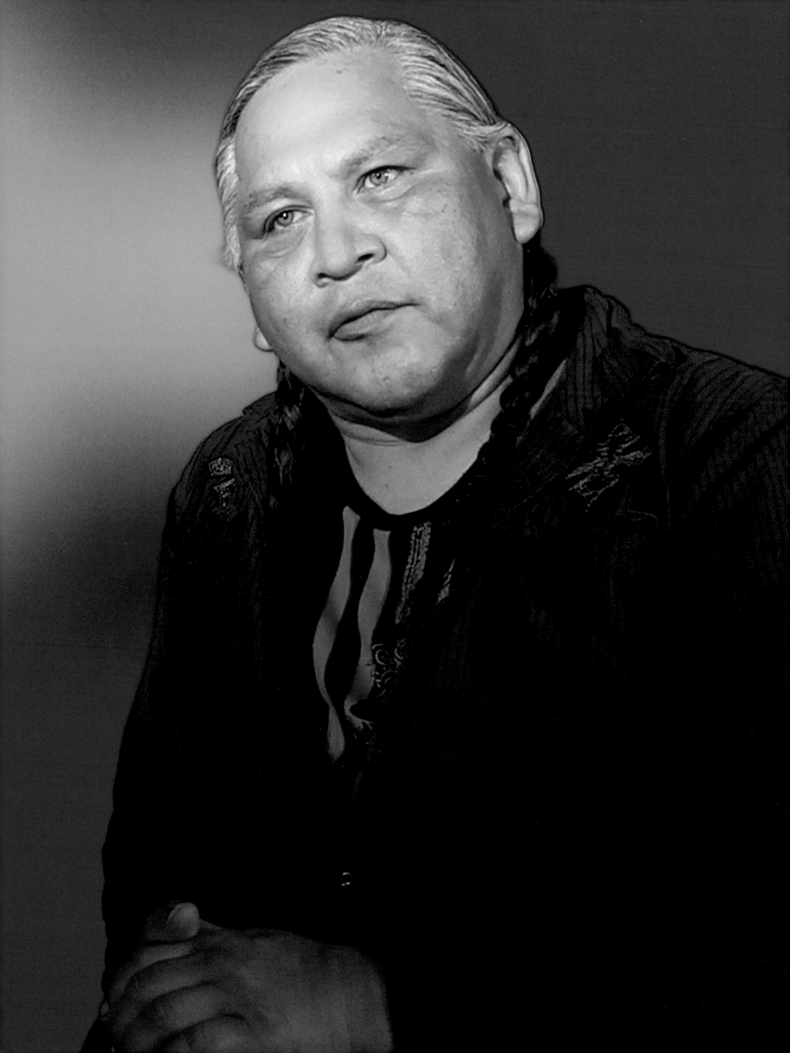

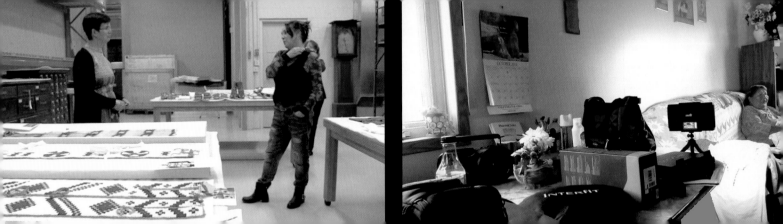

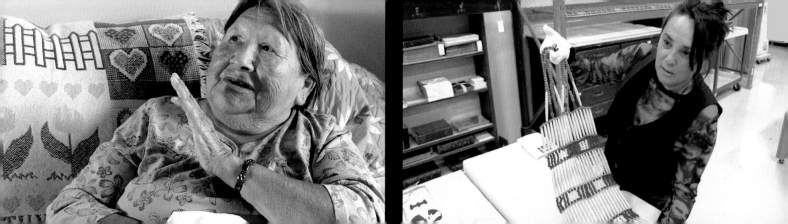

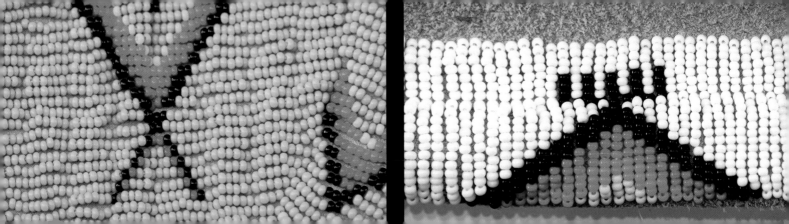

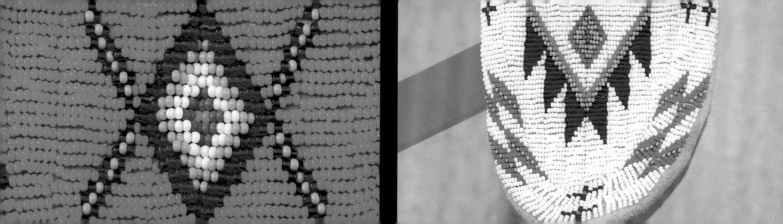

The Sioux Project — Tatanka Oyate
Dana Claxton, Lynne Bell, Gwenda Yuzicappi

Lead Artist: Dana Claxton
Video Editor: Winston Xin
Sound Editor: Doug Paterson—Big World Sound
Camera: Cowboy Smithx, Damian Eagle Bear,
    Candy Fox, Standing Buffalo Youth, Whitecap Youth,
    Dana Claxton, Chris Ross
Media Installation Technician: Bobbi Kozinuk
Screen Design: Dana Claxton, Robert Watson
Screen Fabrication: Andrew Keech
Post Production Consultant: Clark Nikolia
MAX Programmer: Simon Overstall
Production Assistant: Rio Mitchell
Audio Transcription: Olivia Whetung
Production Stills: Jarrett Crowe, Chris Ross
Music: Russell Wallace with voice samples
    by Sissy Goodhouse, Ronnie Dean Harris
    a.k.a. Ostwelve, Mitchell Claxton

With:
Standing Buffalo Youth
Whitecap Youth
Elders Group, Whitecap
Angela Buffalo, Whitecap
Kristen Buffalo, Whitecap
Nadine Deegan, Standing Buffalo
Nathaniel Deegan, Standing Buffalo
Noreen Deegan, Standing Buffalo
Melinda Goodwill, Standing Buffalo
Wayne Goodwill, Standing Buffalo
Dorothy Joyea, White Bear
Nora Joyea, Whitecap
Joely BigEagle-Kequahtooway, Ocean Man
Loretta Lethbridge, Pete Lethbridge Saddle
Denise Lonechild, White Bear
Debra Maxton, Whitecap
Calvin McArthur, Pheasant Rump
Joe O'Watch, Carry The Kettle
Aisha O'Watch, Carry The Kettle
Shana Pasapa, White Bear
Doreen Pasapa, White Bear
Tawachiyana Lonechild-Pasapa, White Bear
Grace Peigan, Wood Mountain moccasins
Paulete Poitras, Muscowpetung
Jordan Redman, Standing Buffalo
Willis Royal, Whitecap
Barbara Ryder, Standing Buffalo
Lester Steffl, Wood Mountain
Connie Wajunta, Standing Buffalo
Angelo Wasteste, Sioux Valley
Jason Wasteste, Standing Buffalo
Angela Whitecap, Whitecap
Allison Whiteman, Standing Buffalo
Jason Whiteman, Standing Buffalo
Derek Whiteman, Standing Buffalo
Bernice Yuzicappi, Standing Buffalo
Claudine Yuzicappi, Standing Buffalo
Beverley Yuzicappi, Standing Buffalo
Gwenda Yuzicappi, Standing Buffalo
Kristen Yuzicappi, Standing Buffalo
Patti Yuzicappi-Buffalo, Whitecap
Sharon E. Yuzicapi, Standing Buffalo
Shalana Yuzicappi, Standing Buffalo
Whitney Yuzicappi, Standing Buffalo

The Sioux Project would like to thank:
Hartland Goodtrack and Evelyn Yuzicappi
Deidre Movescamp
Robert Watson
Tribe Inc. and Lori Blondeau
PAVED Arts for hosting the Whitecap Youth in Saskatoon
Camay Youth Worker at Whitecap
Sâkêwêwak Artists' Collective Inc.
Heather Smith and the Moose Jaw Museum & Art Gallery
Dr. David R. Miller
Michelle LaVallee for her initial interest in the exhibition
Dr. Carmen Robertson, Guest Curator
Andrea Tuele, Dominique Madill, Greg Gibson, AHVA/UBC
STACK firebox image edit by Pauline Petit
Exhibition Logo Design: Jamey Braden, Dana Claxton
Student researchers—University of British Columbia:
    Eric Angus MFA, Jamey Braden MFA, Courtenay Crane
    BA, Angela Ko BFA, Christopher LaCroix MFA, Jules
    Arita Koostachin PhD, Olivia Whetung MFA; University
    of Saskatchewan—Brianne Davis BA
The MacKenzie Art Gallery and their amazing staff
All the presenters for the symposia and you dear reader!
This research was supported by the Social Sciences
    and Humanities Research Council of Canada and
    administered by the Department of Art History, Visual Art
    and Theory at the University of British Columbia.

# Selected Sioux Bibliography

Albers, Patricia C. and Beatrice Medicine. "Some Reflections on Nearly Forty Years on the Northern Plains Powwow Circuit." In *Powwow*, edited by Clyde Ellis, Luke Eric Lassiter, and Gary H. Dunham. Lincoln: University of Nebraska Press, 2005.

Alwin, John. "Pelts, Provisions, and Perceptions: The Hudson's Bay Company Mandan Indian Trade, 1785–1812." *Montana: The Magazine of Western History* 24, no. 3 (Summer 1979): 16–27.

Amiotte, Arthur. "An Appraisal of Sioux Arts." In *An Illustrated History of the Arts of South Dakota* by Arthur Huseboe. Sioux Falls, SD: Center for Western Studies, Augustana College, 1989.

———, Janet Catherine Berlo, and Louis S. Warren. *Transformation and Continuity in Lakota Culture: The Collages of Arthur Amiotte 1988–2014*. Pierre: South Dakota State Historical Society Press, 2014.

———. "The Lakota Sun Dance: Historical and Contemporary Perspectives." In *Sioux Indian Religion*, edited by Raymond DeMaillie and Douglas Parks, 75–90. Norman: University of Oklahoma Press, 1987.

Anastakis, Dimitry. *Re-Creation, Fragmentation and Resilience: A Brief History of Canada since 1945*. Don Mills, ON: Oxford University Press, 2018.

Anderson, Harry. "Fur Traders as Fathers: The Origins of the Mixed-Blood Community Among the Rosebud Sioux." *South Dakota History* 3 (1973): 233–70.

Anthes, Bill. *Native Moderns: American Indian Painting, 1940–1960*. Durham: Duke University Press, 2006.

*An Experiment of Faith: The Journey of the Mdewakanton Dakota who Settled on the Bend in the River*. Flandreau, SD: First Presbyterian Church, 2003.

ArtSask. "Wayne Goodwill: Artist Profile." http://www.artsask.ca/en/artists/waynegoodwill.

Barkwell, Lawrence, Leah Dorion, and Darren Préfontaine, eds. *Metis Legacy: A Metis Historiography and Annotated Bibliography*. Winnipeg: Pemmican Publications, 2001.

Beck, Paul N. *Columns of Vengeance: Soldiers, Sioux, and the Punitive Expeditions, 1863–1864*. Norman: University of Oklahoma Press, 2014.

Bellegarde, Brad. "Whitecap Dakota First Nation Signs Framework Agreement for Treaty With Canada." CBC News, January 24, 2018. http://www.cbc.ca/news/indigenous/whitecap-dakota-nation-treaty-framework-1.4502549

Berlo, Janet Catherine. *Arthur Amiotte: Collages 1988–2006*. Santa Fe: The Wheelwright Museum, 2006.

———. "A Brief History of Lakota Drawings, 1870–1935." In *Plains Indian Drawings 1865–1935: Pages from a Visual History*, edited by Janet C. Berlo, 34–39. New York: Abrams, 1996.

———. "Dreaming of Double Woman: The Ambivalent Role of the Female Artist in North American Indian Mythology." *American Indian Quarterly* 17, no. 1 (1993): 31–43.

———. *Spirit Beings and Sun Dancers: Black Hawk's Visions of a Lakota World*. New York: George Braziller Inc., 2000.

Blish, Helen. *A Pictographic History of the Oglala Sioux*. Lincoln: University of Nebraska Press, 1967.

Bol, Marsha. "Beaded Costume of the Early Reservation Era." In *Arts of Africa, Oceania and the Americas: Selected Readings*, edited by Janet Berlo and Lee Anne Wilson, 363–70. Englewood Cliffs, NJ: Prentice Hall, 1993.

Bolz, Peter. "Die Berliner Dakota-Bibel, Ein Frühes Zeugnis der Ledger-Kunst bei den Łakota." *Baessler-Archiv*, N.F., 36, no. 1 (1988): 1–59.

———, and Viola König. *Native American Modernism: Art from North America*. Berlin: Verlag, 2012. Exhibition catalogue.

Borrows, John. *Canada's Indigenous Constitution*. Toronto: University of Toronto Press, 2012.

Bourke, John Gregory. Diaries. Document no. 917.8 B66d, vols. 43–44, abridged from pp. 1460–504, Center for Southwestern Research, Zimmerman Library, University of New Mexico, Albuquerque. From originals in the Library of the U.S. Military Academy, West Point, New York.

Brady, Miranda J. and John M. H. Kelly. *We Interrupt This Program: Indigenous Media Tactics in Canadian Culture*. Vancouver: UBC Press, 2017.

Brasser, Ted. "In Search of Métis Art." In *The New Peoples: Being and Becoming Métis in North America*, edited by Jacqueline Peterson and Jennifer Brown, 221–29. Winnipeg: University of Manitoba, 1985.

Cajete, Gregory. "Look to the Mountain: Reflections on Indigenous Ecology." In *A People's Ecology: Explorations in Sustainable Living*, edited by Gregory Cajete, 1–20. Sante Fe: Clear Light Publishers, 1999.

———. *Native Science: Natural Laws of Interdependence*. Santa Fe: Clear Light Publishers, 2000.

———. "Reclaiming Biophilia: Lessons from Indigenous Peoples." In *Ecological Education in Action: On Weaving Education, Culture and the Environment*, edited by Gregory A. Smith and Dilafruz R. Williams, 189–207. New York: State University of New York Press, 1999.

Catlin, George. *Letters and Notes on the Manners, Customs, and Conditions of the North American Indians*. New York: Dover Publications, 1973.

Claxton, Dana. *Hunkpapa Woman in Black*. Film. Directed by Dana Claxton. Vancouver: Hunkpapa Films, 2018.

———, with Toby Katrine Lawrence. "Locating Sioux Aesthetics through The Sioux Project—Tatanka Oyate." *BlackFlash* 35, no.1 (2018): 58–60.

Deloria, Philip J. *Indians in Unexpected Places*. Lawrence: University Press of Kansas, 2004.

Dickason, Olive Patricia, and William Newbigging. *Indigenous Peoples within Canada: A Concise History*. Fourth edition. Don Mills, ON: Oxford University Press, 2019.

Diedrich, Mark. *The Odyssey of Chief Standing Buffalo*. Rochester: Coyote Books, 1988.

Elias, Peter Douglas, *The Dakota of the Canadian Northwest: Lessons for Survival*. Regina: Canadian Plains Research Center Press, 2002.

Ewers, John. "The Indian Trade of the Upper Missouri before Lewis and Clark." In *Indian Life on the Upper Missouri*. Norman: University of Oklahoma Press, 1968.

Farrell Racette, Sherry. "Sewing for a Living: The Commodification of Métis Women's Artistic Production." In *Contact Zones: Aboriginal and Settler Women in Canada's Colonial Past*, edited by Katie Pickles, 17–46. Vancouver: University of British Columbia Press, 2005.

———. *Sewing Ourselves Together: Clothing, Decorative Arts, and the Expression of Métis and Half Breed Identity*. PhD diss., University of Manitoba, 2004.

Flandreau, South Dakota: A Brief History, https://www.cityofflandreau.com/index.asp?SEC=9C747F66-D3E8-4AB1-9BB4-930D81F2FD87&Type=B_BASIC

Frazier, Bernard. Foreword to *American Indian Painting*. Tulsa: Philbrook Art Center, 1947. Exhibition catalogue.

Goodvoice, Robert. "An Oral History of the Wahpaton [sic] Dakota." Unpublished manuscripts and taped interviews, Saskatchewan Archives Board, 1977.

Greene, Candace, and Russel Thornton, eds. *The Year the Stars Fell: Lakota Winter Counts at the Smithsonian*. Washington, DC: Smithsonian National Museum of Natural History, 2007.

Hewitt, J. N. B., ed. *Journal of Rudolph Friederich Kurz: An Account of His Experiences Among Fur Traders and American Indians on the Mississippi and the Upper Missouri Rivers During the Years 1846 to 1852*. Bureau of American Ethology Bulletin 115. Washington, DC: Smithsonian Institution, 1937.

Howard, James. *The Warrior Who Killed Custer: The Personal Narrative of Chief Joseph White Bull*. Lincoln: University of Nebraska Press, 1968.

Irwin, Kathleen, and Rory McDonald, eds. *Sighting/Citing/Siting: Crossfiring/Mama Wetotan: Theorizing Practice*. Regina: Canadian Plains Research Centre Press, 2009.

Lee, Dorothy D. *Freedom and Culture*. Engelwood Cliffs, NJ: Prentice-Hall, 1959.

Long, Timothy, ed. *Theatroclasm: Mirrors, Mimesis and the Place of the Viewer*. Regina: MacKenzie Art Gallery, 2009.

———, and Christine Ramsay. "Telling Tales out of Spool: Introducing Atom Egoyan's *Steenbeckett*." In *Atom Egoyan: Steenbeckett*, edited by Timothy Long, Elizabeth Matheson, and Christine Ramsay, 29–46. London and Regina: Black Dog Publishing in collaboration with the MacKenzie Art Gallery and Strandline Curatorial Collective, 2018.

Marshall III, Joseph M. *The Lakota Way: Stories and Lessons for Living*. New York: Penguin, 2001.

———. *Returning to the Lakota Way: Old Values to Save a Modern World*. Carlsbad, CA and New York: Hay House Inc., 2013.

McLaughlin, Castle. *A Lakota War Book from the Little Big Horn: The Pictographic Autobiography of Half Moon*. Cambridge, MA: Peabody Museum Press, 2013.

———. "Objects and Identities: Another Look at Lewis and Clark's Side-Fold Dresses." *American Indian Art Magazine* 29, no. 1 (Winter 2003): 76–85.

McCoy, Ron. "Fully Beaded Valise with Pictographic Designs by Nellie Two Bear Gates." Notes from the Warnock Collection. http://www.splendidheritage.com/Notes/WC9206020.pdf.

Medicine, Beatrice. "Lakota Views of 'Art' and Artistic Expression. In *Ablakela: a performance work by Dana Claxton*. CD-ROM, texts by Beatrice Medicine and Glenn Alteen. Vancouver: Grunt Gallery, 2001.

———. *Learning to be an Anthropologist and Remaining 'Native': Selected Writings*. Edited with Sue-Ellen Jacobs. Urbana: University of Illinois Press, 2001.

———. "More Than Mere Coverings." In *Objects of Everlasting Esteem: Native American Voices on Identity, Art, and Culture*, edited by Lucy Williams, 131–32. Philadelphia: University of Pennsylvania Museum, 2005.

Meyer, Roy W. *History of the Santee Sioux: United States Indian Policy on Trial*. Lincoln: University of Nebraska Press, 1967.

Miller, J. R. *Compact, Contract, Covenant: Aboriginal Treaty Making in Canada*. Toronto: University of Toronto Press. 2009

Momaday, N. Scott. *The Man Made of Words: Essays, Stories, Passages*. New York: St. Martin's Press, 1997.

Nauman, H. Jane. *Lakota Quillwork: Art and Legend*. Videotape. Directed by H. Jane Nauman. Nauman Films Inc., 1985.

*The Story of the Dakota Oyate and the People of Standing Buffalo*. Saskatoon: Office of the Treaty Commissioner, 2015.

Ostler, Jeffrey. *The Lakotas and the Black Hills: The Struggle for Sacred Ground*. New York: Viking, 2010.

Pearce, Richard. *Women and Ledger Art: Four Contemporary Native American Artists*. Tucson, University of Arizona Press, 2013.

Penney, David. *Art of the American Indian Frontier*. Detroit: Detroit Institute of Arts, 1992.

Pennington, Robert. *Oscar Howe: Artist of the Sioux*. Sioux Falls, SD: Dakota Territory Centennial Commission, 1961.

Peters, Stephanie. "Creating to Compete: Juried Exhibitions of Native American Painting, 1946–1960." Master's thesis, Arizona State University, 2012.

Schuler, Harold. *Fort Pierre Chouteau*. Vermillion: University of South Dakota Press, 1990.

Sinclair, Senator Murray. "The truth is hard. Reconciliation is harder." Keynote at the Canadian Centre for Policy Alternatives BC Office 20th Anniversary Fundraiser. 19 October 2017. https://www.youtube.com.

Sleeper-Smith, Susan. *Indian Women and French Men: Rethinking Cultural Encounter in the Western Great Lakes*. Amherst: University of Massachusetts Press, 2001.

Shannon, Timothy. "Dressing for Success on the Mohawk Frontier: Hendrick, William Johnson, and the Indian Fashion." *The William and Mary Quarterly* 53, no. 1 (1996): 13–42.

Standing Bear, Luther. *Land of the Spotted Eagle*. 1933. Lincoln: University of Nebraska Press, 1978.

Thomson, Claire. "Lakotapteole: Wood Mountain Lakota Cultural Adaptation and Maintenance Through Ranching and Rodeo, 1880–1930." Master's thesis, University of Saskatchewan, 2014.

Torrence, Gaylord. *The American Indian Parfleche: A Tradition of Abstract Painting*. Des Moines, SD: Des Moines Art Center, 1994.

———, ed. *The Plains Indians: Artists of Earth and Sky*. Paris: Musée du quai Branly, 2014.

Trudell, John. *Rumble: The Indians Who Rocked the World*. DVD. Directed by Catherine Bainbridge. Montreal: Rezolution Pictures, 2017.

Truth and Reconciliation Commission of Canada. *Honouring the Truth, Reconciling for the Future: A Summary of the Final Report of the Truth and Reconciliation Commission of Canada*. Ottawa: Truth and Reconciliation Commission of Canada, 2015.

Utley, Robert M. *The Lance and the Shield: The Life and Times of Sitting Bull*. New York: Ballantine, 1993.

Vizenor, Gerald, ed. *Survivance: Narratives of Native Presence*. Lincoln: University of Nebraska Press, 2008.

*Wahpeton Dakota Nation Community History*. Prince Albert: Wahpeton Dakota Nation, 2012.

*Wahpeton Dakota Nation: The Story of the Dakota Oyate in Canada*. Saskatoon: Office of the Treaty Commissioner, 2015.

*Wa Pa Ha Ska: Whitecap Dakota First Nation*. Saskatoon: Office of the Treaty Commissioner, 2016.

Warnock, John and Marva Warnock, eds. *Splendid Heritage: Perspectives on American Indian Art*. Salt Lake City: University of Utah Press, 2009.

Welch, Edward K. "Distinctly Oscar Howe: Life, Art, Stories." Phd diss., University of Arizona, ProQuest Dissertations Publishing, 2011.

Westerman, Gwen, and Bruce White. *Mni Sota Makoce: The Land of the Dakota*. St. Paul: Minnesota Historical Society Press, 2012.

Wissler, Clark, *Societies and Ceremonial Associations in the Oglala Division of the Teton Dakota*. Vol. 11, *American Museum of Natural History Anthropological Papers*. New York: American Museum of Natural History, 1912.

Witte, Stephen and Marsha Gallagher, eds. Vol. 2, *The North American Journals of Prince Maximilian of Wied*. Norman: University of Oklahoma Press, 2010.

Wood, W. Raymond, William Hunt, and Randy Williams. *Fort Clark and Its Indian Neighbors: A Trading Post on the Upper Missouri*. Norman: University of Oklahoma Press, 2011.

Zimny, Michael. "Oscar Howe's Wounded Knee Massacre, a Rarely Seen Masterpiece." South Dakota Public Broadcasting. Accessed 13 May 2015. http://www.sdpb.org/blogs/arts-and-culture/oscar-howes-wounded-knee-massacre-a-rarely-seen-masterpiece/.

## List of Illustrations

All images reproduced in *The Sioux Project—Tantaka Oyate* courtesy Dana Claxton unless otherwise stated.

Don Hall: pp. 2–3, 22–23, 30, 48–49, 58, 185.

p. 34
Unidentified (North or South Dakota, Lakota [Teton Sioux])
*Sun Dance*, c. 1895
muslin, pigments
61 × 168 cm
Bowdoin College Museum of Art, Brunswick, Maine, Museum Purchase, Lloyd O. and Marjorie Strong Coulter Fund, Laura T. and John H. Halford, Jr. Art Acquisition Fund, Jane H. and Charles E. Parker, Jr. Art Acquisition Fund, Barbara Cooney Porter Fund, and Greenacres Acquisition Fund, 2017.16
Photograph by Luc Demers.

p. 35
Karl Bodmer (Swiss, 1809–1893)
*Chan-Cha-Uia-Teuin, Teton Sioux Woman*, 1833
watercolor and pencil on paper
Joslyn Art Museum, Omaha, Nebraska, Gift of the Enron Art Foundation, 1986.49.246

p. 36
Unidentified (Sioux)
*Side-fold dress*, c. 1800–1825
bison hide, bison sinew, quill, wool, hair, glass, brass, shell, tin, bead, cotton
overall: 124.5 × 75 cm
Gift of the Heirs of David Kimball, 1899.
© President and Fellows of Harvard College, Peabody Museum of Archaeology and Ethnology, PM99-12-10/53047

p. 38
Unidentified (Métis/Sioux)
*Coat*, c. 1840
hide, ermine skin, porcupine quills, metal, sinew
107 × 78 cm
Canadian Museum of History, V-E-294 a. S77-1858

p. 39
Unidentified (South Dakota, Sioux [Lakota])
*Red Cloud Shirt*, c. 1870s
human hair, horse hair, deer hide, pigment, porcupine quills, beads, wool
108 × 147.3 cm
Buffalo Bill Center of the West, Cody, Wyoming, U.S.A.; Adolf Spohr Collection, Gift of Larry Sheerin, NA.202.598

p. 40 (top)
Unidentified (Brule Band Sioux)
*Robe*, c. 1870
bison hide and glass beads
240 × 182.9 cm
Denver Art Museum Collection: Native Arts Acquisition Fund, 1948.144
Photograph © Denver Art Museum.

p. 40 (bottom)
Unidentified (Sioux)
*Moccasins*, c. 1890
tanned hide and glass seed beads
each: 8.9 × 11.4 × 26.7 cm
Saint Louis Art Museum, The Donald Danforth Jr. Collection, Gift of Mrs. Donald Danforth Jr. 38:2012a,b
Image courtesy Saint Louis Art Museum.

p. 41 (top)
Unidentified (North or South Dakota, Lakota [Teton Sioux])
*Pair of Parfleche Envelopes*, c. 1900–1910
rawhide, native tanned leather, glass beads, porcupine quills, metal cones, and horsehair
69.9 × 33.7 × 8.2 cm
The Nelson-Atkins Museum of Art, Kansas City, Missouri. Gift of Frank Paxton Jr., 2010.60.1, 2.
Photo courtesy Nelson-Atkins Media Services / John Lamberton.

p. 41 (bottom)
Black Hawk (South Dakota, Sans Arcs Lakota [Teton Sioux], 1832–1889)
*Drawing of a Social Dance*, c. 1880–1881
paper, ink, and pencil
24.1 × 39.4 cm
Fenimore Art Museum, Cooperstown, New York, Gift of Eugene V. and Clare E. Thaw, Thaw Collection, T0614(03).
Photograph by Richard Walker.

p. 42
Unidentified (Minneconjou Lakota)
*Beaded Tipi Bag*, c. 1885
native tanned hide, glass beads, metal, dyed deer hair
From the collection of the Cranbrook Institute of Science.
Photograph by Michael Narlock.

p. 43 (top)
Unidentified (North or South Dakota, Lakota [Teton Sioux])
*Women's Shoes*, c. 1920
commercial canvas and leather shoes, glass and metallic beads
length: 26.7 cm
The Nelson-Atkins Museum of Art, Kansas City, Missouri. Purchase: acquired through the generosity of the Kay and John Callison Art Acquisition Fund, 2018.15.1,2.
Photo courtesy Nelson-Atkins Media Services / Joshua Ferdinand.

p. 43 (bottom)
White Bull (Minneconjou and Hunkpapa Lakota, 1849–1947)
*White Bull in Ceremonial Dress*, 1931
pencil, crayon, and ink on paper
26.7 × 37.5 cm
Courtesy of the Elwyn B. Robinson Department of Special Collections, Chester Fritz Library, University of North Dakota, OGL 183.49.

p. 44
Arthur Amiotte (Oglala Lakota [Teton Sioux], born 1942) in a ceremonial shirt made by Christina Standing Bear (1897–1984), early 1980s, Sioux Valley, Manitoba.
Photo courtesy Arthur Amiotte.

p. 45
Emil Her Many Horses (Lakota, born 1954)
*Tasunka Ota Win*, 2014
purchased Christian Louboutin black suede shoes, glass beads
Collection of Cathy and Ken Vogele
Photo courtesy of the artist.

p. 46
Jodi Gillette (North Dakota, Hunkpapa Lakota [Teton Sioux], born 1959)
*Woman's Dress and Accessories*, 2005
native tanned and commercial leather, glass and metal beads, cotton cloth, silk, dentalium shell, metal cones, horsehair, plastic, hair pipes, brass bells, porcupine quills, brass tacks, brass and metal studs, and silver cones
137.2 × 152.4 cm
Jodi Gillette
Photo: Joshua Ferdinand

p. 55
Unidentified (Northern Plains, Sioux)
*Moccasins*, c. 1890
tin cones, porcupine quills, cotton cloth, horse hair, tanned deer hide, glass beads
25.1 × 10.2 cm
Buffalo Bill Center of the West, Cody, Wyoming, U.S.A.; NA.202.7

p. 60
Oscar Howe (Yanktonai Dakota [Sioux], 1915–1983)
*Victory Dance*, c. 1954
watercolor
49.4 × 30.5 cm
Philbrook Museum of Art, Tulsa, Oklahoma. Museum purchase, 1954.6.

p. 62
Colleen Cutschall (Oglala-Sicangu Lakota, born 1951)
*The Third Time: The Judgement of Skan*, 1989
acrylic on canvas
121.9 × 121.9 cm
Collection of the MacKenzie Art Gallery 1992–4
Photo: Don Hall

p. 63
Arthur Amiotte (Oglala Lakota [Teton Sioux], born 1942)
*Us and Them Together*, 1992
multimedia collage
50.8 × 61 cm
Aktá Lakota Museum & Cultural Center, St. Joseph's Indian School, Chamberlain, SD, USA

p. 64
Dana Claxton (Hunkpapa Lakota, born 1959)
*Sitting Bull and the Moose Jaw Sioux*, 2004
video installation
Photo: courtesy of the artist.

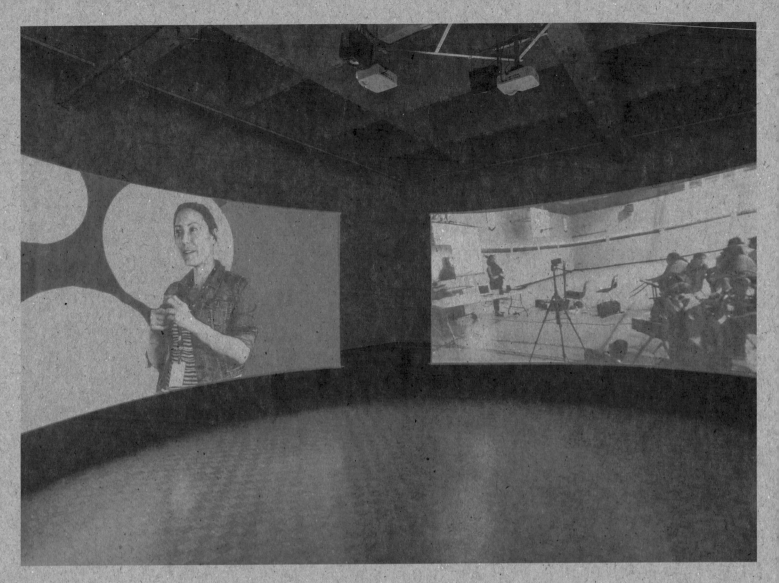

p. 65 (top)
Designer: Colleen Cutschall (Oglala-Sicangu Lakota, born 1951)
Sculptors: John R. Collins and Christopher S. Collins
*Spirit Warriors*, 2003
bronze
426.7 × 1,036.3 cm
Little Bighorn Battlefield National Monument
Photo: courtesy of Colleen Cutschall

p. 65 (bottom)
Arthur Amiotte (Oglala Lakota [Teton Sioux], born 1942)
*The Reunion*, 1994
mixed media collage
45.7 × 61 cm
J. W. Wiggins Contemporary Native American Art Collection, University of Arkansas at Little Rock.
Photo courtesy J. W. Wiggins Contemporary Native American Art Collection, University of Arkansas at Little Rock

p. 66 (top)
Arthur Amiotte (Oglala Lakota [Teton Sioux], born 1942)
*Wounded Knee III*, 2001
acrylic and collage on canvas
91.4 × 121.9 cm
The David and Alfred Smart Museum of Art, The University of Chicago; Gift of Miranda and Robert Donnelley
Photograph ©2019 courtesy of The David and Alfred Smart Museum of Art, The University of Chicago.

p. 66 (bottom)
Oscar Howe (Yanktonai Dakota [Sioux], 1915–1983)
*Massacre at Wounded Knee*, c. 1959
gouache on paper
55.9 × 71.1 cm
From the collection of National Archives and Records Administration, Eisenhower Presidential Library, Abilene, Kansas.
Photograph courtesy of National Archives and Records Administration, Eisenhower Presidential Library, Abilene, Kansas.

p. 67
Wayne Leslie Goodwill (Sisseton Dakota and Lakota [Teton Sioux], born 1941)
*Untitled*, 1970
fibre tipped pen and paint on hide
131 × 108 cm
Collection of the MacKenzie Art Gallery, gift of Mr. Victor Cicansky
1993–42
Photo: Don Hall

# Acknowledgements

A book is a book, a porcupine quill is a porcupine quill, a shell is a shell is a shell. The translation of culture takes many forms with many materials. This book shares Dakota/Nakota/Lakota culture and aesthetics. I would like to thank Lynne Bell, Gwenda Yuzicappi, and Cowboy Smithx for their brilliance, and all the artists, knowledge keepers, elders, and young ones who really brought to life what was in my mind's eye. The MacKenzie Art Gallery further animated this project with the symposium and exhibition. I am grateful to Timothy Long for being so present and for his superb copy editing, to Anthony Kiendl for his foreword and support, and to all the gallery staff who installed the show and organized the symposium — *tanka wopila*. I am grateful to Carmen Robertson for curating the show and for her essay, and to writers Lynne Bell, Janet Catherine Berlo, Timothy Long, Cowboy Smithx, and the late Dr. Bea Medicine for their amazing words and engagement with this project. This book was so thoughtfully designed by Derek Barnett at Information Office and I thank him for his stellar interpretive skills and ways of listening. I am thankful to Andrea Tuele and the Department of Art History, Visual Art and Theory at the University of British Columbia, and the Social Sciences and Humanities Research Council of Canada for supporting Indigenous research. I am grateful to Ted Sitting Crow Garner for allowing us to reprint his mother's essay, "Lakota Views of 'Art' and Artistic Expression," and to my late Auntie Bea Medicine, who brought me into the Sitting Bull Sun Dance circle and told me she was bringing me back home.

Cowboy brilliantly oversaw the video boot camps with youth. We interviewed dozens of artists in the Standing Buffalo gym — the most amazing location I have ever filmed in. The youth from Whitecap First Nation and Standing Buffalo were a joy to be with. I am grateful for every hand, thought, moment, artwork, dance, drum beat, song, and voice. For all the people we met along the way, and the next 70 generations of Tatanka Oyate, this book is for you. For every artist, thinker, elder, youth, community worker, and teacher, this book is for you. For every corn grower, saddle maker, shawl maker, painter, quillwork maker, and beader, this book is for you. For every jingle dress maker and dancer, this book is for you. For every star quilt maker, this book is for you. For every Dakota, Nakota, and Lakota person, this book is for you and your family and the next generations — we are the Tatanka Oyate — we are the Buffalo People and descendants of the stars. This book is also for everyone who wants to learn about Dakota, Nakota, and Lakota art and culture. Thank you for holding this book in your hands and listening to its voices. A book is a shell with texture and story.

Lynne Bell, Gwenda Yuzicappi, and I spent precious days together pondering, dreaming, and articulating what we were going to do, how we could make this "project" work, and how we could engage and invite community to teach/show/share with us their "Sioux" aesthetics and ways of being in the world. I have reclaimed the word Sioux as my own, proudly using it to describe my own cultural heritage.

I understand that this word may offend some and if it does this is not my intention. My intention with a good heart and clear mind is to reclaim this word.

Sioux aesthetics are made to be ready. Moccasins, dresses, cradleboards, shawls, jewellery, quillwork, and head roaches are worn on the body and danced. Paintings and painted robes adorn the home. And the significant star quilt — the star blanket that provides warmth, marks passages of time, and carries the Star — honours *tatanka* who is our ancestor. Sioux aesthetics are made to be ready and in that readiness our communities survive, thrive, and dance into the future.

I would like to acknowledge my family, who teach me always about deep love, and Robert Watson, who graciously hosted the research retreats with Lynne, Gwenda, and me. To my beloved uncle Hartland (Spike) and auntie Evelyn Goodtrack, and their children and grandchildren, who have shared so generously with me; to my sister Kim Soo Goodtrack, who along with my paternal grandmother Gladys Claxton taught me how to pray, and through that deep prayer, and being brought back home to the Sun Dance circle, I receive guidance and fortitude which will forever and endlessly inspire me: *tanka wopila — pilamaya*.

Dana Claxton
Unceded Salish Territory, 2020

## Artist Biography

**Dana Claxton** is a critically acclaimed artist who works in film, video, photography, single and multi-channel video installation, and performance art. Her practice investigates beauty, the body, the socio-political, and the spiritual. Her work has been shown internationally at the Museum of Modern Art (NYC), Metropolitan Museum of Art (NYC), Walker Art Center (Minneapolis), Sundance Film Festival, Eiteljorg Museum (Indianapolis), and the Museum of Contemporary Art (Sydney, Australia) and is held in public collections including the Vancouver Art Gallery, National Gallery of Canada, Canada Council Art Bank, MacKenzie Art Gallery, and the Winnipeg Art Gallery. *Fringing the Cube*, her solo survey exhibition, was held at the Vancouver Art Gallery in the fall of 2018. She has received numerous awards including the VIVA Award, Eiteljorg Fellowship, Governor General's Award in Visual and Media Arts, and Scotiabank Photography Award. She is Head and Associate Professor in the Department of Visual Art, Art History and Theory at the University of British Columbia. Her family reserve is Wood Mountain Lakota First Nation located in beautiful southwest Saskatchewan.

## Contributor Biographies

**Lynne Bell** is Professor Emeritus of the Social History of Art and Visual Cultures, University of Saskatchewan. Her publications include: "Unsettling Acts: Photography as Decolonizing Testimony in Centennial Memory," in *The Cultural Work of Photography in Canada*, 2011; and "Singing the Colonial Blues in the Settler Archive," in *Adrian Stimson: The Life and Times of Buffalo Boy*, 2014. She is co-editor of *Decolonizing Testimony: On the Limits and Possibilities of Witnessing*, a special issue of *Humanities Research*, Australia National University, 2009.

**Janet Catherine Berlo**, Professor of Art History and Visual and Cultural Studies at the University of Rochester, holds a PhD in history of art from Yale. She is the author of *Native North American Art* (with Ruth Phillips, Oxford, second edition 2015), *Plains Indian Drawings 1865–1935* (1998), *Spirit Beings and Sun Dancers: Black Hawk's Vision of a Lakota World* (2000), *Arthur Amiotte: Collages 1988–2006* (2006), *José Bedia: Transcultural Pilgrim* (with Judith Bettelheim, Fowler Museum, UCLA, 2011) and many other publications on the Indigenous arts of the Americas. Her essays have been published in *Third Text*, *Art History*, *Museum Anthropology*, *American Indian Art Magazine*, and in exhibition catalogues of the National Museum of the American Indian, the Metropolitan Museum, the Peabody Essex Museum, the Eiteljorg Museum, and elsewhere. She has taught Native art history as a visiting professor at Harvard and Yale, and has received grants from the Guggenheim and Getty Foundations.

**Timothy Long** has thirty years of curatorial experience at the MacKenzie Art Gallery where he is Head Curator and Adjunct Professor at the University of Regina. His past projects have traced developments in Saskatchewan art from the 1960s to present, including *Regina Clay: Worlds in the Making* and retrospectives of Marilyn Levine, Jack Sures, David Thauberger, and Victor Cicansky. His pursuit of interdisciplinary dialogues involving art, sound, ceramics, film, and contemporary dance has resulted in a number of innovative projects, including *Theatroclasm* (2009), *Ian Wallace: Masculin/Féminin* (2010), and *Atom Egoyan: Steenbeckett* (2016). In 2018 he co-curated *Re: Celebrating the Body*, the latest in a series of exhibition/residencies with the acclaimed contemporary dance company New Dance Horizons.

**Carmen Robertson** is a Scots-Lakota woman from Saskatchewan who is both an academic and an independent curator. She recently became the Tier I Canada Research Chair in North American Art and Material Culture at Carleton University, where her research centres on contemporary Indigenous arts. In 2016, she published both *Norval Morrisseau: Art and Life* (Art Canada Institute) and *Mythologizing Norval Morrisseau: Art and the Colonial Narrative in the Canadian Media* (UManitoba Press). *Seeing Red: A History of Natives in Canadian Newspapers* (UMP, 2011), which Robertson co-authored with Mark Cronlund Anderson, has elicited awards and favourable reviews. Her essay "Land and Beaded Identity: Shaping Art Histories of Indigenous Women of the Flatland," in *RACAR* in 2017, is part of her ongoing investigation into the artistic contributions of Sioux artists on the prairies.

**Cowboy Smithx** is an award winning filmmaker of Blackfoot ancestry from the Piikani and Kainai tribes of Southern Alberta, Canada. Cowboy is the founder and curator of the highly acclaimed international Indigenous speaker series "REDx Talks." He also serves as the Artistic Director of the Iiniistsi Treaty Arts Society, a non-profit organization dedicated to activating the true spirit and intent of Treaty #7. Cowboy writes, directs, and produces film works in documentary, narrative, music video, and experimental formats. He is currently working in Indigenous education, cultural consultation, and youth work around the world. Cowboy has been featured as a keynote presenter at over 150 conferences, symposiums, and festivals across the globe. Cowboy facilitates dozens of interactive workshops for professionals, artists, youth, and elders. Cowboy is also the founder of the Elk Shadows Performing Arts Clan and the Noirfoot School For Cinematic Arts.

**Dr. Beatrice (Bea) Medicine** (1923–2005) was born on the Standing Rock Reservation, Wakpala, South Dakota. Bea or Hinsha Waste Agli Win (Returns-Victorious-with-a-Red-Horse-Woman) received her PhD from the University of Wisconsin at Madison. Medicine taught in the United States and Canada, including Stanford University, Dartmouth College, San Francisco State University, University of Washington, University of Montana, and University of South Dakota. Medicine was active in civic matters that affect the rights of children, women, especially American Indians, LGBTQ, and Two-Spirited. She served as Head of the Women's Branch of the Royal Commission on Aboriginal Peoples for the Canadian government, helping draft legislation to protect the legal rights of Native families. Medicine received many awards, honorary doctorates, distinguished alumna, fellowships, and citations. She was the Sacred Pipe Woman at the Sun Dance at Sitting Bull's Camp in 1977. She served as an expert witness in several trials pertaining to the rights of American Indians, including the 1974 federal case brought against the individuals involved in the Wounded Knee occupation of 1973.

## Community Collaborator Biography

My name is **Gwenda Yuzicappi**. I am a Dakota from the Standing Buffalo Dakota Nation. I was raised by Agnes Yuzicappi, my paternal grandmother, who lived to see her ninety-eighth birthday. I have three brothers (two deceased) and five sisters. My parents and grandmother are deceased. My late grandmother and father went to Residential School, which I also attended. I was nineteen when I started my family. I cherish Unci's words of how important it is to attain my Education. I returned to school to complete my grade twelve and then my Bachelor of Indian Social Work in 1999. I have been employed within the same agency for twenty-two years. I have two sons and one daughter; Wicanhpi Duta Win, Redstar Woman, my only daughter, was Missing & Murdered in 2005 and I continue to share her story. I am a very proud grandmother, as I was gifted a beautiful granddaughter.

I am a proud Dakota and work with the grass roots to unite each Dakota, Lakota, and Nakota nation in Saskatchewan. I am honoured to be part of this project to gather youth, adults, and elders who exhibit their creativeness and skill through their artwork of Buffalo hide painting, drawings, beading moccasins, regalia-making, star blanket-making, porcupine earrings, shawl-making, drum-making, and singing songs from the Dakota, Nakota, and Lakota ancestry. I am very proud to be part of *The Sioux Project* and the publication of this book for everyone to read each one's experience and to have in our homes, communities, and libraries.

*Cante Waste Napa Cheyuzapi Mitakuyapi*
"With a kind heart I shake hands with everyone."

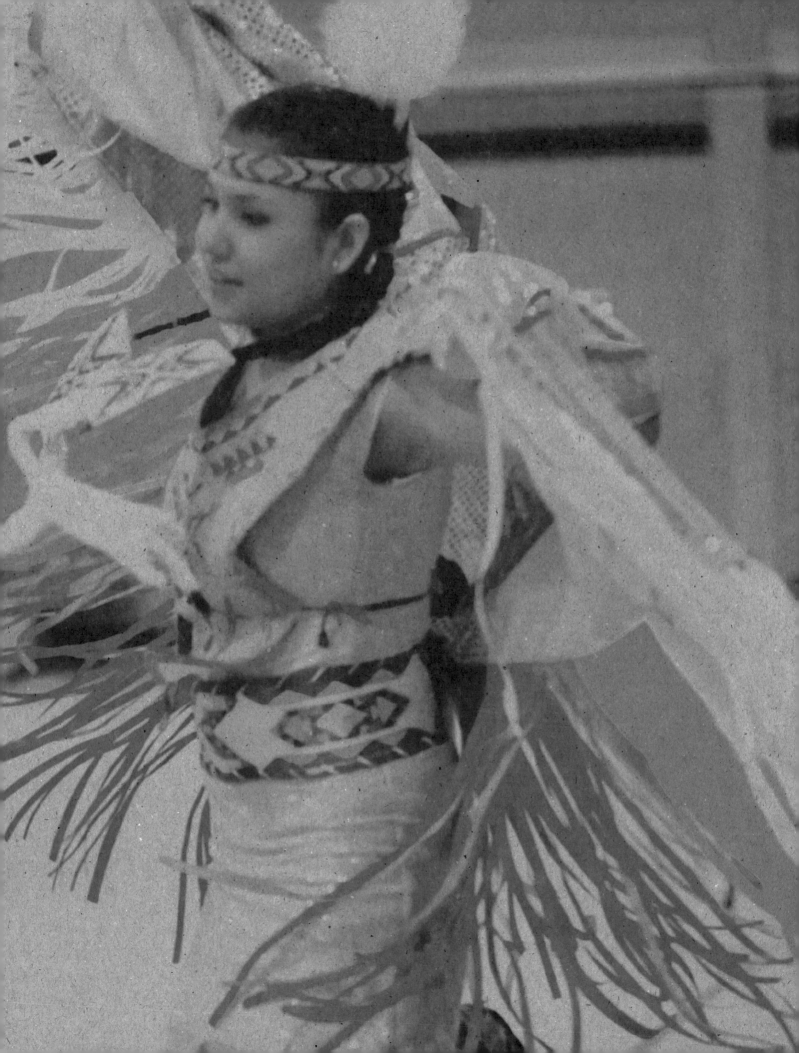

Published in conjunction with the exhibition
*Dana Claxton: The Sioux Project—Tatanka Oyate*,
MacKenzie Art Gallery, September 30, 2017 to
January 7, 2018. Curated by Carmen Robertson.

Editor: Dana Claxton
Copy Editor: Timothy Long
Publication Assistant: Lydia Miliokas
Design: Information Office
Printed in Belgium

ISBN 978-1-988860-05-3

MUSÉE D'ART MACKENZIE    M    MACKENZIE ART GALLERY

MacKenzie Art Gallery
3475 Albert Street
Regina, SK S4S 6X6 Canada
mackenzie.art

# Information Office

Information Office
4780 Main Street, 202
Vancouver, BC V5V 3R5 Canada
www.i-o.cc

Library and Archives Canada
Cataloguing in Publication

Title: The Sioux Project—Tatanka Oyate / edited by
Dana Claxton. Other titles: Tatanka Oyate
Names: Claxton, Dana, editor.
Identifiers: Canadiana 20200198300
ISBN 9781988860053 (hardcover)
Subjects: LCSH: Indigenous art.
LCSH: Film installations (Art)
Classification: LCC N6351.2.I53 S56 2020
DDC 704.03/9752—dc23

*Dana Claxton: The Sioux Project—Tatanka Oyate*
was organized by the MacKenzie Art Gallery with
support from South Saskatchewan Community
Foundation, Canada Council for the Arts,
SaskCulture, City of Regina, University of Regina,
and Saskatchewan Arts Board. Additional support
was gratefully received from the Social Sciences
and Humanities Research Council of Canada and
the Department of Art History, Visual Art and
Theory, University of British Columbia.

SSHRC CRSH